RETURNING LIGHT

RETURNING LIGHT

Thirty Years on the Island of Skellig Michael

Robert L. Harris

MARINER BOOKS

New York Boston

Illustrations © Karen Vaughan 2022

Photographs courtesy of the author

HarperCollins books may be purchased for educational, business,
or sales promotional use. For information, please email the
Special Markets Department at SPsales@harpercollins.com.

Originally published in Ireland in 2022 by HarperCollinsIreland.

FIRST U.S. EDITION

Library of Congress Cataloging-in-Publication Data
has been applied for.

ISBN 978-0-06-326828-9

22 23 24 25 26 LBC 5 4 3 2 1

For Maigread,
and for Daniel and Lillian

CONTENTS

INTRODUCTION

Over forty years ago now, I travelled westwards from Edinburgh in winter to the Western Isles of Scotland. I was a student, and I thumbed, or took buses and trains if I could, to reach this luminous coastline. Over time, I came to love making these journeys to walk out upon the furthest edges of the Scottish coast, beyond which the North Atlantic seemed to stretch endlessly ahead. On one of these excursions to the shore, late on a dark afternoon, I found myself standing on the western rim of the island of Mull and staring across towards Iona. I would be taking the next morning's ferry there.

The next day, I stood on a little beach at the far end of this further island, where Saint Columba, exiled from Ireland, had established a monastery in the sixth century. The heavy skies were filled with sea-birds. They circled irregularly overhead in cross-winds and dispersed towards the horizon, careening out to sea on their short forays, returning out of the grey emptiness. In the far mist, at the very edge of my sight, they would regather and bank to return. I watched them appear and disappear for over an hour. I would almost lose them; suddenly, they would be overhead once more. Edinburgh seemed very far away, and I was utterly alone, having walked a good distance away from the settlement on the

island. The birds were ordinary coastal birds I might see above any beach or headland. And yet, suddenly, I was startled by them circling overhead and held, spellbound, by the endlessly unfolding permutations in the patterns of their flight. At once, I recalled spirals and unravelling lines I had seen in reproductions of early Irish manuscripts. I saw the strange creatures from the Book of Kells, the Book of Lindisfarne, taking shape in the sky above me on that deserted western beach. The lines in the sky unfolding over my head and unravelling out to sea merged into the penned lines of an artistic language used many centuries before, there at Iona, and at many other early Christian monasteries spread along the seaboards of Britain and Ireland.

These ancient manuscripts, which I was familiar with through reproductions, suddenly came alive before my eyes. Within a glance, I saw records of line and spiral differently than before while standing upon that Scottish shoreline. These forms registered at once with something deep within me.

Often since, I have found myself along Atlantic coasts, staring westwards, fascinated by the trails of bird-flight tantalizingly held in the air overhead and disappearing out to sea. In particular, since 1987, I have made a yearly sojourn on the island of Skellig Michael, off the south-western coastline of County Kerry, and I have lived there over the summer months for the past thirty years. Travelling out to that Irish island, surrounded suddenly by great numbers of birds, I have often recalled the shock of sudden awareness on the Scottish coast long ago. For in the waters surrounding the Skelligs some six thousand or more puffins may gather overhead. Nearby, gannets in great numbers erect towers in the empty air, working their flight by thermals that form between these isolated islands. Observing these wonders, I – and, I am sure, countless others – have often been reminded of ancient recordings of natural line and form, as found in early manuscripts, which had suddenly come to life before me in the skies over Iona.

On Skellig Michael, thousands of birds appear and disappear, coming together in wings of movement that build and unravel over the empty sea. They pull me away from my established frames of reference. Often, no one else is there to stand beside me on the island, and the skies and surrounding rock edges are empty. The mind wanders; links with the past are easily made; ancient ways of viewing things come alive.

Lack of human contact, the diminution of human society, contributes to a full engagement with these fluid lines of flight, superimposed as they are upon the endlessness beyond. We know that people long ago came to engage with this endlessness permanently, came to ride within these curves and spirals of evanescent bird-flight on the edge of apparent nothingness. Ancient monks came to spend their lives on bare rock. To us, looking back, there was no real need for these men to come here, no reason for the journey to make a home at such a bleak place. Perhaps, though, they too were intrigued by the natural profusion and the exuberance of light, glimpsed just beyond the last bit of land, the last standing place to be seen on a horizon. Perhaps they were entranced by movements overhead. A deep desire remains, crossing creed and time and hidden within the human heart, to explore, to become a part of, such realms of the border. Inner springs, by which the soul stretches along and above the curvature of the earth, tighten at the edges of all things, so that the soul is suspended beyond the lines of beach or rocky shore and is carried and released by bird-flight, whale song, shark and dolphin fin – beyond the realms of normal sight, normal apprehension.

> How many rooms can be seen: ahead,
> Over the open sea, within the empty air?
> What is spoken or written there?
> A silence descends, breaking from the waves,
> Revealed in a language of the heart
> Rarely spoken: out of nothingness

Air is charged upon deserted shores
And is honed to make a space apart,
To take a meaning from emptiness,
Over time, within an empty place.
In this air, at these extremes,
We begin to recognize one another;
We have travelled long distances
To arrive at edges suddenly familiar,
The rock-cliffs at the terminus
Of each pathway we have chosen.
Doorways appear before us empty,
We pass through to be charged.
Rarely speaking. Yet calling, at times,
One another, over the silences beyond:
'What hovers ahead upon those empty
 spaces, drawing us out here again, looking
 for further speech within the silence?
 drawing us further out along the shore?'

PART ONE

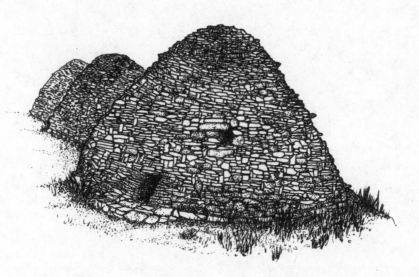

CHAPTER ONE

A Lost Map

I was exhilarated by the sights before me, standing on that remote Scottish coastline so many years ago. I had been a student in Edinburgh for a few months by Christmas 1977, but my life for the most part lacked any direction. I was unaware that my mother was dying in the United States and that I would soon need to leave Scotland to assist my father with her care. Embarking on the discipline of a thesis towards which I felt very little commitment, I felt utterly isolated. I found the city, and the countryside, beautiful, but I also experienced a continual sense of unease and was unsettled there.

At a loss, I roamed out into the countryside whenever that became possible: the more remote the destination, the further away from an uncertain, unresolved commitment, the better I seemed to feel, regardless of any physical or financial hardship to be undertaken. And so, I found myself on the coast of the mainland that Christmas, looking out into the empty western sky, to see the birds suddenly appear out of nothingness. The call of the eternity beyond seemed almost overpowering there, just then.

I sensed a tight spring of unease, of restlessness, which had been mine for months and wound ever more tightly, now pulled toward release at the sudden expansion of vista, at the miraculous

opening of the sea and the sky. And then the birds' flight began to unravel before me in spellbinding patterns that, somehow, I already knew.

I travelled to the US to spend those last few months with my mother, and then returned to Edinburgh once more. I was employed in a small bar and continued to work on my thesis for another eighteen months. I knew instinctively that this period of my life was coming to an end. I met a young woman from County Kerry and, in 1980, we migrated from eastern Scotland to the west of Ireland, becoming acquainted with other shores. We rented a small cottage overlooking Ballisodare Bay in County Sligo. Maigread and I began a family. Among other attempts at providing for ourselves, we slipped out at low tide onto the estuaries nearby, picking bags of winkles for pay and for transportation to the food markets of France. For a while, this became a mind-numbingly cold and exhilarating occupation, undertaken in the company of seals and oystercatchers who were lounging on the sandbanks beside us. We wrapped our infant son in layers of plastic home-made 'oilskins'; he, too, seemed half-seal in the dawn light upon the shore.

We had relatives in Kerry and spent much time there. In the summer of 1985, we woke at a friend's house, in Kenmare, with two free days on our hands. We headed west, in the little tin-can of our second- (or third-)hand postal van: now eager, but on its last legs. We were not particularly heading for the Skelligs – which had always beckoned somewhere, vaguely, within my internal geography. We set out more to wander the then wild coastline of Cork and Kerry at random. We were set loose, our son was minded, and we rolled along small roads that morning, encountering one beach after another, one estuary after another – or so it seems, though I cannot find these places any more – to see a sign pointing towards Ballinskelligs pier and a journey to the Skelligs advertised, under the helm of skipper Brendan Walsh.

We were two of a dozen or so passengers, and were rowed out

from the pier in a small dinghy to board a larger half-decker for the ninety-minute trip. I recall piped music welcoming us aboard, though I hardly heard it. I remember being extremely happy. Suddenly, I was aware once more of being completely surrounded by sea and sky, aware of the sensations that one apprehends on leaving land and that I had not experienced for a long time. I was 31 years old.

Looking back, it seems to me that many things were being abandoned during the course of that journey, but of course I could not have known that then.

What were these things? I was travelling out to an island connected to the modern world by historical associations going back over 1,400 years and by the trails of the protected birds that filled the sky overhead. Otherwise, and in different light, it was a bare rock at sea. Perhaps a youthful prejudice, or arrogance, was being abandoned on that crossing. I would learn, over time, that occasions would arise at this place when I would hear a call to speak secretly with those far away, and to receive messages across the lines of living and dying. At the same time, I would come to experience something of the sense of desolation, and imprisonment, known by those who are incarcerated and secluded, through no fault of their own – the outcasts spread in lonely places across all the edges of the world.

We passed between thick hedges of raised flight on the way out from the mainland. Showers of gannets cascaded into the sea at each side of the advancing boat, their homes glistening on the crags overhead as we neared the islands. Every ridge of stone shone, alight with new life. Countless chicks sheltered above us, indistinguishable orbs of white woolly down packed upon the cliff edges. Their parents hurled themselves into the empty air: veering out upon, and returning from, horizons miles away.

Beyond the first island (Little Skellig), I saw – first a handful, then hundreds of – puffins falling away from the further rock, Skellig Michael. They formed great rings in the air; the sky ahead

seemed full of jewels. Translucent carmine beaks, aglow in the trapped sunlight, circled towards and above us, caressing the curvature of the rock along sheer ledges, establishing opposing fields of movement between the two islands. The little vessel was pulled up high upon a mountain of raised spirit, in the nether region between Little Skellig and Skellig Michael, one mile apart from one another. Suddenly, we moved into a charged place, having passed over empty water on our journey from the shore. We moved into a field of endeavour unspecified except as a place for the exploration of unfolding light: a space where our perspectives became unsettled, and then thrown open.

And I was utterly aware of the light falling on us all, there at that exposed point on the sea: falling in the softest of caresses on the skin, the arms, the hair of my wife, aglow in the beaks of the revolving birds, stretching in little fingers even below the surface, so that the light-trails left by diving birds shimmered in running and electrical currents as we neared Skellig Michael.

Emptiness. And light charging, and changing, the vision of ourselves.

A different order of light formed ahead of us, within a small field, defined by circling waters.

We were descending from this raised ridge of trapped ocean, of confined water between these two remote islands, pushed onto first footfall and to our first leap onto steps to rise upon a concrete pier, bathed in the sunlight running down the shoulders of the mountain. And we were starting to ascend along the road curving ahead – each turn revealing a new vision, a new perspective on the empty ocean beyond, so that these visions and instances gathered and enhanced the brightness around us. Frame after frame of bright empty light accumulated at every turn of the little island road unfolding ahead. The road continues to unfold, and stretch ahead of me in my mind's eye, even after all this time.

On dry land, we climbed along the lighthouse road, along the way where nineteenth-century lighthouse keepers' names were

carved into the stones. All of the light from far beyond seemed to be falling there, the light from all eternity absorbed and distilled upon those vanes of rock, rising out of the sea at a sheer angle, reaching into the sky overhead, far beyond the edge of the mainland. And so the rock stands now, at this distance of time, held in the intense glare of descending sunlight, the beams falling from behind the summit and picking out the circling birds, exposing an architecture of revolving light utterly unique. Creating a vision held together by bird-flight and by the continual dissolution of all static things. Ahead of us, ancient and enigmatic steps rose: climbing, layer upon layer, through the surrounding emptiness and into the emptiness above, rising to a high vantage point, rigged as a lookout upon the even further emptiness beyond.

We ascended onto bedrock behind the ancient monastery, some six hundred feet above a bright summer's ocean. We sat, Maigread and I, and watched my map lifted, almost effortlessly, in a warm breeze, crinkling happily in soft air, flitting outwards, downwards, slowly towards the sparkling and eternal sea spreading before us out towards the Arctic, to the northwest, away from this warm fragrant rock, this mild summer's day in June 1985. And it was as if something of myself had been given away or taken away into the emptiness of the air and into the teeming ocean beyond. Something lost forever – though inessential, irredeemable. Some interior logic had been broken open.

Sometimes, the light that holds everything before us changes; the lines of our communication break. We stand exposed; chance openings hove into view. The thin film that separates us from what is beyond alters. We wait and wait, and suddenly a drastic action is forced on us. Finally, there is one choice to be made.

And then the map disappeared, and there was only the light falling over us.

CHAPTER TWO

A New Home

Maigread and I had little interest in the guided tour when we visited the island that day. A resident archaeologist gave a daily talk in the monastery at the time, but we quickly steered ourselves past. We climbed up onto the high rocks hidden behind the monastery, from where we could survey the peak stretching into the air just beyond us and the open sea twinkling below. The world spread out on all sides. It was possible to roam the island more freely then than now, as the numbers coming to the island were much smaller. In fact, over the years, I have met elderly returning visitors telling me of happy days in their youth when they were dropped off for the day by relatives, who were fishing locally, to be picked up again in the evening, having had a day on the island to themselves.

At any rate, that morning, as we climbed onto the rocks behind the monastery, our sense of freedom was palpable. We felt a bit like the wild goats who roamed the island into the 1950s. In the nineteenth century, lighthouse keepers even brought a cow onto the island, guiding her up the steps to graze in Christ's Saddle, the ridge that separates the two peaks on the island, halfway up the steps to the monastery. We were high on this day, having sensed the completion of an excursion to a bright

edge of all things; we sailed back ashore, found a restaurant, enjoyed a long and involved meal, and pitched our tent in darkness. We drove home northwards with a new light ablaze upon our internal geography, and within ourselves.

Two years passed. We had to move inland from our little rented cottage isolated on the shores of Ballisodare Bay, and away from the basking seals we would see out on the sandbanks in the early morning, and from the running breakers we could see over at Strandhill and behind the dunes at Culleenamore, around the corner of the bay. We moved into the hill country of north Leitrim and rented a house by the lake at Loughadoon. Right behind the house a steep hill rose, topped by ancient worn earthworks, from which we could yet view Knocknarea and the far ocean, now ten miles away. Whooper swans came to overwinter right beside us, calling out on the frozen night air. Daniel, now six, said that they were having parties, with their laughter reverberating through the ice and cold. At least twice we were snowed in; and when we were able, after two or three days of seclusion, to drive down to Sligo town, we found to our surprise that there had been no snow at all below our hills during the time we had been isolated. Everyone else had been going about their normal business as we had been sledding on cardboard.

I joined a small theatre group, and Maigread continued to work on her landscape drawings. But our trip to the Skelligs had opened a perspective on a further distance, both in space and in time, and we often remembered, and spoke about, our trip there. And aside from the sheer magic sensed on our journey out that day, the visit to the island was for me, in a certain sense, a culmination of the shore-hopping that had long been a part of my life. I had known of the Skelligs long before I had stood on that beach in Iona, in Scotland, staring at the patterns the birds were making in the sky and remembering the similar patterns in old manuscripts. On arrival, it wasn't so much that I had 'dreamt' the place before, as others were later to tell me. It was more as if, almost without

thinking, I was suddenly embarked – once out at sea – upon a journey that seemed somehow utterly correct, for which unknown preparations had been made, leaving me open to accept the absolute freedom of the falling light I would experience there. I was embarking on some altogether fresh experience, which made me instinctively aware of why men would have wanted to establish a toe-hold, a lookout, at this far place. These things I sensed, without overly thinking about them, outside of any studies concerning this establishment and its community, which I would have been engaged in during my college days, years before.

My wife's mother was housebound for the last decade of her life in Killarney. She loved to meet Daniel and called for him to visit as often as it was possible. In May 1987, I took him on a bus trip to visit with his grandmother. In the house, I idly picked up a week-old *Kerryman* and, just by chance, saw in its back pages an advertisement for a position as part of a new guiding team to be established on Skellig Michael.

I had to reread the ad several times. The deadline was practically immediate. My mother-in-law assured me – quite wisely – that it was very unlikely I would get the position and be employed on that far island. I walked out to the interview a few days later, held just beyond the limits of Killarney town, on a brilliant summer morning. I remember rows of huge orange oriental poppies in full bloom in the little front gardens of the old estate cottages along the way, lining the road. After the interview, I walked back into town again along the Muckross Road and stopped in the old hotel bar, long gone now. The jarveys were inside; a man was singing.

The new team was needed on the island immediately. Within just a few days, I learned that my application had been successful. There was hardly any time for deliberation; we had just a short while at home to discuss what this change might mean. Maigread and I both decided that an opportunity was being presented that should not be refused. So, within a very brief interval of time, I

was uprooted and was heading down the western coast once more to embark upon this completely new, and unanticipated, venture.

This time, I was setting out to establish residency on the island, and the trip out was different from my earlier one. The day itself was different: rain bucketed from the heavens as I was dropped at Portmagee pier by my brother-in-law. There was one fellow newcomer – Eugene – aboard, as well as two workmen, who carried out essential maintenance and repairs on the island. They took great delight in stressing to Eugene and myself, the two new guides, both the dangers and the length of the forthcoming journey, not to mention the perils awaiting those spending nights on the island. This banter was light-hearted and good-natured. At the same time, I knew that all of my possessions related to the upcoming two-week stay – during which I would need to quickly familiarize myself with the island and learn to speak with visitors as knowledgeably as I could – were packed within an ancient American army duffle bag, certainly not waterproof. My bedding, change of clothes and food for the fortnight sat forlorn, wrapped up in a very small package, stowed in a corner of the deck awash with rain and spray. In truth, I had no idea of what lay in store for me with regard either to the physical accommodation to be provided or to the company I would be keeping.

Two years earlier, I had taken no notice of the temporary housing on the island (two men had been spending four nights weekly there). On this second trip, in 1987, I had been told that I would be sharing a hut, that there would be crockery, a gas stove, and a portable Elsan toilet. And so, travelling out in the pouring rain on the *Agnes Olibhear* to begin employment, I imagined a roof of corrugated iron, the company of mice and a dirt floor. But this in no way dampened my enthusiasm. I was unconcerned regarding any living conditions I might find, hastily – and of necessity – prepared for us, the new arrivals to the island. I was elated concerning my good fortune at landing any employment at all in a country in the midst of severe economic

depression. However, staring at my duffle bag, which was steadily darkening in the continual downpour during the ninety-minute journey, I wrapped up quietly in my oilskins for a while. I seriously considered present prospects, especially with regard to my health.

On the way out, we passed the Lemon (a small bare rock, over two-thirds of the way there, and a marker all seamen know). Joe – one of the workmen – informed me that we would be nearing 'halfway' to the island before long. We were actually nearing our destination but, as far as I knew, we still had far to travel. I could not see where we were; the island stood invisibly ahead due to the squally rain and thick mist. I smiled at the joke made at my expense. My cheap oilskins were soaked through, and the trip seemed long; the surrounding seas were now uninviting. After some time, though, grey, jagged rock began to emerge from transparencies in the gloom, and the Little Skellig appeared. I encountered again the otherworldly company present at this far place. Gannets began to draw their cloaks of white flight-trails over the boat, dissolving into the rock, then suddenly immediately ahead once more. Suspended before us – hundreds of them, it seemed, just at arm's length – they lifted the orange hull of the *Agnes* forward, into the otherworld of Skelligs waters, weaving the spell of the place again and marking their territory, creating the barriers of a world utterly apart from the life ashore.

I sailed into the landing on Skellig Michael for the second time. Peaks disappeared above us in the fog; the birds screamed as they circled overhead in the confined space of the cove. We slowed at the pier; bright green tresses of seaweed rose ahead of the prow, glistening within trapped light. The pink sandstone of the inner cove, exposed by countless assaults of the sea, appeared as raw skin above the waterline, almost flesh-like along the intertidal spaces, just at the surface as we made quickly in. I climbed the steps from the pier onto dry ground. Joe – as I always saw him do after this – knelt quickly and kissed the holy ground of

Skellig Michael. My soaked bag was tossed into the bucket of the mechanical Device – a strange skeleton of an enlarged wheelbarrow powered by its erratic engine, and deadly dangerous; only one man was allowed to drive it, and I was perfectly happy that it wasn't me. I remained always somewhat frightened of the Device, but it faithfully powered our materials up and down the lighthouse road; it took my bag and delivered it to the door of my new home. And I found that this was much more than I had expected. This tiny box-cabin stood at the bottom of the steps rising to the monastery, about fifteen feet square, with three tiny rooms: an enclosure at the rear for two bunk beds; a place partitioned for the Elsan; and then a very compact living and kitchen area, containing a small gas stove and a gas-run camper fridge. All told, it was not much larger than a caravan. Most magically, though, there was a table by a small window, looking out at the narrow road and then the sea, and an apparently solid floor covered with clean linoleum.

This hut was tied down with cable, which hummed and whistled all throughout that season but kept my accommodation rooted to solid ground. There were gaps in the floorboards the mice and gusts found convenient. The linoleum sometimes buckled and curled underfoot in storms. But the hut was solid enough for Skellig Michael and the open Atlantic weather. We had gas lamps for the night. An hour after arrival, I was drying bedding by the little gas stove and cooking rashers. Not having any idea of what lay in store, I felt that I had established a small foothold. My new companion, from the very first meeting (and always afterwards), was extremely amiable, and this hut was to serve us well throughout that first season on Skellig Michael.

A Second Ascent

Looking back, life over those first few days unfolded naturally. Eugene and I shared the small hut. We were given twenty-litre drums of water and advised to watch rations carefully. Josie and

Ger, the two workmen, stayed further down the road. The lighthouse had been automated the previous year, 1986, so there was no one else on the island that first week besides the four of us, but for the tourists coming and going in the late morning and early afternoon, when the sea was fit. When our third guide, Claire, arrived, she was given a tiny hut further down the road.

Josie and Ger came out on a Monday morning and left on Friday afternoon. Eugene and I and Claire stayed for two weeks at a time in rotation – for a while in the 1990s this was increased to a three-week stint. We went home for six days between stays on the island. The first Monday turnover, the sea was rough and the *Agnes Olibhear* never arrived. Eugene sat on the wall for a while, looking out at the white horses, philosophical concerning our weather-enhanced isolation. We would learn to be flexible regarding our arrivals and departures and come to know that it would always be the state of the sea that dictated possibilities. So our system of changeover, and our approaches to rigid scheduling, developed over time.

The birds were everywhere. One of my strongest impressions is of grey light filling the cabin, making it suddenly a luminous, self-contained space. Outside, beyond the window, the Atlantic progressed along inscrutable, ever-changing rhythms that were hypnotising; they have always been so since. A knock at the door was shocking.

We had little. I had my green duffle bag and a box of food hastily purchased in Portmagee. Eugene, though he lived locally, had not much more. There were two saucepans, cups and a small amount of cutlery. The few shelves still seemed empty after our supplies were stowed. Tea, coffee, Ryvita, peanut butter, bread, eggs, pulses, rice and pasta. There must have been some chocolate as well. Not much fare; yet, perched on those narrow shelves, they seemed exotic and out of place, greatly changed from their relative plenitude on the shop shelves back on the mainland. We would quickly learn to ration and calculate supplies. There was

little contact with people back on the shore at that time; we hardly saw the boatmen, except when the relief was taking place.

There was a sense of not knowing what to do and a sense of the endlessness of time. I had a copy of a book about the Skelligs, a history of Ireland and several copies of articles concerning the island, which had been left for us. There were the visitors to attend to; there were maintenance duties on the steps and up at the monastery. Somehow the rhythm of each day evolved – almost without thought or planning, it seems now. But for each of us, in our own way, this became a rhythm set and organized to balance our physical requirements against and within a remote and isolated place, and always a place of overwhelming and changing light.

There would be little further communication during our time there, besides our conversations with each other or with the visitors; back then, there was only one VHF handset, and it was with Josie and Ger down the road. Though a much larger master-set came into continuous use in later years, and we came to know the great radio-men at the Valentia Coast Guard Station well, those first few years were marked by radio silence for the most part. I don't recall using the radio at all during my first two years on the island, even to call the coast guard or the boatmen. The boats simply arrived, as if by magic, when visibility was poor.

~

That first afternoon on the island, after the rain had cleared away, Eugene and I climbed up to the monastery. This was my first ascent as a resident; I had only been on those steps once before, on the journey with Maigread two years previously. I sensed that sudden strange Skelligs vertigo once again: the strange and steep rise of the curving stairways, the sudden wrench from solid ground, perhaps as dramatic as any first setting sail from shore, departing the ground for the air. For we were rising – it seemed – almost

perpendicular to solid ground, the angle of ascent much higher than seemed natural, the ground falling away at times from either side, the birds scattering the loose, friable soil, scampering away from us as we climbed; and no one else there.

At the top, above the domes of the beehives, we sat along the sharp edge of the bedrock, looking out over the wide range of open sea reaching beyond us in almost a full circle, a circle only broken by the thin spiral of the South Peak rising above and overhead and a few hundred yards away. I can see the day clearly: a pale blue sky, ragged clouds, the headlands of the shore gleaming to the east eight miles away. In the distance, the little lights from a few houses glimmer in the late afternoon, reflecting the sun's rays. The isolated beach at St Finian's Bay stands alone and cut off from the rest of the main peninsula – a little beach from which, legend has it, the monks first rowed out to the island – empty now, only a faint pink line at the bottom of the cliffsides. And the sea, the sky are every-where, and the far coastline seems extremely remote from the perspective of that day long ago. Each step of ascent, each disembodied leap and scamper in places where there was no path, behind and above the cells – seemed to cement the permanence of that isolation.

There was a different air, a different calculation of movement here. Every step or gesture was briefly held, outlined, drawn out within thin clear air, in this element of height and exposure. And there was a continuous sense, a barely conscious one, of being suspended far above the ground and sea. The whirring birds everywhere only added to the sensation of existence along a suspended and altered plane of life.

We made idle chat, standing on the bedrock that first afternoon. I made some comments about the monks, wondering aloud with regard to their motives and purposes: what were they doing here, how many lived here, when had they come, what had the island been like on their arrival? Josie looked over to where Eugene and

I were standing: 'No one really knows, boy. And don't let anyone tell you otherwise.'

Between the Peak and the Bedrock

I wandered a bit further along the bedrock that first afternoon. The bedrock behind and above the monastery stretches over the top of the cells at a sheer angle to a ridge, beyond which there is a steep drop into the sea. Just over the lip of this ridge are a few natural ledges where one can sit. Over the course of that first season, I would sit there and watch the progression of the sun's setting, watching it moving towards its most northerly point at midsummer, then slowly and steadily, by a few degrees each day, beginning to head back towards its most southerly position, at the winter solstice in December. On clear evenings, I would watch the sun fall as an orange ball through the horizon-line, setting the sea on fire. I sat there, looking straight ahead towards the Arctic. It was there too that Maigread and I sat during our first visit to the rock and where we lost our map, watching it descend slowly towards the water below.

The ridge reaches some 70 or 80 yards further west, above and behind the monastery, and then cuts back at a sharp angle, high above Christ's Saddle. There are places one can sit there as well. When visitors are on the island I can see them far below from this place. They gather in little dots in the valley, just as they come into view at the top of the last few steps of the ascent at this central space on the grid of the island. Possibly they rest there for a while, in small colourful clusters, beset by the gulls, before ascending the last range of steps to the monastery. From where I sit, high above them, across the empty gulf of the cove below, the South Peak rises, twisting as a narrowing pinnacle towards the sky. Its tiny oratory terrace perches on a ledge near the summit.

Between the peak and the bedrock where I would sit those first days, there falls a deep inverted cone of open space. This is the playground of light and birds. Birds suspend, hover, cross and burst

from deep shadow into full colour. Strange currents of wind spring up between the two summits on the island; the wind begins to swirl. Within short ranges and distances, it can be blowing at contradictory angles. Exposed to a north-westerly gale, the seaward side of these ridges, facing towards the north-west, can be so pummelled by updraughts that it can be nigh impossible to stand free there, or on the northern side of the saddle far below. And yet a few feet away from each place, in the lee of the bedrock or on the large flat rocks in the centre of the valley, all may be perfectly still. Fleets of puffins sail into this open space from the sea to the north, fighting stiff contradictory winds, adjusting their positions in mid-air, their feathers electric with quivering – though it may be still from where I watch – their beaks on fire in the direct light, turning, balancing against the rough surfaces of the vertical cliffs, landing in a sequence, one quiet thud upon another, turning at the last moment against the updraughts into their burrows and the perches where they rest.

Just a few feet away, over the steep crest rising to the saddle, the vegetation is completely still; it may feel considerably warmer. Gulls and puffins wander around aimlessly, at their ease, while above, in the gusting and funnelled air, the birds are balancing furiously for their survival. Sitting high above on the cliff edges, I observed the display of channeled flight which was going on below me. And so, watching the birds' continual struggles, I became closely acquainted, over those first few days, with the fulmars on the island.

The fulmars cannot twist as quickly as the puffins when flying against the rocks in contrary winds. But they hover; they soar with wings outstretched with apparently much less immediate effort. They glide incessantly, in and out of and around the cove, hovering ever closer and homing in on their nests, which are perched on narrow ridges. If thrown off course, they sometimes hang in mid-air for several seconds, inching down slowly against the rock face and catching another gust upon which to fall away. Sometimes it seems that it is through no effort of their own that

they hang against the rock, slowly moving up and down along the ledges as if pulled on by co-ordinated strings and guided from high above the cove below.

They narrow in on me purposefully: spookily, they round and rise ever nearer, hovering right at face-level, their huge eyes staring into mine, making some strange and curious connection. It is easy to see how sea-birds such as these could, long ago, have been appreciated as spiritual messengers or as harbouring the souls of those who had disappeared at sea. From my very first day up on the bedrock behind the cells, my fascination with these strange white birds began, as they moved back and forth over the empty cove of the valley far below, falling so quickly and effortlessly down through level after level of empty space, filled only with the living forms of moving light.

Oddly, I remember little about the visitors who arrived out to the island over the first few days I was there. I was there for their care, for their introduction to the island, and for the care of the monument. Over the course of a couple of days, Eugene and I began to gather our thoughts in order to share some information concerning the monks, the island, and its wildlife. Mostly, though, it was a silent space we shared with the handfuls of visitors who arrived suddenly into the monastery in mid-morning. We would briefly answer the questions they might have concerning this unusual place. And one thing struck me, even in those early days: that this was a place for a quiet, and often unspoken, exploration of, or sharing of, common humanity. The open doorways of the cells beckoned from another time, offering glimpses of another way of seeing. The long and uninterrupted journey to the pier at the shore, and then across the open sea, led all passengers to the steep climb up the mountain: to reach a high perspective from which all gazed back, across the miles of the crossing, back to the setting for all human lives unfolding on the mainland. Together, these shared prospects, shared experiences, made for a sense of a common vision. Questions concerning the monks' motives quickly became questions concerning our own.

Distant centuries would merge with our own time. We were looking back towards both the present-day mainland and the one of centuries ago.

The monks had stood there centuries before us, establishing their own lookout upon the beyond. They must also have had connections with the mainland. Eight miles away, on a clear day, they might have seen smoke rising from the fires of other monastic encampments at Loher, at Killabouna, on Puffin Island, on Bolus Head, or on Valentia. Maybe their cousins or brothers or other relations were in some of those other establishments spread on the hills beyond. But this pilgrimage or martyrdom they had chosen took them to a further edge. Where everything was, at times, disassembled. Where the depths of the soul were plumbed.

A Wider Perspective

From May until early October, my little cabin and observation post is my home when I am on the island. During this time I spend two weeks there, return ashore for a few days, and then return to the island. For some three out of four days during these months, for a few hours the sea is calm enough and landing conditions safe enough to allow visitors to land. But whether or not visitors come, the basic dynamics of life on this island remain more or less constant. There is the hut; there is the road down to the pier; there are the steps leading up to the other ancient 'village' or habitation on the island, where the monks lived so long ago. Overhead, beyond the valley, the South Peak hangs, with its ruined reminders of a different sort of habitation, or biding place, altogether: this was a place constructed for solitary prayer, perched on a precipitous summit, high above the sea. But all the doorways of all the dwellings on the island – in the monastery, on the peak, down in the contemporary huts on the lighthouse road below where I stay – share one basic dynamic. They require extensive and continual

preparation so that they might be supported, and then remain standing, right against the sea's edge: they all open outwards to the emptiness beyond, but also inwards to a darkened space within.

My accommodation has undergone different incarnations over the past thirty years. As if to remind me of the uncertainty of all human accomplishments on this island, this apparently sturdy hut was utterly destroyed by an Atlantic storm in 1987, after my first season on the island. Very little remained when I returned the next spring – a drawer with an apple left hastily behind upon departure, among other bits of wreckage.

The hut lost to the wind and sea was replaced further up the road, on a site where lighthouse people kept their domestic fowl decades before I ever set foot on the island. Though the mice still found open season, though the pilot lamps on the gas fridges (probably designed only for brief jaunts in caravans to the seaside or the woods, and not for Atlantic conditions) blew out often in certain winds, the huts were made more secure, and over time the men working with the human infrastructure at the Skelligs site learned how to hone their skills against the weather.

But no one could provide for all eventualities. One year, most of the accommodation for the workmen on the island burned to the ground. And on another occasion, we returned to find that, over the winter, the hungry mice – perhaps an understatement – had reduced the wooden furniture in the small room where I stayed to useless rubble. Solar panels power the fridges now (often erratically, especially if the batteries become strained after days of poor visibility and low light, and during early and late summer). There is no longer an Elsan loo, which, for the first years, required a trip down the often slippery disused steps near the huts once a week to empty it. Some twenty years ago it was replaced by a small composting toilet for staff living on the island.

But while these improvements have taken place, my home on the Skelligs, particularly over the past twenty years, has remained

substantially the same. Now the hut is a bit bigger, and I no
longer have to share space, but my accommodation remains, in a
most basic sense, a little cockpit suspended against the open sky
and the endlessly unfolding drama of the North Atlantic. I still
see by gaslight at night; the hut still rattles wildly in the frequent
gales. Drums of water for drinking and washing are carried up
the road by a much safer, more dependable version of the Device;
but the bunk-bed still sits against the corner under the mountain.
The small industrial table against the window is the same one as
long ago. The window is bigger now; I have a wider perspective
on the open sea.

———

I knew, after a short time on the island, that I had engaged on a
very unusual venture. I had come to live upon a rock at sea: appar-
ently empty, but with rich ties to the mainland – historically,
spiritually, archaeologically – as well as ties that reached to wider
seas beyond, as its sea-bird colonies roamed open oceans winter
long. How could I record what I was seeing and the effect that it
was having on me? And on my sense of my place in the world? I
had seen professional photographs of the island. I took my own,
but they did not convey the width of vision, the cloak of light that
would at times catch me unawares. Back ashore, my descriptions
of my experiences seemed hollow, or off the mark, or somehow
in error. At times, I wrote brief notes to myself. In the morning
light, I could not remember what they had signified. I knew that,
sometime, I would come back to try to decipher, in the light of
further experience, my thoughts from long before, and year by
year, as my life unfolded on the Skelligs. And so, at different periods,
my journal entries would fill, especially at times of intensity, when
events on the island were particularly affecting me. Accidents,
illnesses, euphoria, excitement all played out here under the great
cloak of passing light and weather, which I attempted to at least

partially capture in fleeting notes – in little boxes, parcels of words
to be dealt with sometime later.

———

At the end of that first season, when just myself and one other
guide were left on the island after days of storms, I only became
aware of our long-postponed relief by the sound of the *Agnes
Olibhear*'s horn under my window as she came along the south
side of the island. I was asleep on my bunk, and the storm that
had been up for three days was still blowing. I did not think
anyone would yet be venturing out of the shore harbours for us.
My colleague was elsewhere – in another hut, presumably, or else
in the monastery.

In the midst of a rollicking sea, out of a grey mist, the bright
orange hull of the *Agnes* was glowing below, just off the rock
directly below the cabin. Dermot, the skipper, was grumpily
waving a long arm up at the road and at the two tiny huts where
we lived. Within a few minutes, interpreting his gestures while
standing at different places on the road, we realized we had to
leave the island straightaway. We threw our things into bags, ran
down to the pier, and were gone. That was the nature, and the
suddenness, of life on the island that first year.

I sat back behind the wheelhouse and watched the island
diminish above the wake of the boat. I presumed that it was
unlikely I would return again; it already seemed an alien, remote
place, bereft of any human influence or presence, five minutes
away from the pier. I would have been astounded – perhaps
horrified! – to know that I would keep coming back for more
than thirty years.

15 September 1987

Little clusters of gannets wander across the broad board of the
evening sea in groups of twelve, or fifteen, disjointed fingers of

light, stretching away from one another, then closing again. They gather in the emptiness, then disperse. This vastness ahead is tied within their very make-up, keeping them buoyant, afloat within the thin lines of mist glowing in the evening air they are passing through.

Over and again this far-flung light is rejuvenated, brought alive by the forays of these birds: nearing the island, dividing around it, passing by. This bright moving living light extends to brush against the dark emptiness of the rock; it wraps its trails of heavenly wandering around my skin, reilluminates and inscribes its ancient tracks there. This living script stretches the skin taut, gives it the consistency of the evening sky, and enables it to take again, by its pale colour, by its even consistency, the wandering and discursive writing of the language of flight.

Endlessness comes very near; its messengers rest upon the pale seas just beyond these rocks

Last night, the pale half-moon rose over still water, directly ahead from this hut. It left a road of cream and white stretching towards the island. The gannets were returning home in the near darkness; as each passed under the moon, they became suddenly, individually transfixed above the white road to the horizon.

CHAPTER THREE

Secret Places

No more than with the monks, there was no real reason for me to be here. And yet, climbing the steps on lonely days in drizzle and in fog, flocks of colourful birds would suddenly be there, swirling in the air around my head. A pool of water would glimmer, shimmering in silver. There was no other way to experience these things – except by ignoring them, or seeing them as symbolic of a forced and miserable exile – than to accept them as gifts, as the acquisitions of a spirit somehow emptied, at least temporarily, by its stay here.

The seals would look at me warily down at the pier. The ravens would sit on the steps and occasionally sing along with me.

But beyond any of my own dawning awareness of this new place, the Skelligs world, and the extended oceanic world beyond, continued undisturbed throughout my first weeks. For three out of every seven nights, there was only one other person – one of the other two guides, Claire or Eugene – on the island with me. We couldn't have caused much disturbance. We trailed the odd flashlight beam across a night sky; crumbs and leftovers were left on the lighthouse wall. Mostly we moved in a great silence when everyone was gone. Life continued undisturbed around us: in the

burrows underground, in the nests on narrow ledges, in the water around the island, in the sky above. Trawler lights would pass across the horizon in the distance. On a brief walk to the landing, I was an interloper; but I also felt accepted by the place. Or at least on probation. It didn't take many of those long nights to reawaken feelings which are common to all when alone: feelings of inconsequence and irrelevance in the midst of a great wilderness at work. Here, that wilderness seemed very real. After a short while, I realized the need to work out my own place here.

These were common thoughts – but they were hammered home in the isolation here.

There was no other view on offer, no other perspective at hand, but that of the wilderness unfolding uncaringly just beyond me, just outside the thin walls of the hut perched over the sea.

I would wake sometimes in the middle of the night to see the ocean outside my window agleam in phosphorescence, the window full of glistening white brightness, even the interior of the room strangely aglow – appearing as a city from an airplane window at night or the earth from space. But more than this, I was briefly immersed within the natural illumination rising from millions of creatures, otherwise unseen by human eyes. The light rebounded from one cove into another in the movement of the ocean. Then I would go down to the landing in the darkness, hearing the music of the seals, walking under the shadow of the canopy on the road in the utter dark, feeling my way down the road, placing my feet down gingerly through the darkened air, knowing I could call on no one else's assistance, for I would not be heard. The shearwaters would be screaming their unearthly cries above my head. And I would turn the final corner to the landing: a seething presence, glowing strangely white and, if the phosphorescent plankton were active, aswirl with unfolding tentacles of light,

quickly unravelling themselves in briefly exploding sprays, which built in layers, one upon the other, within the cove. When the landing was stirred, there was a presence there, larger than the sum of any life, cutting away all access from the island for days. Then I would turn to walk back to the hut, up the slick flagstones, wet with spray, glowing ahead of me incongruously from what I could only suppose to be accumulated, stored starlight, or the reflection cast from a churning landing, now far behind me, or from the sea beyond. Now these lights would take me, as if by the hand, up the empty road.

The emptiness would unfold in various ways to become a presence briefly and repeatedly alive. The power, the personification of emptiness, would seem to stand there, an unseen spirit before me, reaching ahead on the lit road. It would descend over me in the countless petals of petrel wings quivering in the sky over my head, covering their tiny nests within the walls, from which at times an endless cacophony of chirps and whistles would rise. The emptiness would magnify the steady drilling of the shearwaters calling – females calling to returning males, males calling to returning females, back from their foraging parties on the open sea that had lasted for days.

And I would return to open the door of the little hut – nothing more than a tent of thin timber tied down by cables into the bedrock – and crawl into a bunk suspended high against the Atlantic, hearing the ocean pounding pounding pounding against the rock below.

I would take to the steps and it would seem as if I were climbing on darkened air through the circles of the heavens, through the hovering shearwaters and petrels, to arrive into the glowing compound, the monastery at night. The clouds of the spread stars would revolve over my head and turn slowly in the sky above the leaning figure, almost human, of the High Cross: standing in the darkness, raised in the middle of the compound. Through the hours, the stars would revolve upon their trains and circles overhead.

Like the light on the flagstones above the pier, the light in
the monastery seemed to trickle through the darkness, even down
through the ruined shells of the corbelled domes that the monks
had lived in. A collected light seemed sometimes to gather there
before each opening, leading me into the darkness within. A
strange light was sometimes glowing in the interior, glistening
upon the smooth floors. And, over time, the entire cosmos – the
collected soul of the world – came to display within these dark-
nesses, hovering there by pinpricks of light within strange
planetaria, prepared for instruments of observation, deliberation,
triangulation, and dissection, towards the exposition of the cartog-
raphy of the heart.

What can I say about these times and my very human memo-
ries of them? There, the darkness would form hands and arms,
casting its darkened light over me. Hence the preciousness of the
shearwater, of the albatross, petrel, whale, their forms becoming
alive within the night sky and sea, as these strange passers-by
illuminated their ways beyond me within the darkness.

The darkness was taking living form beyond, in all of these
strange brothers, strange relations. Welcoming, spurning, ignoring
me as I made my way down from within the observatories over-
head to walk finally again upon the road below.

I would rise to see the dawn and the visitors of the morning,
my map destroyed, passing through an undisturbed, unfallen Eden.
The forms of unfolding light were always hinting at, and outlining,
other orders, other ways of sight.

I would walk down to the landing in the morning, watching
the arrival of those who seemed from another world, another
reality. I would greet their smiles, register their enthusiasms. I
was also confounded by these visitors sometimes, particularly
after periods of isolation that might have lasted for days. I watched
for the effect of the strange light, which seemed resident here,
falling upon newly arriving faces. Some were dazed after the sea
journey; others were full of energy and geared for adventure.

Thousands of them, from every walk and denomination of life, arrived at the landing and paraded up and down the road.

Few whom I met seemed to recoil from the harshness of life that the monks would have experienced here. Even if arriving from radically different ways and experiences of life, most visitors would comment upon the sense of peace they apprehended immediately on arrival at the island – which they acquired in simply walking along the ways of the place, absorbing and observing the wide vistas of sea and sky. They loved the dazzling light. I have met with more awe and astonishment on the island than misapprehension or disbelief.

Often, I would hear visitors attempting to express their appreciation of a sense of a different order, of new limits, vistas, and borders, suddenly sprung upon them.

On occasion, a visitor would relate to me a sense of distant familiarity, suddenly revisited, as they entered the monastery or turned a corner on the road. After the steep, angled climb, and perhaps a rough and unpleasant sea journey, there would be, for some, a few moments of brief contact with a unique and personal wilderness which had been glimpsed, before beginning the descent and the retracing of steps.

Visitors would break into tears. A woman grabbed me and affirmed that, though this was her first visit to the island, she knew the place well in her dreams (long before instantaneous images were available everywhere on the internet). More than one person, after entering the monastery, informed me of their readiness to die – their preparations complete, having been able to walk the rounds of the monastery platform and to look back upon the other, human world shining resplendently in the Kerry hills in the distance; and sometimes a desire would be expressed not to return to the world ashore at all.

Occasionally, there were reactions which were more challenging. Once, a young man began to issue loud threats, and eventually he directed these at me. He stood on the wall above

the sea at the little oratory, threatening to cast spells and push me down from the terrace to the rocks below. When I accompanied him to the boat to ensure his departure, he threatened to return after dark, again swearing that he would cast me into the sea. I was utterly rattled, and I scanned the waters frequently over the next two nights. At the same time, I recognized something in the intensity of this young man, whom I met many years ago, and it is relevant to all who have since visited the island whom I have met.

They came from every extreme, from every sort of life, to descend on a few small piers on the mainland. This was a much more haphazardly arranged journey in the early years than it is now. Suddenly, an unprotected sea journey. A steep climb. Exposure upon a height. Looking back at the inhabited peninsula or out to the open sea beyond.

For some who came on a trip to the island, all of their troubles, all preconceptions and ordinary vistas, were momentarily shaken, exposed and resettled. I became familiar with these people, came to experience the common currencies of their brief visits. The shared sense of exposure. The enigmatic recognition. I came to understand the many divisions within human smiles and glances, when veils might be lifted for a moment, when a view might dawn of a different world. Some would have experienced here a resettlement of vision dependent upon an embarkation into the unknown, however short, for they had entered briefly upon a world of strange silences. It would be the same for me each time I returned. This is the way I remember my first experiences of living on the island and meeting those who visited there.

As well as this, it was a world fraught with danger. I, too, of course, was a visitor.

I can see myself, from the earliest days, rising and descending along its steps and pathways, walking its ancient tracks anew. Moving up through the levels of the island by day and by night, the birds constant company, spiralling away from me on both dark

and light skies, returning as quivering or gleaming and colourful messengers from places far beyond my sight, speaking and reminding me of the journeys they had made upon distant seas beyond. And I could sense the island under my feet, quivering with the preparations for, and the rest following, these distant journeys, some lasting for protracted periods of time. The depths of the island underfoot grew to have their own reality for me: the soft loose ground, the network below the surface of rabbit and puffin burrows, the different veins of rock wearing away over time, the legends of deep tunnels to the mainland, the coves and caves at sea-level burrowing their way deep into the core of the mountain, all combining to build a solid structure. And above it all, as if upon their own ether, floated the structures of the monastery and of the peak, suspended in the air above the ocean far below.

An understanding of an island made of many layers seemed to develop over time within me as a way of coming to navigate the place. I saw the fragility of its exposed structures, the richness of textures congealed and hardened and given permanence, for a brief while, by centuries of the oncoming wind and sea and light, which would harrow the place down to the very bare rock each winter. Late storms would strip the vegetation with salt, leaving the island brown until far into the summer, bereft of its green cloak for much of a season. Lumps of exposed soil would be tossed into the air in gusts of wind and fall away in small clouds of dust. Strangely exposed burrows would turn to powder, leaving the birds to scramble over loose dry soil. And heavy rain would turn these exposed banks to mud, sloughed away in downpours, leaving little showers of grit and stone to fall continuously onto the road in places for the rest of the year. Inbred rabbits, their hiding places reduced, would become exposed at these bare places of the island where they had to cross: the black ones, the red ones that used to haunt the island thirty years ago, easy prey for gulls and falcons.

Many who stayed for only a short time would sense these

things: sense the air of unreality, exposure; sense a place filled
with moving light.

And this shifting, evasive island became over time a ship for
me, a vessel suspended upon a far sea, slipping its moorings,
repositioning itself, adjusting course daily against all oncoming
sea and weather. The island would dissolve along layers and
fault-lines and reassemble, readjust itself upon an otherwise empty
sea of spirit; dissolved, dissected, exposed in such a way that I
would stand upon each rising step and see and hear and meet
so clearly voices and spirits from long ago. So that I would be
accompanied up and down the empty steps, but also so that the
stairway up to the saddle would split, be exposed between each
course of stones, between every step, so that the entire extent
would become a living keel, a system of vertebrae, the flexible
spine of an island vessel. This spine of stone would entail and
mix and interfere with my own spine in a helix of binding and
release to centre me at a vertiginous place and to balance and
cement an understanding of there being a place for my being
here, of there being a mutual relationship between myself and
the island – not unique to myself in any way, but by extension
for everyone across the darkened world beyond. There was a
music of this interconnection playing out in the wind and on
the elements driven through this opened and exposed spine of
rock and bone and sea, so that my soul would be razed through
by the forces of oncoming light and air, singing on their arrival
upon the pinnacles of the island.

16 June 1992

I walk down to the landing in the bright morning light. Cold
gusts of wind. The pier swept clean; the water luminous. Blue
surges; very active but very clear water. Full of white swimming
forms. The young seal resting on the pier flops down across the
steps, dives into deep water, comes up for air, then stares at me
– an action he repeats several times, rising to stare back from

different points of the cove. Razorbills, guillemots: their neatly divided white and black forms dive through the water – ten, twenty feet down – swim a distance, circle, and come up for air. I trace their routes; they spell their movements very clearly there. Their forms suspend; the trails they weave underwater linger for a few seconds, cross upon each other in the depths. Then all the birds rest upon the surface, absorbing in their feathers the direct rays of morning sunlight, gathering in the pool of the cove.

25 June 1992

Up on the road to the peak, each step, each ridge of the island comes alive under the shadows of passing birds. Puffins pass against the cliffsides below and behind the monastery. Their shadows mark out other time, the time of this abandonment. White light is strung on the little terraces above the Needle. Light runs in hair-like strings and gathers at the ruined oratory terrace there. And a gull lifts straight into the air just before my feet, abandoning a nest with two green eggs.

I sense different dimensions, moving from tiny platform to platform, terrace to terrace, in that otherworld, as if suspended in the air. I sing the 'Cantate' at the far station, and the birds gather in a knot overhead in the late light.

A fulmar curves in again towards me at eye level, and the gulls scream at arm's length away from me. Together, they draw the unspeakable logic of abandonment: the letting go, the balance required against the emptiness, which depends on taking down, taking in, in great armfuls, the light spread above and below me.

I look through the gaps in the rock: the Little Skellig hangs in air above the long flight of steps as I rise above the valley, and the birds cross in shadows over the deep ridges; the monastery, the Lemon, the Reeks of the mainland beyond are spread in a curve of directed sight.

7 August 1992

I set out down the empty road for the landing again at the close of day. Pale grey light: five shags, three oystercatchers, two turnstones. Several gull chicks. The water roaring into Cross Cove. Gleaming empty flagstones of the road stretch ahead: each of these is a lever opening, pulling me on above the emptiness below, up and down along the road. They direct me upon a line on which light gathers. Gannets pass across each ridge, each indentation of the island, then spring off into empty air, making their way home to the Little Skellig.

The turrets and crags rear high overhead, stand against the pale blue sky. A thin sliver of a moon, almost as pale as the evening light, sets now to the west, as I walk up to the hut again. This training ground, this testing ground is uncertain; quivering underfoot. In another way, it stands solid, adamantine: set against the world beyond tonight.

An Unfolding Kaleidoscope

From my home in the north-west, in County Leitrim, the Skelligs often seemed a distant target. In the early years especially, each journey seemed protracted and open-ended. The trip usually involved making my way down the length of the Irish coastline without my own means of transportation. Often, friends or my wife Maigread would take me down the road to set me on my way, my large green duffle bag in tow once more. From there, I was at the mercy of a desultory selection of lifts, sometimes just a few miles at a time. At times, when schedules were getting close, I would travel part-way by bus and arrive – that seems miraculous now – at my mother-in-law's house in Killarney at the end of that day's journey. The next morning, I would need to walk to the other end of town in hope of getting a lift, or a series of them, to Portmagee, fifty miles away, to meet the *Agnes* for the island, with an extra box of groceries in hand. And I

always made it more or less in time, which in hindsight seems to indicate a series of individual miracles, or else that my days were in general charmed back then.

A two-day trip down the western seaboard, while not a typical journey, did not seem as crazy in the 1980s as it might today. I met all kinds of people on these trips. And stepping onto the *Agnes Olibhear* marked a small victory each time – hopefully having had time to buy stamps, fresh milk, and possibly fishing line from the shop at the pier. For some reason, it seems all this time later that the sun was always streaming down over the boat at the pier as we pulled away, but I remember several trips marked by downpours at sea, so I know that was not the case. Strangely, somehow, with the land left behind, the open mouth of the channel beckoning ahead, and the cliffs of Iveragh passing behind me southwards, I felt reconnected with my family more closely than on the journey down, knowing that only the clarity of the intervening and uninterrupted water separated us. I sometimes felt I could see them; I wanted to show them what I saw.

And the trip out was often utterly spectacular: the land spreading out behind in the wake of the boat, the indentations of the coastline so clearly pronounced in the morning light, the little coves that had been haunted by pirates, buccaneers, and smugglers or Vikings long ago, the crest of Valentia Island retreating away north-east and, on its headland, the little turret of the Napoleonic tower, the last remaining man-made structure we would pass. And then, entering open water, the birds and creatures of the sea began to mark the steps and progress of the journey, long before the magical convoys of gannets from the Little Skellig would draw us near the far islands. They were still an hour away. And, in the meantime, an unfolding kaleidoscope: rafts of shearwaters, a shag or cormorant beating its way slowly up out of the water, the fin of a dolphin. These fluid markers of the way were in continual flux, changing and unfolding upon the sea's surface in a different way each trip, charging the surface of the spread sea with life –

each lonely, isolated creature, each clustered grouping, each island of movement vibrant and colourful and almost shockingly alive within the vast and unfolding surface of the ocean.

Which sometimes upon a swell would rise precariously high. After most of the trips I made to Portmagee, I arrived successfully on the island some ninety minutes after departure, but this was not always the case. Riding a heavy swell out to the island, I can feel the tug of the boat underfoot while sitting against the gunwales, the whine of the engines straining against the uncaring wave, the sudden quiet and poise at the crest before a sudden crack of descent, a boom shaking the timber spine of this most sturdy of boats, still taking me to the island thirty-four years later.

My great skipper, Dermot Walsh, was sometimes accompanied by his brother Dodie during these rougher trips. Once, an hour out, with only myself in tow astern and the island still a further hour away in the heavy sea, Dermot cut the engine back, and Dodie came out of the wheelhouse and turned to me, saying, 'It's a fright, what some people must do for a living.' This man of few words – at least for me – had always been friendly and helpful, yet I believe this was the first time he had spoken directly to me, though we had been on several trips out together. I knew from his remark that the sea was exceptionally rough. Borderline for the trip. I didn't mind and was not affected by the sea; but I hoped we would be able to land.

And sometimes this was not possible, and we simply had to turn back. And sometimes, in spite of promising signs in the early morning, we simply didn't leave the pier. I arrived to the boat to see Dermot anxious and telling me of quickly deteriorating conditions, that it was now unsafe to travel. Once, we didn't depart for twelve days. After travelling up and down the coastline, embarking on a precariously timed and protracted journey, arrival at the island itself was an astounding relief. A new chapter of life began each time.

The last fifteen minutes of the sea journey is impressed most

vividly upon my mind, even hundreds of trips later. The rounding of the Little Skellig, and the undertaking of the last minutes of the journey for the main island – the images and sensations from many trips merge together recalling this. The little pier comes into view between the steep grey veins of rock sheltering the entry cove; fingers of white water from a disturbed swell stretch here and there ahead of the boat; the birds are screaming overhead; the white crests of waves are turning at the northern point, surging regularly into the dark cave past the concrete pier, creating a regular series of pulsations from the water being funnelled into the cove. And the calculations are churning in the skipper's mind, whether it is safe to enter or whether we will be returning to shore.

I was completely unaware, on my first two trips out to the island, of just how intricately involved each further trip out would become. I did not yet know about sitting in a bar in Portmagee for hours in the rain on small funds, and then hitching fifteen miles back to Cahersiveen to cash a cheque for £5 to stretch out more cups of coffee over an uncertain number of days. These parameters applied to many people's lives in Ireland in the 1980s, and I didn't think much about them. They certainly applied in small fishing towns along the coast in uncertain weather, and long before the juggernaut of modern tourism descended. But I learned a few things quickly. Being in Mayo in the afternoon of the day before departure did not augur well, with half the country to cross still before me. A lift straight south was a magic ticket.

And there was always that wrench of departure, the almost unbelievable severing caused by the strange road ahead drawing me towards the island, carrying the green duffle bag, down the coast and out to sea. Everyone else was making their own journeys around me. This was the arc of my flight.

Looking back on those trips now, I see a deep rut carved along a map of the west coast of Ireland, running from my home on the Sligo–Leitrim border down to the coast at Portmagee, and out

over the sea to the furthest westward extension of the Irish coast-line, the peak on Skellig Michael. As time passed, I began to occasionally use the train for part of the journey, taking the Sligo train to Dublin, crossing with the duffle bag, a fishing rod, and a box of tinned goods to the other side of the city and onto the train to Killarney at night. Sometimes there was a bus going on to Cahersiveen early the next morning; I could arrange a taxi from there to Portmagee. People began to know me along the route. I took no heed of how I looked and felt inconspicuous.

It seems curious that I was never able to arrange – bar one or two occasions – my own transportation for the first thirty years on the island. There was always a combination of lifts, B&Bs, buses, trains, taxis, government trucks. Ireland back then seemed huge. And by 1987 the post office van that had originally taken us to the pier for the Skelligs was in places held together only by duct tape.

Sections of the journey stand out, particularly the return trips. I remember stepping back on the *Agnes*, sensing the hull shifting in the water on descent from the pier after two or three weeks on the island. And seeing the first trees, the first cows and sheep on the mainland. And turning the corner of the channel after the crossing to see the painted shopfronts of Portmagee. And climbing onto the pier there, standing on the mainland once again.

I particularly remember standing under trees in full leaf along empty Kerry roads in the late evening, with the island behind me and the grey clouds hovering over the mountains beyond, clouds lowering over the hills of Iveragh after passing so quickly over the island, then stalling upon the high headlands of the shoreline. I remember so clearly standing under the shade of a resplendent sycamore, its leaves floating glistening butterflies over my head: the first living things growing higher than a few inches above ground that I had seen for weeks after living within grey rocks and endless vistas of the ocean.

I cannot tell you how beautiful these trees appeared to me, or

how deeply I would be affected by the general progression of growing vegetation I would come to know on return to the shore, at monthly intervals, from May to October. I followed at regular intervals that trek along the spine of Iveragh over the course of a season, from Portmagee to Killarney, experiencing, in sequence, the shock of rhododendron, then fuchsia, followed weeks later by foxgloves and, in August, montbretia. I would stand on the road, looking back from Kells Bay toward the ragged forms of the Blaskets and the island worlds I had just left behind.

CHAPTER FOUR

A Toe-Hold for Habitation

The light plays tricks with perspective on the open water. From the cliffs behind Portmagee, on a bright, clear summer's day, the Skelligs will sometimes seem to hover almost overhead. Then they are erased from sight: fog, mist sets in; the islands, and their inhabitants, disappear. Far to the south, from Beara, they can suddenly gleam like diamonds, as thousands of white gannets are caught up on a bright morning, a brief flash in the distance. The two islands have many faces, depending on light and weather and from where they are seen.

They have long provided reference points along this south-western coast. The Milesians were said to have been shipwrecked here. The kings of Lough Léin, near Killarney, are recorded as having sought refuge at the Skelligs. Legend has it that a Norwegian king was baptized on the main island. An unknown 'king of the world' was said to have travelled to the islands in the obscure past. Such a list of strange visitors merely heightens the sense of other-worldliness that has long been associated with the Skelligs.

Nearing the islands by sea, they rise from the open ocean, the only disturbances upon the clean lines of the horizon. Over a journey of eight miles, they steadily loom larger and come to stand high overhead. The Little Skellig is the more easterly, so it

is the first encountered: it bristles with ridges and pinnacles that rise to a central peak several hundred feet above the sea. On every conceivable tiny ledge or crevasse, tens of thousands of North Atlantic gannets make this island their home. They give the bare grey rock an unearthly white glow, falling away from its edges in circular and elliptical flight continually through the spring and summer months, and on into early autumn.

The birds hover above the boat as I pass near, diving at intervals from within the high towers they have formed, lifting hundreds of feet into the air, circling upon thermals, then plummeting from a height into the sea as white rain. With this continual flow between bare cliff and open air, the edges of the rock become fluid, opening to expel cascade after cascade of flight. Passing below, I enter this field, between these spheres of revolving light.

Few are unimpressed by these birds. Gannets have a six-foot wing-span and can live to be forty. When nesting on the Little Skellig in the summer months, partners travel alternately on three-hundred-mile trips to the south to find food for their young. They appear tireless. I often see them from my own perch on Skellig Michael, suddenly appearing from the western horizon late in the evening, on their way home after a long journey.

The boat turns clear, toward a green, higher pinnacle: the Great Skellig, or Skellig Michael, a final mile to the west. This further island stretches for three-quarters of a mile into the Atlantic and is perhaps a quarter-mile wide, but such measurements give no true picture of the dimensions of the rock or of what it has come to signify over the centuries. The Little Skellig may be an unfathomable warren of gannets; Skellig Michael, since the monks arrived in the sixth or seventh century, has harboured human activity. As the boat approaches from the east, the first peak on this island reaches some six hundred feet above a tiny landing site: a concrete pier reaching out into a small cove, facing north-east. This cove provides the only real shelter from the Atlantic on the island. Coming in, if we are lucky, the arms of rock reach out to embrace

the boat, cut into the advancing sea, and provide safe harbour. During the summer months, an endlessly unfolding kaleidoscope of birds – razorbills, guillemots, kittiwakes, and puffins – scream a fierce, strange welcome. Far overhead, if the sea is calm and there is time to observe, uneven stretches of masonry can be seen to perch upon an almost vertical descent. These support the remains of a steep staircase of stone, leading to the high terraces one can just make out near the summit. The island sometimes seems to reach right over and above the pier, sending shafts of sunlight between the pinnacles, onto the surface of the still water of the cove, ordering the falling light within shifting and hidden rooms.

From this pier, a nineteenth-century road rises around the southern flanks of the island, a hundred feet above the sea. Built to give access to the lighthouses being constructed in the 1820s on the western side of the island, the road winds along the contours of the rock for half a mile. Along the way, slabs stretch high overhead, and some are inscribed with the names of light-house keepers, testifying to the long months and years spent here by those tasked with building and keeping the light. Halfway to the lighthouse on the far seaward side, stone steps appear, rising steeply on the slope, disappearing overhead and out of sight, heading for the summit and the monastic terraces above.

There are three sets of stairs leading towards the summit now. I rise along the main southern steps, and birds veer off in all directions. In summer, the air fills with spiralling puffins. The ground is penetrated with countless burrows underfoot where thousands of chicks are fattened and fed through May, June, and July to keep the engine of the colony on this island progressing and alive. Standing on the lighthouse road at dawn, looking up at the green flanks of the island, the steep surfaces quiver, ripple with activity. The air is fragrant with campion, the little white flower of the succulent plant that binds the loose soil together, showing the island green from a distance. All along the way, as

the ascent seems so steep, the birds fall away at my feet, and it is easy to feel that I too might be able to fly off, as they are able to.

I rise on switchbacks and eventually emerge in the clear flat area known as Christ's Saddle, between the two main heights on the island, and some four hundred feet above the sea. For the first time, the sea to the north becomes suddenly visible. I am at a crossroads and completely surrounded by water, but for the two slender peaks of the island, rising on my right and left hand. To the north, the Blasket Islands float, fifteen miles away, stretching west from Dingle. In the evening, as dusk draws near, the Inistearaght lighthouse begins to flash regularly upon that horizon; the lighthouse on the Bull Rock is lit on the Beara Peninsula, at a similar distance to the south. The Skelligs light begins to flash beyond the western ridges before me. Standing on the saddle at nightfall, I am aware of a thread of light inching along the entire exposed coastline and regularly illuminated every evening for nearly two centuries. Each lighthouse of the coast was provided with its own 'character', or flashing rhythm, linking these outposts by a triangulation of light stretching along the western seaboard and vital to the lives of mariners on the open ocean beyond, when no other points of reference could be observed.

Now, from where I stand, the North Steps descend precipitously, out of sight and into the sea. They are no longer used, are exposed to rockfalls, and their lower reaches have been to a great extent eroded by the sea over many decades. But in previous years, this way, too, formed part of the vital network of safe access on the island for monk, pilgrim, and lighthouse resident. Here, while watching the lights come on far away in the evening, seeing the island give way far below to the north and south, and aware of the arms of weathered rock raised into the sky on either side, I sense the strange uncertainty of my foothold and my very tenuous connection with the mainland beyond.

To the west from Christ's Saddle, there is a path to a ridge

above the lighthouse, from where the rock rises precipitously, in a spiralling inversion of upheaval and erosion, twisting to the highest point on the island, the South Peak. There are no steps, but a series of small cut foot-ledges, as well as handholds, leads to terracing near the summit: a place dedicated to utter silence and solitude, over seven hundred feet above sea-level. The tiny terraces at these heights were constructed at some period during the monastic habitation, between the sixth and twelfth centuries.

For long it has been believed that this was a place of solitary retreat: a 'hermitage', where one man might have lived, set apart for periods of time. It is not known whether someone lived here full-time, whether things were grown there, or how the terrace might have been serviced by the other monks on the island. The ruins, though, speak for themselves: three low connected walls of a small oratory that might only accommodate one – or at the most two – men, with the remains of an altar and window pointing eastwards above the abyss of the valley. This ruined window stands directly in a line with the oratory in the monastery a few hundred yards away, and some hundred feet lower. They are separated by the yawning cove between them. The huge gap in the open air above Christ's Saddle lies between the two structures. Together, they form a line and point further on to where the sun rises to the east at midsummer, above the hills of the mainland. Just by this tiny oratory, far above the sea, little troughs were cut into flat rock to collect rainwater for anyone there. These tiny open-air cisterns continue to operate, shivering in the exposed height, in the more or less continuous wind. Little birds come and bathe there now.

From Christ's Saddle, another ladder of stone rises eastwards, flanked by vertical slabs of natural rock, disappearing into empty air. Halfway along, there is one tiny built shrine where a small cross has been erected. To the left, the island falls away quickly to the sea. At the summit, I walk along a flat ridge, the sea now on the right-hand side. For a few moments I seem to stand on

air. Ragged vanes of rock become a man-made wall, and I enter through an opening into the compound of the monastery. Here, in a configuration of platforms, stands the final flowering of a dream and vision set in motion by the first monks who settled on bare rock in this place.

A ruined medieval chapel stands directly ahead; beyond, spread in a circle, are six dry-stone beehive cells and two oratories – one large to accommodate maybe a dozen men and one much smaller. Near the centre of the enclosure, above an altar of white stones, stands the roughly hewn High Cross. A small raised graveyard is lined with other smaller crosses directly to the east of the oratory, jutting out above the sea below. Running beside the cells and connecting them are flagged pavements, and a little 'street' runs from one end of the compound to the other and then around the graveyard at the far eastern end. Some of these paving slabs are inscribed with barely visible crosses.

Entering alone, it is utterly silent. Each time, one thing continues to arrest my vision: the open doorways of the cells, remaining more or less as they were and constructed so long ago, leading into their dark spaces within. Men lived apart here in the pursuit of an extreme idea, resting in these cells at night, using these dark spaces for habitation, high above the ocean – which was roiling, pushing over the rocks below, cutting them away from the world beyond.

A few things should be remembered. First of all, in the sixth century it would have been impossible to stand where I stand now. I would have been in the air, above any solid ground. The island drops away at a sheer angle, and quarrying, as well as terracing, would have been required before anything permanent could be built. Building the monastery took an extensive effort and probably lasted centuries. Access to this summit would have been very problematic without the steps. At the summit, there was only steeply inclining bedrock, so there would have been no level surfaces on which to build. There was no fresh water on

the island; the monks would have been completely dependent on catching rainwater. Without anything of any note to burn, without water, food, shelter, this was a most inhospitable place in every way. And, of course, as far as we can see, there was no need for them to come here at all.

In spite of these difficulties, a toe-hold for habitation was established by a small group of men. Over time, two massive dry-stone walls were erected and back-filled, and terraces were created to sustain permanent structures. This is the monastery that remains, perched on precarious terraces high above the sea. The vision of these men remains – however little we actually understand of it, however alien it may be to modern sensibilities – in the row of dark doorways drawing me into them, one after another, on entering this silent compound. These men arrived into a wilderness – the desert, they might well have called it, harking back to the early Egyptian monks. At some stage, building lasting structures became important to them – more than the tracks they might have used early on to reach the summit, more than the makeshift structures they might have put together at first – and these are the structures remaining and greeting the dawn daily, whether or not the monastery is attended, whether or not the island is visible from the shore. The platforms continue to stand above the sea, suspended in the air above the landing pier on Skellig Michael.

~

Suddenly the monks are there again. Perhaps there are twelve of them, rising before dawn from the four south-facing dwelling cells, coming together in the oratory to say the first office of the morning, to recite the psalms and prayers together, moving along the pavement to the little cisterns where rainwater has collected, moving into the westernmost cell, Cell A – the only one big enough for communal activities, possibly a place for cooking or

a large fire – working on the slightly lower gardening terrace, moving up and down the steps to fish, returning throughout the day to say the successive hours of Christian monastic life, intoned at each similar gathering throughout the western world.

And always around them, they would encounter those features of the desert – the widening landscapes of sea and sky, the lack of visual disturbance but for the sudden outpourings of nature. The skies suddenly filled with birds, the seas with migrating fish, the sudden storms, high winds, high seas. These were the things they would see. This was the life they would come to know.

The Roadway Beckons

In a way, I worked my way into the island that first year and have continued to do so since. There were jobs to do in establishing and maintaining a domestic regime, such as clearing growth from the steps and from the pathways in the monastery. I didn't mind; in fact, a kind of elation of independence would come over me from time to time carrying out such tasks, or any other simple endeavour on the island. Suspended in the air high above the road, feeling I was in the air almost without foothold, scores of birds would depart and return from all around me as I sat or worked kneeling halfway along the ranges, feeling that the fierce blue sky to be observed at every angle was also underneath me at those exposed levels, that this fierce unbounded light was cutting through the mountain of loose soil to my right and left, leaving me over and over again airborne, requiring a gyroscope, a different understanding of balance. I was poised upon a ribbon of stairs, suspended practically on nothingness, a ribbon sprung to carry me high above. Having to balance, to readjust, to stay alive: simple as that. The silence, the sense of exposure was at times over-whelming; a different sense of time was developing. A different sense of support, of definition.

There were narrow footholds, suspended over deep drops. Far below, a ribbon of narrow road snaking down to the sea. A

platform suspended overhead seeming to hang in the air. And even further above, on the highest point on the South Peak, hung in a series, the little hidden terraces, almost invisible from below: a further lookout upon the wilderness of sea and sky. A place of unobserved speech, song, shout, gesture, based on different constrictions and boundaries: those of empty air – a wilder world, a different world. A place that was confined and circumscribed within seventy acres in area, but which seemed to unfold infinitely every day.

There were hidden places everywhere upon the island, I came to see. Different vantage points from which the light, the sea, the past would suddenly come alive in different ways.

～

No more than the route I came to see etched on the map of the west coast of Ireland, due to the journeys I had been making back and forth to the island, over time a route up and down and across the island itself came to be embedded in my mind's eye.

Even over the course of the long sojourn out across the water, the things of the coast and of my life ashore were thrown open and then reassembled differently in an unconscious preparation for my time ahead. Over the course of the sea crossing, I could sense time opening as the birds spread in waves before me, reaching to unseen places in the open seas beyond, and the boat bobbed up and down, slowly nearing the island. Then, after the emptiness of that hour, I would find the gannets suddenly casting thought and dreams simultaneously in a million directions, and the possibilities of all my wishes opening beyond normal ken in the great dispersals of their flight.

The light, the sky was brimful with life; then it would as quickly be emptied, and there would be nothing but the eternal blue of empty maritime sky overhead. There would be sudden explosions of life all around me, then equally sudden disappear-

ances, weaving a veil of motion around the Skelligs and beginning to outline, to foreshadow the days on the island ahead, the extremes of light and dark vision, or imagination, that would be encountered there.

I would arrive, standing on the pier, with a new and developing understanding and knowledge of its volatility; a knowledge, developed over time, that the same sea, gently lapping against the concrete steps now, might easily rise, cut off access repeatedly and for days on end. I began to learn of the natural dangers of this place.

My awareness of, and respect for, the dynamics of shifting movement within this mercurial portal developed through time. I learned that the landing could turn quickly from a benign, still, inviting presence into a dangerous cauldron over the course of just half an hour. Lighthouse men used to speak of the worries of experiencing the upset of the 'channels', a term describing a fear of a changed landing overnight so that a relief might not be effected – and then possibly there might be no going home for Christmas, or a child's birthday, or to attend to a wife's illness. This fear of uncertain landing conditions meant that no lighthouse worker due to go ashore was meant to make the call at the landing the next morning on whether it was safe to bring the relief boat out. For it was very easy to misinterpret the rustling of a swell around the corner at Pointaweelaun, where the water might turn in and crash high over the pier a few hours later. Lighthouse men might not sleep the night before the relief, experiencing the unsettling effects of the channels: a condition of worry, uncertainty, hazard.

Records are scarce, but I have had stories related to me, passed down through generations, of the men who built the lighthouse in the 1820s, hungry for food with the boats unable to access the pier in stormy conditions. One story tells that some men threw themselves into the sea at the landing place to reach the boats waiting for them outside. Most of these men could not swim. In

my time, I have seen people driven to utter distraction by the inability to get ashore because of a volatile landing. I know what it is like to feel unwell and to stare at a landing white with anger. And sometimes the landing will be up and impassable for days. The doorway to the island will both open to access to the mainland, and then lock tight. Laughing visitors, suddenly thrown against the concrete steps by a sudden surge, become quickly aware of danger.

The roadway beckons, lifts ahead after the drama of arrival: a half-mile or so in length, the life-blood of the island. Climbing above the pier, I turn away from access to the land and enter into island life – a separate life, a life stretched out of time, at a tangent to ordinary time. For me, this life has entailed walking up and down this road and over the trails and steps of the island, internally marking out its routes in many ways. And a greater part of this perambulation has involved ascending and descending the steps to the monastery.

That first summer, I gingerly made my way for the first time up to the South Peak, with the way unfolding before me in a series of narrowing spirals and lifting me into empty sky as I felt my way up handholds, through the Needle's Eye, past the Stone of Pain, to emerge at tiny compact ledges tucked into a narrowing summit from which the entire world would fall away. I would experience the strongest of vertiginous sensations there, as if my footholds were being curtailed by height and the quick constriction of this spiralling apex of stone. Somehow, almost because of that, I felt I might see past the rounded humps of the Blasket Islands ahead, past Mount Brandon on Dingle, past Kerry head, and straight into the landscape surrounding my Sligo–Leitrim home, two hundred miles north – something that was physically impossible by sight, but then, in the mind, almost possible, with

nothing to interrupt the line of sight, or of imagination, except the curvature of the earth, and that very curvature poised to spring me giddily forward.

Feeling myself airborne, I could make my way down to what seemed the very edge of the island's entire foundation, as I crawled down a ravine past the old lighthouse to stand in what appeared at first glance and from a distance to be a place inaccessible, but from where vision northwards might be calculated from a completely new angle and perspective: seven hundred feet below the peak, spiralling over my head.

I would climb down from that peak, or up from the old lighthouse, to the central saddle of the island once again, the crossroads of its backbone, to make my way down the ruined North Steps, where relatively few travelled and which gave themselves up three-quarters of the way down to jagged rock, twisting back on slimy, worn rock-cut steps, hard to discern, onto the bottom of a fold in the island's topography: Blue Cove.

Here the birds were not as used to humans as on the well-travelled southern steps (the ones now most in use). They were skittish and jumped away from me. I crawled slowly down in the late afternoon in early summer, the sky resplendent with the unfolding swirls and helixes formed by puffin flight, the translucent beaks and talons of the birds aflame with red fire, and the razorbills leaping into the air ahead of me, working a steady, slow accumulation of speed of wingbeat, practising some flight algebra that suddenly released these birds into clear air and quivering beat out beyond the confines of the cove. There they caught the full, quick rhythm of flight after their methodical departure. And fulmars were suspended there, as if on strings, directly ahead of my face – those same fulmars I observed from the cliff edges high above. I was going down a ladder of stepped wilderness.

The retaining walls were gone in places; the steps were overgrown and only to be followed by shuffling on unbalanced advancing feet. I came across little platforms that I would come

to know, where little caches of quartz crystals, 'Kerry diamonds', lay, glistening and undisturbed. At times, I could sense myself suspended by these little fires of clear light, these tiny lanterns of pressed rock, more than by the steps themselves. They would crunch and sparkle underfoot.

The steps then suddenly ended, just at the level where a high and incoming swell might reach. Here, black-backed gulls would build their nests in the little hollows of the rock. Maybe ten nests would be clustered together. The little chicks, their heads raised above the low, jagged lines of the rock, appeared raw, misbegotten, and I imagined them to be emerging from a different world altogether from my own – their gangly, unsupported heads still tufted with down, their little stubby wings much too short yet. Furious parents would bank out to sea and dive over me, approaching from before and behind at once, swirling away and back overhead, their flights whistling dangerously by my ears, tricking me with their apparent disappearance till almost knocking me off-balance once again.

If the weather was fine, I could turn upon the old worn rock-cut way, descending back under the mountain from that point – a way that is hard to decipher and make out now – to rest deep within the cove in the late-afternoon light: at a place filled with scattered carcasses, dull red beaks, rabbit skeletons, and the detritus of life accumulated over time. I would sit in the midst of that wild place, with the late light falling directly into the cove, with the peak spiralling interminably over my head.

The place seemed incredibly remote; I sensed that I had reached the very foundation of the rock, and of the entire island. But I was at the same time, of course, resting at exactly the same level as that found at the landing – on the other side of the island, and apparently a thousand miles away.

I would think there that I was underneath everything substantial, and that the sea was rearing high over my head, yet I felt – and was – perfectly safe in that little cove. I also sensed that I

was on the edge of a still further place: a wilder world. I don't know why this happened, but I am not sure if I have been down those steps more than a handful of times each year I have been on the island since that first summer: down to the little platform where lighthouse men arrived long ago, when the swell direction meant that the main landing was impassable while the sea remained calm here, deep within this northern cove, Blue Cove.

Though I was right down at the level of the incoming water, I could see the world curving away, and I felt that all communication with those beyond me might work and be brought to bear by agencies and means other than those normal and assumed – however fanciful that might seem – that distant communication might be made through the agencies of the churning deep, moving before me, even in the most lazy of forward movements in the gently raised sea, travelling to hit rock for the first time in a thousand, or two thousand miles. I looked at the little castings of water on my hands that had been lifted clear in light splashing, quivering on my skin. Cast from so far away. And no land visible ahead, only the piercing rays of low direct sunlight as the day died directly before me, and its great and golden orb gently melded with blue water. The water was set aflame, to simmer there: that same flame within water I had been watching from the cliff edges, high above the bedrock. All communication – at whatever distance, in whatever medium – was, from here, made of equal breadth and reach, because of my arrival, for a brief hiatus, at this low and extreme border.

I often look down at that little cove from the now-restored steps overhead, towards the place where the steps cut back, and it seems in memory that scores of gulls used to nest there (though it could have only, realistically, been a handful), and I sense that strong surge, that strong charge – of a communication upon indeterminate lines, upon indeterminate distances – once again. It is the charge of the sea running deep into the core of the rock, eating away at the foundation of the island, setting it free within

the air. And myself, somehow, caught up within this fundamental process, this continual eating away at the rock by the moving ocean, only because I am there and allowed silent observation.

That first year I explored the island, I would also descend from the monastery directly down the eastern steps, the third way down the mountain, incomplete since the 1820s due to blasting to make the lighthouse road from the eastern landing. I would leave through the open doorway of the Monks' Garden, in the lower retaining wall of the monastery, to see that other way – the steepest of all in places – spiralling quickly down and ahead, passing a few enigmatic ruined walls and half-structures, with the vista of the mainland ahead, holding the Little Skellig within its distant arms. Halfway down, the ruined steps would cling in places above the natural level of descent as I walked onto beautiful tiny platforms, set upon raised terraces of masonry. Patches of these remain original and intact and lead to an intricately wrought maze, suspended just out from the rock and over the landing, where the steps end, hanging in mid-air. The landing glistens some hundred and fifty feet below, and the Little Skellig stands ahead: gleaming and, apparently, closer than at any other point on the island. Standing on that exposed point where the old steps end, I often believe that I have actually walked out to that jagged white rock – to the Little Skellig, though it remains, as ever, a mile away. It is always hung before me on the island, whatever the weather. As if I might touch it.

Changes in perspective, arrived at from different vantage points of the island, were occurring everywhere, all the time. And I could sit there, suspended in a small nook above the landing, and watch unobserved the traffic of the boats below or the business at the landing. From there, near the bottom of the slope but still suspended almost in mid-air above the road and pier, I could turn and look at the monastery far overhead – a tiny fortress rearing against the sky – imagining the perspective of centuries ago, when monks, or relations, or Vikings might have landed.

My sight and vision would shift, depending upon where on the island I would move, to what extent I might ascend or descend or shift direction. All of these footholds would cast my views upon far places dependent upon a sense of height and depth not known back on the longer and softer contours of the mainland, and removed from the social perspectives of crowds or society. This was the context for my experiences here.

And so I quickly, in my first weeks and years on the island, began to devise a map of this place and position it within my own compass, my own sense of place. After some time, this map developed; a map of paths falling away upon clean air, of a string of places, both high up the rock and at shore level, from where contact might at times be assayed against distant shores, and upon the wilderness beyond, notwithstanding the great wall of the intervening sea and sky standing before me. In fact, over time, and paradoxically, it was precisely this sense of wilderness, this sense of constriction, that came to seem a perfect medium for communication with further places, further shores. A restriction cutting away impediments, distractions. A restriction forcing a simple repetition of travelled, if limited, pathways as a vehicle, a structure for containing and concentrating thought and memory into a prayer that might be cast far up into the high empyrean, the high stratosphere, to mingle by some strange chemistry with the music of the movements of stars, the aimless and rambling winds, and the migration of birds into the wildernesses beyond – from which they were always returning – all to fall in unseen, unfelt rain upon loved ones far away and deep within the seats of all trouble occurring upon the mainland beyond. Learning that we hold each other up from distances, as well; we carry each other's spirits over wastes and wilderness.

This was the context of my experiences:
A living background; a spine exposed,
Whipping against, and taking in, empty air;

Sending ahead channelled, confined air and light,
Scoring a map inside, showing a path leading
Up a hill, over a dark wall.
My sense of place changed; this became
A place from which high walls were exposed,
Torn down, letting empty light through, upon the
 empty air.

The Story of Saint Brendan

The island is often cut off from the mainland. A swell develops, rides across the open sea from mid-Atlantic, divides and sweeps its arms around either side of this dark fulcrum of rock. The ocean washes in and over the small north-east-facing pier at the landing cove in surges of white, folding upon one another, greeting each other spectacularly with a combined force to raise white roses of spray, to allow them to linger high above the now-lost pier – all making access impossible, sometimes for days on end, even in summer months.

At the end of my first summer on the Skelligs, in September 1987, we waited to depart the island – a colleague and I – riding out one of these Atlantic swells. The high seas of these early autumn days coincided with the equinoctial gales, a window of time well known in sea lore and occurring between mid and late September when, if tides, full moon, and equinox come to be stacked upon each other, and if there is an added push from the hurricane season taking place simultaneously off the coast of the Americas, swells will build and push seas into the high register for days on end.

And so we waited for a few bright days as the year turned that late September, the light intensely white upon the island, the sea rising to peaks and stretching to the horizon, elevated upon widening, deepening troughs that pushed by the island at great and uninterrupted speed. Despite these high winds, and because of the folds in the rock that can play the devil with wind direc-

tion – the wind can actually be blowing from two opposing directions within the distance of a few feet – the lighthouse roadway where our huts were located was often a pool of stillness in the lee of weather, trapping the intense sunlight in wells of yellow brilliance. The surge continued over days, running round the Washerwoman's Rocks just to the west and raising a continual mist to hang above the four-foot sea wall, which provides shelter for the road. At times, this driving mist would break upon our faces in prisms of light. Young fledgling gulls, together with other birds migrating south, as well as the island's ravens and crows, all shared this shelter with us from time to time, gathering in the lee of weather, hopping along the eerily quiet road. Occasionally, as the ragged white clouds bore down overhead, little pipits would wander into our huts to rest in the quiet light.

In this little well of silence, with the sea and the elements dividing around me and careening against each other on all sides of the island, I read for the first time the late-medieval account of Saint Brendan's voyage out over the Western Seas, and of the various islands he and his fellow monks are said to have visited during their mythical journey to the Promised Land of the Saints. Entranced by the description of the seascape that Brendan's crew traverses, I found it easy to superimpose his ancient journey, undertaken into the unknown, upon my own situation – for, after all, I was stowed away in a tiny room on a small bunk, as a small window provided glimpses of the elements raging just beyond the glass. The timber walls would creak and quiver as if they were of paper – or, more appropriately, boat-hide – in the wind that would turn suddenly, so that the hut would bear the full brunt of the weather. The rain seeped under the doorway in long fingers to cover the floor; the wind shook, then lifted, the linoleum. After an afternoon of such outrage, there could then be a sudden stillness, sudden brightness. Brendan's men were said to have encountered similar vicissitudes, similar radical extremes. I read of how Brendan would lift his arms in the face of storms and

dangers, urging his men to persevere in their journey, and, then, of the storms abating, and of mysterious islands they would visit – a cyclical voyage undertaken on the open ocean in an unknown timeless spiritual arena off the western coast of Ireland, on the so-called Western Seas.

Most fascinating to me, and having special relevance to my stay on Skellig Michael, was the account of St Brendan's sojourn on the Paradise of Birds, an island set in the mysterious sea his men are traversing. His boat's arrival there is at first heralded by a white bird alighting upon the prow and singing unearthly and beautiful music. When the men arrive on the island itself, scores of similar white birds gather on a tree to sing the psalms appropriate to the vigils of Easter. This whole experience is ecstatic, overwhelming, and rejuvenating, for Brendan and his men have been lost for days. He is particularly entranced, though also disconcerted, by the mysterious appearance of these birds; he is most anxious to discover why they are on the island. He prays fervently through the night for this secret to be revealed. Then, on the next morning, he is told by one of these beautiful white creatures that they have been released as wandering spirits, and that together they comprise a lost crew of the fallen angels who rebelled against God with Satan. They have been given a reprieve and must wander disembodied throughout the year over the face of the earth. However, at each Easter-tide, as Brendan is told, the birds will assume the brilliance that he and his men have observed. Then they are able to sing beautifully throughout the feast, and they will always return to the same tree on the island, year after year. Brendan is told that his arrival has been timed to coincide with this miraculous display.

As I read of Brendan's encounters with these birds, I could not help but think again of my own situation and of my season on the island, which was coming to its conclusion. I, too, had become enchanted by the activity in the sky before me: watching the gannets, the puffins, and all the other birds of the island, turning,

hovering, banking ahead of me in the unfolding, unravelling permutations of their flight. I had watched them circle together near their nesting spaces, clustering together for mutual security and support; I had seen them spinning out in wider arcs, stretching to where they became invisible, feeding far out to sea. In a broader sense, I had come to be aware of their yearly patterns, of their seasonal departures and returns, and to learn how the birds would leave the island for months on end. These interwoven cycles of flight and time, which the birds made, captivated me: their pathways rested one upon another, unfolding within the sky overhead; their trails lingered within my mind's eye.

Halfway up the mountain, the sky both rises above and falls away beneath me. It is easy to talk to the birds. They come at me at eye level, sometimes resting at my feet, glancing my way with mild curiosity, departing on their own business. Thousands upon thousands pass by, hanging before me, gazing briefly into my eyes, day after day throughout the summer. In fact, on many days, nothing will disturb my vision, focused otherwise only on empty sea and skies, except for the arrival of flocks of birds converging upon the island, suddenly filling the sky ahead. Within the dull greens and greys of vegetation or rock, a puffin beak suddenly gleams, a glistening jewel hidden in the grass. Walking down the lighthouse road in the evening in near darkness, kittiwakes glimmer, strung in lantern-strings, high on the cliff overhead. Brief displays point to patterns of life and movement which extend beyond sight and remain unknown: the birds arrive, suddenly hovering about me; they materialize out of an empty sky, quickly arriving at every interface, every corner and ridge of the island. They stand in rings and towers just off the flanks of sheer rock, creating fields of running, living light.

We are told in the story that Brendan cannot complete this journey without coming to understand the mystery of the white birds he sees on the island, without learning why they appear and sing. He desperately needs to know the significance of their

brilliance and of their appearing. Appearances are enigmatic on Skellig Michael. From this small rock, thousands of creatures roam deserted swathes of our planet, the island their only reference, their only home. The island becomes, over the course of their lives, a land magnet, the lodestone that pulls them back, that swings them around the island and sends them off again over the open sea. We walk along the lighthouse road and up and down the blades of the stone steps climbing through the air and up to the monastery, completely immersed within these cycles of flight, as the birds appear suddenly before our faces, then veer away again. Our paths, too, round the verges of the island and skirt the nothingness beyond. Day by day, we walk the lighthouse road circling the island, climb the steps upwards, aware of the emptiness ahead on every turn. The birds leave, and suddenly the island darkens and is still. We know they are out there, out upon the empty waste of the ocean where they ride out the winter, upon their natural domain in the open sea. They establish the fretwork over which our spirit hovers.

These birds, having been reared and nurtured on the island, carry a homing instinct from the Skelligs. They range as far as South America, they dwell upon so wild a place as the North Atlantic in winter, yet their instinct is to return to the same burrows, to the same little crevices of rock, to the same inaccessible sea ledges, each spring. Some of them do this over more than thirty years. As with Brendan's monks, the sudden arrival of birds at an exposed place points sensibilities outwards to the unknown and unseen.

PART TWO

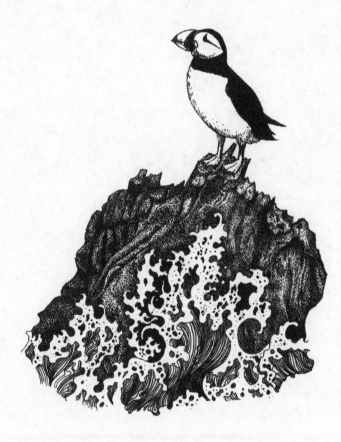

CHAPTER FIVE

A Paradise of Birds

B irds fill the air of the island over the summer months. Puffins put on miraculous displays at dawn and at dusk, but they are active all day long, bringing fish to their chicks waiting in the burrows pocketed all along the steep slopes. There are over five thousand of them. They remain wary but over time, if I remain quiet, they will become curious. Little heads peek out from burrow openings from early June as the chicks wait for the parents to bring food. The adults repeatedly sweep out to sea, dive sixty feet or more, and rise into the sky again with beaks filled with shimmering fish. Over the months of June and July the young are reared, and by early August the burrows are all deserted. As time has gone by, they have come to ignore my presence and to realize I am unthreatening

~

In 1991, two ornithologists arrived on the Skelligs to re-establish an annual census of nesting birds on the island. Over the course of a weekend, they plotted sections of nesting areas on a master map, in order to indicate as many nests and resident adults as they could. Obviously this was a difficult undertaking in the more

inaccessible regions of the island. At night a mist-net would be set up on the slopes, and an unnaturally enhanced – so it seemed to me – tape of a calling storm petrel was broadcast out upon the night island air. The plan was to attract wandering petrels towards the net, catch them there, stick them in pockets, or loosely in boxes or bags, place a tiny, almost weightless, ring on their leg, and release them into freedom once again. By the time these men came to the island, this had been standard practice on coastlines all over the world for decades; and it is by means of this and similar ringing that we have begun to realize the intricacies of flight that sea-birds worldwide undertake. Over the intervening years, these visits have continued; they have become an annual feature of life on the island.

The first year that Oscar and Alyn, the ornithologists, came, they brought with them a hundred plastic yellow bands, marked with clearly visible black numbers (00–99), to place on a hundred adult puffins. The birds were trapped briefly and ringed with these yellow tags, along the southern slopes of the island and above the huts. After that weekend, these hundred were easily distinguishable from their thousands of companions. Their yellow bands were caught by daylight in flight, and were discernible along the steps when the birds were resting outside burrow entrances, as they stood guard protecting their chicks inside.

I must admit that, early on, I felt sorry for the birds and for the intrusion on their lives. At that time, we were less informed about the whereabouts of puffins in wintertime than now. No one really knew where they went when they left the island in late July and early August. 'Out there ...' was the answer always given about their movements away from nesting sites, implying a general dispersal across the North Atlantic, to return to nesting sites in late spring.

Tens of thousands of puffins were nesting on cliff edges across northern European coastlines, yet relatively few of these were spotted on their winter migrations. Occasional loners were

reported by shipping during winter months. Given that puffins had provided a major food source at many places for centuries, these 'disappearances' in some ways secured and blanketed them from continual culling. For long – and in some places still – fresh and preserved puffin meat has been eaten in the Faroes, Iceland, Scandinavia, Scotland, and Ireland. Coastal monastic middens hold puffin bones. And there are nineteenth-century accounts of men climbing precariously down the cliffs along the west coast of Ireland, hunting for fattened puffin chicks. It seemed only right that these birds were lost in the relative obscurity of the wide Atlantic from August until May.

Our puffins, though, did not seem disturbed by these yellow rings, and some returned, still wearing them, twenty-five years later.

Unusual observations were sometimes made at these night-time listening posts. Once, a little storm petrel was picked up, last ringed in the late 1960s, indicating an age well over thirty years. The calls of unusual petrels and shearwaters, inhabitants of waters much further south, began to be occasionally heard in response to tape calls.

And I began to know what to listen for and how to distinguish between calls. Between returning male and female Manx shear-waters, making the most unusual and eerie vocal connection on cloud-covered, rainy, misty nights (they don't usually travel near nesting sites on bright nights, for fear of detection). The strange elongated call of a Cory's shearwater, with a high-pitched piercing cackle at its conclusion, standing out, from time to time, from the tens of thousands of regular petrel and shearwater calls each night.

In those early years, my young family would visit from time to time. My son Daniel was around 10, and he became obsessed with tracking these yellow-ringed puffins. Many of them nested right along the steps. On a beautiful day, at the beginning of a season – possibly 1992 – my family and I climbed the steps above

the Wailing Woman (some two hundred feet above the road). We were all delighted to be on the island again, and everything was glistening and new in the May morning light. We were also torn, as there would be regular and sustained separation over the months ahead. Daniel was furiously looking for more puffin numbers along the steps – for me and for himself – and plotting the way along the southern flanks of the island by his own system of interior mapping.

At a sharp corner of the stairs, high above Cross Cove (the kittiwake-filled, canopied cove all visitors walk along), just where there is a sheer drop and turn of the steps, a pair of puffins scampered into a burrow just beside our feet: number 40 and one other. Daniel was fascinated, engaged with the fact that the pair were rearing a chick, deep within the burrow they were protecting. Getting down on his knees, he saw a pair of eyes staring out at him from another world.

He said he would provide for these birds with a small courtyard for their home, a 'foyer'. So he picked up the four small stones I would allow and placed them in loose earth before the burrow. Those stones are still there, over thirty years later, though they are now practically obscured by earth and growth. Puffin 40 and mate still returned to this home burrow and foyer, rearing a chick each year, until about fifteen years ago.

I would regularly watch 10 and 98 (the only numbered couple I could with certainty monitor, after a number of rings naturally fell off over the first couple of years they were worn) for many years. And while 03 would regularly stand above the alligator rock, 53 was usually to be found around the Wailing Woman. And, up until five years ago, I would spot 24 on occasion, just along the lower reaches of the steps.

Thousands of creatures are always returning to home in on the tiniest of targets, on their specific burrows and ledges on Skellig Michael, a spike eight miles at sea; they move upon a map that is alive and changing, a shifting range of flight.

Over the years, knowledge and understanding of this range has increased. This living map works in innumerable ways, and is subject to fluctuating forces. These cycles become woven, over time, into our own understandings.

Food supplies shift, probably for a variety of reasons. In recent years, a greater awareness of these things has developed, and we have begun to see how both climate changes and the effects of commercial fishing trends might impact on the stocks wild sea-birds depend upon.

Unexpectedly, for two years in the early 2000s, supplies of sprats and sand eels – the main source of puffin food on the Skelligs – were severely diminished in the waters around the island. We began to observe adults, desperate to feed their chicks, bringing in hard-scaled pipefish, which the young puffins found extremely difficult to work on and swallow. Some European colonies of puffins suffered drastic decline in numbers at this time. Somehow, miraculously, the Skellig colony remained more or less intact. Perhaps this had something to do with its remote and southerly (compared to most North Atlantic puffin colonies) location, but no one is sure. For the last decade or so, though, sand eels and sprats have been more plentiful, and adults on the island are now observed bringing large mouthfuls of them into their burrows once again.

I am always aware that Skellig Michael is the magnet on which the lives of these little creatures depend. The different species fan out in various orbits of wandering through the winter, returning to specific points on the island in spring.

The island juts up into the sky, glistening in the Atlantic air, rising from the continuously shifting sea below; the light pinpoints the island, exposing the wide circles of influence and migration spreading out upon the sea's and the air's emptiness from this small rock off the southern coast of Ireland. The puffins hatch and fledge and move outwards on their discursive and rambling journeys in searches for food throughout the winter months, lost to

us often in mid-Atlantic. The lives of some of these birds correspond with those of my children. I see drawings on my wall of puffin chicks made over twenty years ago; perhaps these birds are still alive, preparing to return once again to Skellig Michael, or some other Atlantic colony, as long-mature adults. I can see my six-year-old daughter furiously trying to catch the visiting ornithologist's attention and informing him most seriously: 'Number 40!'

There is always an explosion of life on the island in the early summer. In mid-May, around the time we are arriving on the island, no voices are heard underfoot when rising on the steps. Then, usually in the first week of June – in recent years, a week or two earlier than this – one begins to hear the faint chirps of newly hatched puffins underneath the steps and on the hillside. In a few days, this sound gathers and increases into a continuous music of whistling sounds all along the way as I climb to the monastery and descend. From some four weeks later – from late June on – growing chicks begin to haunt the entrances to burrows, often barred from exiting by parents for their safety, preparing to flex their wings and depart for the sea, which they do from the age of six weeks or so. Gulls haunt the skies, looking to pick off the foolish or prematurely adventurous ones.

Chicks are everywhere – furtively darting out from a burrow, whirring wings in the open air, retreating to safety once again. We see them scuttering underground, carried off in the beaks of marauding gulls high in the air, lost or fatally damaged on the road. Little stubs of wings flail unprotected and exposed in the island light. The first impulse one has with regard to these little lost young ones is to simply pick them up and put them in a pocket or box for their immediate protection. But to what end? The food sources at sea may well be sometimes subject to human greed, but the puffin colony on the Skelligs is robust, and this natural culling has always been a feature of their lives. Yet here, our lives – the few of us who live here – and those of the birds

always overlap. We, too, are utterly insignificant in the grand extent of all things, and we share concerns with the wildlife here. There are interconnections; there is codependence between us, even if it is attenuated – at least in our human minds. And birds keep arriving at our doors.

On many occasions, during my early years on the island, I would pick up a puffin chick astray and utterly abandoned on the road in the early morning, or else be handed one by someone working on the island or by a visitor. Often these little chicks would still be tiny balls of down, with a dull-black beak and two black 'shoes' projecting above and below. I would often fish from the pier back then; knowing that the chick would have no other possibility of survival, I would sometimes try to pop a slice of fresh pollock into a beak prised open with my fingers. Often these attempts were useless, but over time I became more assured and adept at feeding; and, if the little ones were a bit beyond being newly hatched, they just might take to this treatment.

One of these, 'Lucky', that I began to feed sometime in the early nineties, came to thrive in my hut. At that time, we lived for three weeks straight on the island, so I was able to develop a certain continuity in feeding this bird and, hopefully, not have to foist his care on others remaining on the island when I would be going ashore.

Lucky came to stay happily with me for a few weeks. He lived in a Pampers box under my table, with one hole carved out for a window, in eyeshot of my upper bunk. He would rest his head on the little cardboard ridge of this window, waiting patiently in the morning for any sign of movement from me. The moment I made any stir whatsoever, or even opened my eyes and contact was established, his singing began. He wanted more pollock. In the evening, he would come right up under the table and rest on my shoe. I was uncomfortable, but also honoured, during this nightly ritual, briefly observed.

It was always strange to set these birds loose if they had been

with us for a day or two, or even for longer, perhaps weeks. On many occasions, chicks would be fearful, exposed on the walls. While brave on the cabin floor and whirring their wings furiously, practising flight so emphatically in their makeshift homes that boxes would actually leap off the ground, the birds, when set loose in the open air, might run right back toward human shelter. Terrified or confused by the sight of the open sea under an empty sky at nightfall, these little creatures might run back to the shelter of my coat or elbow.

Many of those we released perhaps did not survive their first night on the open water, once released from the wall or into the landing at the pier below.

And yet, there was undeniable joy, and a great thrill of participation, when a quivering young chick would be released over the lighthouse wall to fly down and away, its wings suddenly catching flight just at the furthest extent of visibility or in a dim torch beam – in a first extension of its world into the bird's permanent home in the ocean, a delivery and flight towards which all its instincts had geared the little creature.

Now, the puffins wander on the capstones of the lighthouse road just outside the door.

Over the years, more and more of these wonderful, colourful birds have come to gather near the huts. They seem to find human company reassuring. Sometimes thirty or forty of them are lined up, just out from the window on the opposite wall. Gradually, they have come to know, and feel at ease with, those of us living in the huts. Many years ago, not long after I first came to the island, a pair began to nest in a hole in the wall directly in front of my hut, across the lighthouse road. Daily, over the nesting season, we became able to mark the habits and progress of individual birds living so close by. Then, just a few years after this,

something more strange began to happen. Puffins, and then razor-bills, aware of the safety we provided, particularly as far as the hungry gulls were concerned, began to burrow directly under the hut where I sleep on the island. At first, one or two couples – and then several – began to set up home there in early summer, about the time I would move in. Over time, we began to notice unusual adaptations in their flight.

When I first came to the island, I was told that puffins found it nearly impossible to 'get over' the lighthouse road wall, which rises before the hut. This wall protects the road and is about four feet high on its seaward side. Because of their anatomy, which makes it possible for them to swim and dive as well as fly, puffins can only take off from the island by throwing themselves outwards and downwards at the same time. From the cliffs, this is easy for them. But along the road, they generally require a runway, of sorts, to give them a head start and propel them forward. They do learn to climb barriers over time, but the lighthouse road wall provides an imposing hurdle for them in their progress and return from the sea. However, over the years, we have watched the puffins gradually adapt to the new-found safety of a home under the huts: they have learned to walk up the road (a distance of some few feet – the road rises westwards from the hut towards the lighthouse) and then, wings whirring furiously, beat down and up above the road to veer away, over the wall, lifting out to sea! Because of where the hut has been situated, mostly away from tourist traffic, I have been able to become familiar with this small party of puffins, who continually take off and land before my window.

Recently, there has been a further twist to this developing relationship – the puffins have now become eager to come into my hut and walk around. I sense that these birds have discovered that the cabin might provide the ultimate solution with regard to their requirements for accommodation. It is warm and clean; no gulls dare venture inside. We seem harmless curiosities. They seem

set to push me out and take the hut over! If I am not watchful, they will run through the doorway, under my feet, and make for a new haven under my bed.

We could hear the puffin adults chattering like chainsaws under the floor through the nights, over the course of the six weeks or so when they were rearing their chicks. After a few years, razor-bills would make nests under the huts as well. I am not sure what caused the little colony under the hut to grow or whether it will continue to exist. Perhaps it continues to survive because of the increasing familiarity between the birds and ourselves, which has developed over time.

Puffin chicks usually make their own way out to sea. The little balls of fluff that emerge from burrows underfoot, fed through a continuous stream of foraging flights by their parents, come to fatten and grow until, if conditions are right, some six weeks after hatching, they make their way under cover of night down the rocky slopes of the mountain. Sometimes scampering, sometimes bounding from one rock to another, sometimes not making it seaward. They are heading for the safety of the ocean below the road.

Sometimes it takes them two days to do this. Some have already been abandoned by their parents; others depart on their own. They have none of the adult colouring yet – their plumage is black with various shades of grey, white here and there. In time this will become the bright puffin breast, so clearly marked and defined. Often these young departing chicks still retain cockatoo-like tufts of down, or trail bits of fluff behind them.

Razorbills are quite different. The chicks are identical junior versions of the adults, apparelled in neat tuxedos, wandering out from hiding places under the watchful eyes of parents or sheltered on high ridges where they are exposed together in small groups.

Sometimes, if one studies the falling darkness carefully around the island, these little birds can be seen making their first leaps into the sea. In late June and July, the piercing cries of these chicks – of razorbills and their cousins, the guillemots – is heard everywhere throughout the evening sky around the Skelligs. My first years there, I foolishly had no idea where this sound was coming from. The little creatures screaming on the evening sky are tiny, only a few inches high.

Just over the wall in front of the hut there is a great overhanging rock, underneath which a family of razorbills has been steadily expanding in numbers over the last ten years. In the evening, as night falls, a couple of weeks after hatching, the little ones begin to emerge from the darkness under this rock with their penguin-like profiles, white breasts aglow in the near dark. Gulls hover overhead, ready to pick them off if they are left unprotected. Parents furiously patrol, sometimes in groups, keeping little ones away from the edge until their time for departure comes.

Screams intensify over several days, and the activity becomes more frantic. The little chicks come out to hover over the sea, which is rushing, crashing over the rocks far below. Directly underneath this ledge are further jagged outcrops; there is no straight chute down to the water. A fair leap and half-flight will always be required to make it to the sea. Looking at these tiny creatures, such a feat seems impossible. The little stubby wings, so far from full development and extension, appear to have no strength for such a challenge.

But there is more to this story. A general sense of intuitive understanding, expressed somehow through screams and deep guttural croakings, establishes successful communication between chick and parent, ensuring a drawn-out delay to the process of departure. Sometimes they seem to dance to and fro together on the ledge for days. The tension within the young one's cries rises to a strident crescendo, to be heard all over the island and far up in the monastery. One wonders why it is so loud, so insistent,

giving away the location of these fragile and beautiful little jewels so clearly.

It is obvious when the night for departure has arrived; the tension is palpable. The little one is screaming at the edge of the long flat stone; the deep-throated call of the parent is equally intensified. As opposed to previous evenings, the chick is left free to go towards the exposed edge of the rock. It calls repeatedly under the night sky, dancing back and forth to the safety found under the ledge, venturing out to the edge over the dancing sea below once more. The calls reverberate back and forth upon the night sky.

It is difficult to describe what happens next, as it all occurs so quickly. After years, I remain confused about the sequence of events. It is not always the same. Usually, the chick will go first, followed by the adult; but I have also seen the adult in the water first, followed by a screaming chick.

The little chick is poised once more upon the ledge. In a blink of an eye, there is a leap into the darkness, with a combination of forward propulsion, assisted by the furious whirring of tiny wings, and an almighty thrust from thigh muscles sprung, released for the first time. It seems, at least from this observation post, that these muscles must be specifically designed for this leap; at any rate, they are vital. This is a frog-leap, a first thrust into darkness, and into perpetual and constant use henceforth.

One can see the little body leaping over into the darkness, to the sea, where it is immediately blanketed. The screaming from the water is sometimes ferocious. The parent's descent is instantaneous. The cries of adult and chick reach a deafening pitch. It becomes clear once they are in the water why the screams and calls are so loud, so piercing: they must find each other in the darkness immediately. Their cries unite them. Sometimes you can hear them afterwards, if they are briefly separated, calling through the darkness in the night.

Unlike puffin chicks, razorbills learn from their parents for some time in the sea. Until they are fully grown, some two to

four weeks after they leave the safety of the ledge, the high-pitched whistles are continuous.

We hear them out upon the water. Their cries pierce the airwaves, even to the top of the steps, even at the monastery. Lying on my bed at night, on warm evenings in mid-July, if the sea and wind are still, I can hear the cries travelling far across the night sky. Somewhere down below, within the sighing sea, little razorbills are reuniting with their parents. For two or three weeks, they learn to stretch from the relative safety of the rock and into their new dwelling, the open seas beyond. Like puffins, these birds depend upon using their wings as flippers, and they dive well down into the water for fish. But by mid-July, razorbill calls are rare. And soon afterwards, most of the island's sea-birds will be gone, but for the night birds, to roam the waters of the open ocean for the winter.

Underneath and beyond everything, the world is carved away. Communication operates through a different agency of the churning deep.

What is the nature of our communication, our exchanges with these little creatures? And what contact do we make with the great world beyond, here at this crossroads, watching the birds leaving us, departing for destinations far beyond us, into nothingness that stretches beyond on every side of us?

CHAPTER SIX

Dark Interiors

Gannets tower lazily just off the rock beyond in a concentration of brilliance over the water. Their brightness waxes, then quickly wanes; they then turn into the light and are revealed again; in suspended strands of silver-white, they bear in from the horizon. They spiral upwards, build towers that shift slowly over the surface out to sea. They disperse and slowly vanish into the air; black wing-tips flash suddenly ahead, in an enclosed zone of the sky; they disperse and disappear.

Puffins appear suddenly in whirling rings. They whip the air clean as they hover inches above the rock in cross-winds. They caress every pocket, each contour of the island. They appear quickly, suddenly large, brilliant in the sunlight, their landfall drumming across the slopes, a halo of swirling colour, of continuously unfolding movement.

Cross Cove fills with kittiwakes. Constantly calling in the wells of light, they circle between the cliffs. They settle for the night at precipitous points, cluster together upon the vertical faces of stone. Their lit breasts register in a white code across the gloaming. Falling darkness glistens by their presence; lanterns flicker over the green and red paint, the slime of oxidized sandstone, along the walls of the now-darkened island.

Then, on the surface of the cove, in the evening – and further on, all along the rock edge – seals stretch their necks high above the white swell, glistening above water that becomes inaccessible to swimmer or vessel as the sea rises. Their heads lift above the extreme movements of the swaying arms of the water; they play within the froth, their calls rising over the surge below.

The light shifts over and between these living things, held within their ambit, balancing and breaking apart in ways that are peculiar to this place, this time.

A rainbow breaks ahead, forming a halo over the summit of the Little Skellig, further suspending that rock within its coloured arms, juxtaposing the stark outline against a declining sun so that it is held in a frame beyond any arm's reach. It lifts from the water, a vessel rising precariously, steadily, against the swell.

These are the features of the island's compass. The immediate interface with such abundance is drawn so thin that Eden is established here: it can seem that we have truly entered this otherworld.

But then a shadow falls swiftly across the southern slope of the island. Puffins instinctively know what this means: a falcon, a gull, a kestrel. There is instant consternation. Very quickly, a black-backed gull will strike into the puffin ring, within the whirring circle these birds form for their protection each evening. He brings down a little bird, rips open the breast and begins to tear its flesh. These confrontations regularly fill the skies. Many chicks falter, or remain unfed, or perish in some way on their way to the sea and to first flight, only a few days or weeks old. Their carcasses litter the road on August mornings. All creatures on the island fight for their survival upon this precarious rock. The ones that survive this radical culling, from the gulls and storms and winter seas, will return the following spring and suddenly appear out of the empty sky. This is the cycle of time that prevails here.

After waves of passing brightness, the rain spits continuously, and the north-east winds stir the dust that will cover the

monastery. Weather systems pass over, one behind another, and the grey troughs between the waves out to sea broaden; the mist falls down over the vanes of rock. For days there is this darkness; all things close in. The brightness declines; the eye concentrates upon the few solid things ahead or in the surrounds of a small hut, and there is lifelessness everywhere. The Egyptian monks had a name for this: 'acciddie' – dearth of colour, meaninglessness. This was the word for what life sometimes would become behind the pale of living light.

All roads here lead into empty space. The lighthouse road leads to a dead end over Seal Cove; at its other end, it leads down to the white water at the pier, to a raging and inhospitable sea. The steps lead upwards to disappear into thick mist, into driving rain. Hands of the gale tear at the climber to sweep them away. The birds disappear. All is compressed inwards. This place becomes a testing place, a laboratory for the harrowing of the soul, where it is tempered and humbled, or destroyed. All past miscues of a lifetime, all private darknesses, return upon the wings of now ungraceful, struggling birds, passing ahead as they fight the cross-currents. One of them appears suddenly out of the mist in front of the window, falling heavily onto the rock below, unable to rise.

This is a desolation that becomes part of the insulated vision of this place. This desolation is part of the width of vision demanded. Light held through time retains power, and darkness serves as a resistor. A great darkness shadows and follows the outline of the stairs, creates from them a skeleton of stone, a ladder of sharp, bright knives glistening in the rain. Carved flagstones shine in the late afternoon as wave after wave of storm and darkness cover the wet, green, uncaring rock.

This place opens and rises to the unknown upon the sad whine of the wind, which will bind the air for days on end, making ominous, mocking, threatening sounds. It splits open the mind to the colours arriving from the darkness: the darkness of the

night, of the cells, of the empty days. When writing of the first Christian monks, of the Desert Fathers of Egypt, Edward Gibbons long ago remarked that these men seemed to live in a half-death. These words still resonate.

Words intimating darkness touch upon the light one struggles for upon entering the cells, and one enters not into an absence of light, but within a positive darkness. Active darkness of long standing reaches for you at the blank doorway of a cell suspended upon a high platform over the ocean. Dark interiors open slowly ahead at the threshold, and the emptiness spreads above and beyond across the face of stone. The pitch turns to grey, streaked with brown light; brightening shafts, which can appear as fire, rise from a depth. The dark is compounded, intensified over the space of a little time, as it takes form. Then darkness in full bloom surrounds us. Sitting for the first time, for a half-hour or so, upon the floor of the dank cell, an apparent eternity away from company, the fullness of the dark reaches overhead; it invades the spirit. Darkness falls over the soul, blanketing it, hiding it here. This is the other Eden – also beautiful, but dark and challenging – that manifests itself on Skellig Michael, aglow within this dark light.

Solitude or Seclusion

At the beginning of the summer of 1993, I read *An Evil Cradling* on the Skelligs. This is the account given by Brian Keenan of his abduction and captivity, along with fellow hostage John McCarthy, in Beirut a few years earlier. They were held for months in unknown places, tortured, mistreated, and kept in seclusion. The book describes the various ways Brian Keenan attempted to deal with the absurdity of the unjustified evil being practised on them. He describes in detail methods concocted to deal with continual fear and uncertainty as to when torture might strike again, when he and his fellow hostage might be immersed within total darkness once more.

The solitude I experienced on Skellig Michael was self-imposed,

and it was broken almost daily by mingling with others. In many ways, the situation in which I found myself was utterly different from Keenan's. I was surrounded by dramatic beauty; I had what I needed; I knew I had loved ones at home who waited for my return with confidence; I loved the company of the birds. And yet, even though they might be very different from those experienced in Beirut, terrors of the night are common on the Skelligs; the methods of dealing with fear and uncertainty described in the book I was reading are common to many human predicaments.

In all isolations, one must reach out to the unknown. The boundaries of my station were clear, impassable, and all too apparent. At times, I would open the door of the cabin in the early morning to see the sea running and high just beyond arm's reach. Usually this was a source of exhilaration. Sometimes, though, the sense of loss, of being uncared for, was overwhelming, standing to view the raging ocean just beyond my door. I knew this was not the case, but at the same time I would often sense the activities of sheer evil taking place at the other extremes of these waters spread before me: upon further shores, where these same waters were lapping, hostages were taken, beatings were taking place, the forced and brutal disruption of peaceful human life was continually occurring as a result of wilful ignorance, evil, and greed.

This divided sense of entrapment charged the air, the atmosphere, just as it enriched my appreciation of the simple things, the most basic of things, around me: the surroundings of my room, lit with the light from the charged sea; the mechanical mysteries of the Device, parked outside my hut; the little rock pipits wandering in gusting winds down the road, venturing in through my door to pick up tossed crumbs, transfixed by morning light.

~

This same year, events related to the island, as well as those occurring back on the mainland, brought change to the quiet routine of life. My mother-in-law was seriously ill throughout the summer, as was my skipper and friend, Dermot Walsh. Both eventually passed away in August. In a sense, an older order was passing. Dermot had been coxswain of the Valentia lifeboat for years and had been involved in dramatic rescues at sea. He would refuse to take visitors to the island if there was any hint of weather that might be difficult for them. He used different criteria for taking me, believing correctly that I should be able for brisk seas. So, a few times, we took our time making our way out in very high and rolling waves. I would be back on the deck by myself. I can still see vividly Dermot's back in the wheelhouse, swaying slowly, stopping against the crest of an unusually high wave, proceeding on. He knew exactly what he was doing and inspired utter confidence.

As I read Brian Keenan's book that summer, and as these events took place on the island and beyond, the descriptions of hostage life, of perseverance in utter uncertainty, touched me deeply.

21 June 1993

The sea is steady, raised high, spread 360 degrees before me. It lashes against the coastline beyond, regularly tossing great combs of white hair against the headlands, beyond which men impose the most evil of practices upon one another. Now, in the Balkans on the far side of Europe, but also, to different degrees, everywhere. Perhaps even within sight before me.

What is there for us here to do but to recognize death in all of its many forms? The depths of despondency are easily recognized here; they are evil, insidious. The monks knew of them, just as Brian Keenan describes them. Against these fears, the dramatic brightness, the unfolding of living colour, stands. That is why we recognize both the extremes: of brightness and of darkness. The jewels of all living things appear before me, unfold

upon the sky. But, for now, they tell me nothing: they glisten, shine, then disappear.

Last night, as I was fishing, I saw a seal follow my feathers as they flew through the air. She dived, surfaced directly before me, and was gone. She stared at me for a moment, fifteen feet away. There are flashes of unknown life rising from the water everywhere. On Saturday, on the way out, the dolphins followed us almost the whole way, leaping clear of the wake the boat's trail left behind, over and over.

On these back lanes of history there is always a different order of time. The razorbills break up their flight in departures from the rock: they fall away and forward from the cliffs, with four or five agonizingly beautiful drawn-out beats, falling down and forward in full extension, larger than they have seemed when perching. Suddenly, their flight rhythm sets in, their wings whirr, so that these wings are no longer distinguishable, and they are propelled quickly into the emptiness beyond. All opens up in moments like these, accumulating one upon another: new knowledge, new order.

Midnight. The Big Dipper rests in the crook of the South Peak; dragons spread bright and jewelled wings across the sky. The night is bright with starlight; four, five trawlers ring the horizon; four small crystals glint in the light of this purring gas lamp. A storm petrel is chirping insistently in the wall, in the dark just outside.

I plunge deeper into life here. I must dance the mad dance that Brian Keenan describes, that all are called to in one form or another: to come out safely beyond, to surface, to lose life, to gain it.

There is music everywhere within this cabin tonight. I went down with a lighthouse keeper this morning to tie new ropes at the landing. He told me stories of the riggers of Irish Lights, trained solely to set the ropes for derrick haulage, for the masts and outriggings necessary with all lighthouse activities on these offshore stations long ago. He told me of the old lighthouse steamships, of the original *Granuaile* lighthouse tender. He spoke of Joe Roddy's father, keeper of the

Inishtearaght lighthouse, who designed the engine for the little cable car system erected there, now sitting derelict in the depot in Dublin. And of one keeper at an off-shore station, who carved his own false teeth out of the ivory of Irish Lights knife handles.

27 June 1993

Earlier today, before dark, I climbed down the South Steps below the road to fish. The tide was extremely low, the tide-line along the rocks several feet above the surface of the water. It's been fogbound here for the past two days, and this great and enveloping grey cloud began to lift in the late afternoon. Right down there, at the level of the lapping and softly lit sea, the air suddenly seemed the freshest, cleanest that I had known for days. Below the fog, the odd trails of white froth, left over from the dying swell, wandered aimlessly ahead of me. There was the occasional flap from a passing gannet wing, a soft recurring, then dying, series of gunshots reverberating over my head.

Regularly, the surge would pull back from the rocks, exposing an underbelly of water, lifting the lazy froth in slowly swirling tentacles. Showing the bright red, the glistening slime green of the lower reaches of rocks, not seen except at extreme low tide.

It seemed as if the island were being lifted out of the water; then all would be covered over again. I'd flick out the line, watching it wander through the air.

This ebb and flow is carrying everything around me, undermining the sense of the solidity of the island, as I sit in this tiny lit box hut this still night. The midges wander in through the open window, the lighthouse beam flashes its bright white flame out upon the mist, and the sea sighs quietly, endlessly: pushing me outwards, then bringing me back in upon myself.

Brian Keenan writes of opening one's self right up, of a complete exposure. This seems very appropriate: a call to run myself through, to be skewered clear. All of the widow's mite is given away. This is the calling in the full sighing of the ocean out here on Skellig

Michael tonight. The idea of the monk in the desert, weaving straw mats only to undo them, springs suddenly to mind. Undo everything. Open everything up. You will lose nothing. Somewhere there are men and women tonight, sitting perfectly still, in the bowels of the earth, on mountain tops. It is easy to ignore them; yet they live. They sit there. That is a basic truth. We run back to what is familiar, we come back to what is necessary; still, they sit there. Doing what? Praying for the reorganization of the world? For us? All the deep rivers of connection seethe; they wind sinuously around the rocks before me, through the bottom places of the earth, at these low tides.

Soft forms of the storm petrels flitting by outside the window in the light. Pale moon upon the water; white fire leading somewhere far, far away; that sea road, as we stand here upon the very foundations of the earth.

29 June 1993

I read last night where John McCarthy begins to suffer from the overwhelming effects of his isolation, and he desperately seeks some form of help. Brian Keenan tells him to imagine a room, place two objects there, and then to begin to multiply the objects in the room, to bring each one to life, to give each one its story.

I look at the interior of my little hut; I study the knobs on the cooker, the lamp, the press, the marine radio, the bed. These are the essential things within this boxed space.

18 July 1993

News from shore; my wife's mother is in critical condition once again, in the final stages of fighting an illness which has left her debilitated for some time, and which she has fought against with great fortitude.

I read, near the end of Brian Keenan's book, of an unfolding vision of freedom, even when held within terrible chains and when undergoing tortures, beatings.

Interrelationships will push one beyond ordinary levels of meaning: I am pushed beyond ordinary sight this afternoon, sitting up in the monastery through the alternating rain and sunlight, sensing the borderline ahead, the sea sizzling in front of me, covered with the beautiful white wings of the passing birds.

1 August 1993

Today, three men rowed over in sea kayaks from Portmagee. At seven, we listened to the sea area forecast, which told of worsening conditions. My colleague Diarmuid and myself headed toward the landing to round up the men for shore, but they were in no mood to set off at that hour. Even though the weather and sea were fine. It was of course unwise to make them leave, as chances were they would not get ashore before nightfall. We were annoyed, as this timing had probably been planned, and it was decided that it was safest for them to stay (as they had always hoped to do).

I ventured to the landing at nine; they were drinking cider there and had themselves set up for the night. The weather was holding fine, but I informed them of the oncoming deterioration. They said they planned to set off about ten in the morning, before the boats were due. We agreed to communicate before their departure.

When I went down at nine, they were already gone. A very strong wind had come up, precipitating, probably, an early and uncoordinated departure. I was very concerned. I called the boats coming from Portmagee by radio at 10.30, but no one spotted them at all over the next several hours, even though the boats were heading for the island across the direct route the kayaks should have been travelling on.

At one, Valentia radio sent out a request for information regarding the missing kayaks having left the Skelligs at some time in the morning. We looked out across the eight miles of crossing, seeing nothing all the while. The sea was becoming quite rough.

Sometime later, they appeared in Keefe's Bar in Portmagee. We were told by the men at the radio station that they had got

a bit of a 'fright', that they had headed too far to the south, but that they were okay.

By that stage, we were watching the *Fionan of Skelligs* tossed around like a toy in the rough water.

———

Brian Keenan and John McCarthy were forced to make uncertain trips in the darkness of car boots to unknown destinations. They were never to know where they were. They wrote of the knowledge of contact, invisible but palpable, coming from far shores. Of the incredible strength obtained through this knowledge. And of the strange sense of freedom that emerged – though they struggled desperately for it at times – from the utmost depths.

After the kayaks were located, I walked through St Michael's Chapel in the monastery, with the white-capped sea rushing by below, and I felt I was walking with my infant daughter Lillian, communicating with her some thoughts in this regard, sharing them with her silently for her future. How we all fall to dust. How we are all nothing – but at the same time, as is poetically said, a 'little lower than the angels'. How life bubbles, seethes, rises, and falls on all levels, and how there is an infinite array of routes to be entered, and tied together, and set loose again; and how we must lift veil upon veil, which fall on us here. These are the lessons of this raised place.

Life out of Darkness
Consolations to be found within darkness are individual and strange. The most well-meant expressions of sympathy, or even of shared excitement, may fall on deaf ears, even when coming from long-known loved ones. I have known of the difficulties of broken physical contact during my time on the Skelligs; and I have also seen how a tangible but silent thing or action can be used to establish contact, and so resonate, deep within the heart.

When I was told to come off the island because my mother-in-law was dying, I had no time to make preparations. It was a sunny August day, and visitors seemed everywhere. I grabbed my things and ran to the pier to catch the *Agnes*. At the bottom of the steps, surrounded by the feet of passing visitors, a tiny ball of fluff was standing in the middle of the road: a baby shearwater, probably dropped from the mouth of a surprised passing gull, possibly a week old. His death was imminent, and there would be absolutely no way to find, or for him to be returned to, his original home. There was nothing to be done, and he was going to be killed unless I did something; I stuck him in my pocket.

Two hours later, I stretched out in the back bed of a truck whose driver I knew and who had offered me a lift for the ninety- minute trip to Killarney. I took the little bird from the box I had put him in and showed him the passing trees. I really had not expected him to still be alive.

For the next four days this little creature flourished on the floor of my mother-in-law's home. Lillian was three, and he would crawl very slowly over to her on the floor. The barman from the pub in the Arbutus gave me mackerel and salmon for him, which seemed just as OK as Skelligs pollock. This little creature was no more than three inches of weightless down on arrival, and he visibly grew in the house. My mother-in-law would watch him from her bed. One of her last nights, she wanted a Magnum ice cream, which she declared delicious. She sat up in the bed, watching this little creature from the sea brought for her inspection; she watched him, wide-eyed, entranced, savouring those moments.

The next morning they were both gone. My two children had lost their grandmother, as well as the little friend they had made. Before the funeral two days later, we slipped the little bird from the Skelligs into her coffin.

I am not certain of the circumstances in which the following happened. I presume it was towards the latter end of the season. I know that I felt lost and ill at ease; perhaps this was because of island events or because of news from home. On recollection, the one thing I can say for certain about the circumstances is that it was a time when I felt cut off from everyone and everything.

I was sitting in the hut, at my table, and looking at the black, blank window. The gas lamp and my fuzzy outline were reflected back into the room by the glass, emphasizing the fragility of this tiny cockpit, its precariousness within the great waves of darkness at work beyond, the arms of the rock embracing and overhanging the little suspended room holding dim light. Lost again. Hanging there. To what end? Incommunicado.

There have been many times when, sitting ensconced within that tiny cabin at night – as comforting as it can at other times seem – a great inertia, a sense of pointlessness, has overwhelmed me: when, of a sudden, mistakes, miscues, and careless actions I have played a part in have returned extremely clearly, just like the visitations on the steps. I speak into the dark night things, voices, names I might not have thought of, not to say mentioned, for years. A secret life becomes vivid in this purring lamplight. The great stretch of the soul's webbing can become a map by which I stretch far into the darkness beyond, far past the range of any night vision, connecting with, intersecting with, the fringes, the borders of other souls active, far away, crossing ways above dark water, to connect with yours, to co-ordinate with yours, to conform for an instant identically with yours, and then to move away. And afterwards, feeling immobilized; lost. And I sat there in the near dark upon some variation of this enervation, this sudden rising of the dark, a dark becoming a seemingly insurmountable wall.

A sudden fluttering against the window. Then, the quick unfolding, the beating of an orange light, a flame, caught by the lamplight. Incongruously – as natural events here generally follow

a set and predictable pattern – for the first time in my memory, a butterfly flutters against the window in the night. It is common to have moths in the room, and it can be a continual task to keep them from harming themselves in the lamp, but this butterfly was an utterly exotic visitation that night.

He was beating desperately against the glass barrier directly in front of my face, thrown by all of his resources towards the source of light. Desperate wings were forcing his movements upwards, and he slowly rose upon a meandering frenetic curve to the top of the glass and over the little timber rib separating the small opening panel at the top. This took about fifteen seconds, and the butterfly was sprung into the tiny cockpit of my room with me.

The strangeness of this exotic new friend is overwhelming. For moments, it flutters wildly about the room, larger than life against my face, heedless of me but unable to control its movements precisely, knocking against me and everything else in the room. Confined in a little room, suspended above the sea, lit within a dark night, following upon miles – hundreds, or from the shore of the mainland? – of uninterrupted flight. The light rising from the corners of the room, the cream and ochre shadows over the cooker and over the bed – these are all absorbed, explored, united within a trail of flight, leaving a glowing, flickering pattern of orange and black suspended in the cabin air in a rapid, if wandering, electrification of the room, bringing it into life. The butterfly rests periodically against the wall.

Within ten minutes, a second one appears, following the same pathway against the window, landing suddenly against the glass in a soft thud and almost immediately beginning to beat forward and upwards to spring itself upon the open window panel – a little panel only 8 to 10 inches high, but funnelling all the incoming air from the Atlantic into the room – and into the tiny lit space to join his fellow in an unstoppable and intricate dance, clashing against each other in mid-air, retreating into the darkness, hanging there for a moment, and then homing in upon each other again,

almost by chance: mostly, inexorably, beating for light and following some rite of movement only appropriate now, and within this tiny space.

And in their midst, and against their movements on this black night, more butterflies begin to appear. Two arrive almost simultaneously, following each other up the window-path. Suddenly, more are here in a stream up the window. More than fifteen over the course of a half-hour fill the small and lonely room, in a mostly controlled explosion of unfolding light – providing an illumination I've never seen before here. An exposition of a sudden arrival of life out of darkness, through hostile and overwhelming currents and charges that have been taken on in the challenge of flight to dance wildly against one another, and against the light, there upon that dark and late night.

A haphazard, accidental arrival: weather and instinct and light conspiring to draw in these singularly and collectively exotic and beautiful creatures. I am transfixed by the whole thing.

I run right through them momentarily, as they fill the small interior space, to turn off the second lantern in the room, returning to the table to keep my arm around the lantern there, to stop them from harming themselves near the flame. Beating them away for half an hour or so, I give up: I hook the lantern onto the ceiling hook just above my head in the upper bunk, still having to beat them away even as I lie down, protecting them from singeing the beautiful dustings on their wings of patterned black and orange. Still animating, charging, electrifying the room. Still swinging out, as if over the open sea beyond the window, above my strewn boots, books, utensils, falling in over the bed and lamp once again. These are the last things I see, the continuation still of this wondrous exposition of moving pattern and light, hovering and moving through layers of flight-paths drawn over the space of the room. As I turn the gas down, some of the butterflies begin to settle against the wall, still quivering, wings beating quietly, though now at rest. I turn the gas off, aware of my own

suspension within the darkness, covered by these instruments of flight, slowly coming to rest upon the walls around me.

I open my eyes a few hours later. Dawn has broken. For a moment, in the grey light of the room, the air is perfectly still, and the butterflies are scattered asleep on the walls of the hut. It must have been only a quick moment's observation, this seeing them in the early light at rest. Antennae and wings almost unobserved begin to quiver; one, and then another, and eventually all fall out upon the morning light in the room.

Within a few moments, all of the butterflies are awake, active, fluttering between wall and window, filling the room with their wandering firelight; resting, stretching wings out upon my desk, wings fluttering over my books, their lights firing back and forth again within the tiny space – much too tiny for fifteen butterflies, maybe more!

Almost without thinking, I open the door to the morning and on to the open sea beyond, the bright light. One butterfly immediately follows me out, caught by the draw of the magnet of this rectangle of open calling light, and hovers for a moment, wings transfixed and on fire just before me, head-high.

And then, as if a lever is opened or a switch is lifted, they are all there outside in an instantaneously rising ladder, shot upon the air of the mountainside, lifting in an instant high overhead. More than a dozen small fluttering orange flames, transfixed within the morning air.

Following heat, rising on white light, they are instantaneously far above my head in the sky. I see them jumbled together, a shimmering presence out and over the ridge above me, and then they disappear.

It is instantly as if they have not been here at all.

Different Signs, Different Signals

All things seem to come here over time, but in different ways. When I first came to the island, I was ready to receive hands

leading me in every direction: I would stand in the landing and swirl my arms within the teeming phosphorescence, watching the light swirl upwards from the deep.

Once I stood at the landing for half an hour as a huge basking shark slowly circled the perimeter of the cove, coming back against the step where I was standing. Close enough to touch. His eye staring up at me from deep within a different realm. The flesh inside his huge gills pink, vulnerable – the same pink as the exposed lower sandstone at water level within the cove – and large enough, it seemed, for me to be able to stick my hand through. He slowly proceeded, led by a huge open jaw, showing as a glistening white moon, ghostly over the water, returning right against the steps, right against me, for a half-hour. Marking a different time. This was the time generated by that gentle and inexorable force, basking shark time pushed up against my own.

Men had run up the road, saying there was a huge turtle in the landing. Basking sharks can sometimes double themselves almost in two, and their projecting tail and dorsal fin can appear, as the creature is so large, to actually be two different creatures. I had run down to the landing to see and had met this shark – of dimensions way beyond my normal ken – reappearing, coming close to me, eyeing me closely as I arrived, and each time he passed.

Around this time, the summer of the arrival of the basking shark, the first fatality of my thirty-four years on the island occurred. A group of foreign birdwatchers wandered from the path; one fell some fifty feet onto the road below. By the strangest of coincidences, a helicopter was temporarily parked on the helipad: men were working on the lighthouse that day. Within a few minutes, the body had been airlifted ashore.

People called over the marine radio, asking how we were, were we all right. The passing, the departure had been instantaneous; the accumulated breath on the island for a few days was taken away.

The next day, and since, visitors have passed the place on the road.

> I remember Carola Korta as I pass down,
> towards the landing on the lighthouse road:
> To meet a basking shark
> To meet a landing full of phosphorescence, as if
> the glowing there were illuminations from
> another world
> To meet danger
> To meet the sea risen upon a swell, rising high
> within the air

All these events were of immense importance to me on the island. The balance of survival came to be understood so very clearly.

At that time, two divers went missing in Skelligs waters. They had gone down for a half-hour dive, and on rising to the surface they had begun to drift away from the island. They could not be seen from any boats. It was a fine clear day. A message went out over the Coast Guard radio station, a Pan-Pan emergency call for lookout. Those of us on the island climbed to the monastery to keep watch, keeping our eyes peeled for the next hour, scanning what seemed to be calm, seamless waters south towards Beara. Eventually, we heard the drumming of the rotors of the rescue helicopter. We saw it proceeding far-off, south-south-eastwards, its bright lights piercing even from the distance and in the afternoon sun. Hovering over a point far away to the south, further than one might reckon that bodies would drift in an hour. Rescued. The chopper had homed in on a calculation of wind, swell and tide – local marine lore, developed over lifetimes along the coast and fed into this pattern of flight.

And while we sensed signals coming in from far away, from distant skies and invisible shores, there was little direct contact with the world beyond. Wars proceeded unknown to us: economic

turmoil, great upheavals in Russia and the east, events of global importance. We took these in as an old newspaper might be passed our way, at several days' remove. Or as suddenly one might arrive at the island full of shore talk.

Sometimes it almost seemed to me that what was happening on the island was of equal importance, equal validity. Or that occurrences in the wider world were completely intertwined, immersed within the events happening on the rock. A few sentences, brief exchanges, passing looks conveyed more than endless dialogue or discussion.

After tragedy, after every brush with mortality, after hearing of the horrors of 9/11, I would have to walk up the lighthouse road, close the door, see the surrounds of the little timber hut – hundreds of times over the past decades – and know that feeling so many know, of being stuck there, in myself. And knowing that this was the only laboratory available to me, to take in, to understand, to reflect upon what had happened. A strange combination of claustrophobia and isolation and euphoria developed its own regime, its own way of life, over time.

I was going up and down steps to a place with a far lookout, carrying handfuls of shining light in my hands, sculpted by experience, with very little in the way of external commentary on my actions, thoughts, or movements. I would strike out, again, upon the island.

And there was always a desert spreading out just beyond. There was always the returning emptiness of self: hollowed out, scorched, ready to speak. There was always the full flow of energy, the riding of weather over the rocks here. There was always the search to source this flow, this whisper of passing in the dark.

~

Once, a few years ago, a white-tailed eagle rose above the monastery wall just above my colleague's head as she was standing with

her back to the sea. I was on the other side of the monastery when he appeared. I know eagles are not that unusual elsewhere, but most Irish people have never seen one. As the bird rose above her, she let out a wild scream. There were maybe ten people in the monastery. The bird slowly circled around us, just above head height, its bright talons, tufted claws, clearly visible. You could touch them, too, it seemed, as he flew so low above us. He was curious. What would the monks have made of that? Slowly – interminably, it seemed, though actually only for thirty seconds or so – he soared above us doing a circuit of the monastery; then he headed out toward the Little Skellig. A handful of crows and gulls went mad around him, harassing this much bigger bird as he slowly soared towards the east, apparently unperturbed. Then, for some reason, he stopped in his tracks and turned back towards us again, as if with unfinished business. After a brief turning our way, he headed off, straight for the mainland. All in five minutes or so.

Then, two years ago, an albatross suddenly appeared in the skies over the island. Another eagle followed me down the road as I walked to the landing one day, completely unknown to me. A colleague observed him swooping down near my back as I went down the road to the sea.

All that is required is one moment of exposure and the heart is opened. That is all that it has ever taken. The dangers are always there, and all too real. We remember and take to heart – and sometimes speak with, in a way – those who have fallen. The island is still regularly cut off. Regardless of all plans, it remains for the most part empty, a glistening dark form on the horizon.

Here we must work upon what happens, on the simple things we are given. We see gannets, eagles, albatrosses, sharks, petrels, razorbills, and we hear the gunshots, know the torture chambers, experience the violence lowering in the sky, just beyond the horizon. Murders take place here. Acrimony. The horrific tales of paramilitary violence, of random acts of hatred. All that is

humanly possible. We tell ourselves new stories made from these new characters, these new events.

The panoply of life, of all things living, glistens ahead on the road, in the niches of stone, as the gusts rise higher, all melded together under the sweeping hands of the elements rushing by overhead. The elements becoming alive and taking on light. Making a place of dissolution. And all personal time is split open here.

CHAPTER SEVEN

A Vessel Suspended upon a Far Sea

People can begin to feel their balance shifting even on first setting foot in the boat. The little vessel tosses its way out through the channel towards its rocky sea-gate, after which it turns to the south-west to face two stark pyramids on the distant horizon. Ninety minutes after crossing over open ocean, unsteady feet clamber onto a concrete pier: a green gully rises steeply above; a dark cove lies immediately ahead; birds circle and scream loudly in the tiny isolated pool of bright light. People speak of feeling that they can fly. As one climbs, the sense of the land dropping away on all sides, of it disappearing altogether, intensifies: land gives way to sea and air.

Thin veils of mist hover within the ravines and outline the ridges that stretch above the steps. Shifting light becomes a prism through which the island is seen. Changing light sets the place adrift across an endless sea of spirit. The mainland dissolves in the distance. Relative distances between islands, and between the headlands ashore, disengage completely, lost within the grey haze of changing light.

In the late evening, as the sun has begun to decline behind the cliff-face that shelters the monastery at the top of Skellig Michael, I have seen the light gather in pools on the deserted pavements

and avenues by which the place is ordered and arranged, and seen
the stones partially liquefy within my mind's eye, seen them run
together, covered in a sheen of white gold. Little birds bathe in
the overflow of rainwater there, sending bright showers high into
the air. The sea can bellow underneath the monastery, yet the little
showers thrown upwards by pipits, scattered upon the stone plat-
forms, ring clearly as bells; their tiny fountains form perfect
concentric patterns on the ground of the monastery floor. Soft
light in this confined space gathers in rising waves as the sun declines
and light streams into the monastery; this light tumbles from ledge
to ledge, stretches along the main pavement, climbs the wall of the
deserted chapel and then – over the course of a half-hour in the
late afternoon – pushes shimmering rectangles of pale yellow light
deep into the interior darkness of the central oratory.

The platforms glow in soft light in the late evening. Shafts
of light stretch and retreat, alter shape and angle with the sun's
slow decline. The light gathers in pools, quivering in sudden
illumination, tumbling and pushing over empty avenues. The
monastery floats, hangs upon the air; bird-flight cannonades
overhead in the restricted airspace; the surge of the ocean is
constant far below. There is isolation, as if a curtain had suddenly
descended, cutting asunder ties with all else. Within this atmos-
phere, invisible bands of pale grey light cling to every turn of
the outline of the rock.

Monks suddenly walk within a cloister again, as gannets spiral
overhead, circling above a shoal of mackerel and veering towards
the sister island, Little Skellig. By their sheer exuberance, these
lines of movement are almost visible. And when these lines are
withdrawn – when imagination inevitably lapses, flickers, and dies
– then there is utter darkness.

Extremes of motion, pendulums of swinging light – leaving a
trail upon the air, a mark upon a stone, a vanishing internal
register – repeat themselves: their effect increases and accumulates
over time. We read of the old monks, and of how some of them

were said to have prayed in the same spot over many years. In some cases it was said that light came down to rest upon special sites within or near their monasteries, places that became sanctified and holy because of the monks' prayers there. Angels were said to gather over such holy sites. On Skellig Michael, I come to know how localized and continuous rhythms conspire to support separate realities; how the profusion and diversity of flight can make networks in the sky, lifting the spirit over distances.

And then desertion, emptiness.

Shifting light, appearing and disappearing within the island, swinging powerfully through the corridors and up the ravines, affects all who stay here: the flow of light rises, captures, animates all spirits; then, this charged light disappears. Then solitude and emptiness fall heavily upon these stones and within the heart.

Over time, a map of the island began to direct my movements and thoughts. The terrain of the island became internalized, as I wandered over its steps and pathways. The island was opened and exposed for me over time; and my soul correspondingly was opened; and the two intertwined and became a vessel, set upon a far and distant sea – the same vessel all souls become, and are rendered into being.

I was beating an ancient track, but anew. The rock would divide around me, throwing me always out to its extreme points: to the pier, to the edges over the sea, the empty skies over the saddle, to the lighthouse and around its ruined further access route, to the exposures of the monastery and of the peak. I was internalizing this active terrain, trying, almost without thinking, to understand and see its ways as conduits for the thoughts and activities of the soul. The soul's ways would reach ahead and beyond me, out upon the island's solid pathways, which were gleaming ahead in afternoon sunlight.

I sensed a different order of things, always just on the verge of realization, in the sunlight gathering on the terraces in the late afternoon, as I scratched and scraped at the weeds between the stones of the monastery and along its little avenues. I saw the light building, gathered in the cups of worn stone, developing its own currents of movement, suddenly cleared away in great descending gusts of wind, or in downpours, or passing storms, and inhabiting the spirit of every passing thing. The elements, gathered in that emptiness, would strike through me from a height straight to the depths of my being, in order to balance it there, root it there, make it live there, over and over and over again. My time was made new; its intervals were divided upon new lines. Everything seemed to be falling in upon the rock, the monastery, and the heart there; every current found on earth was conspiring, funnelled through empty doors and windows; the rock was churning on in its journey out to sea, carrying me aboard. These were the transportations of the light, being drawn up upon a high place.

Often I sensed that I was being led up the stairs, pulled up to the peak, led out to the island – and not by any person, or personalized force, but by the emptiness ahead. Taking form, beating against the great wall that had reared before me, all of my life.

Breaking it down to see emptiness, clarity, open vision.

Over time, the routes I came know on the island would assume their own character. The portal of the landing became extremely significant, and I needed to learn its moods and character well. Sometimes hours would be spent trying to judge whether the landing would be safe a couple of hours later; whether it would be permissible to make a relief call, to let the crossing go ahead. If the crossing was important – if someone was ill at home, if

someone on the island was not well – and conditions uncertain, I would watch, at different times of the night, to see whether a swell was dying as had been vaguely predicted. Nowadays, there is a plethora of 'certain' and 'fail-safe' websites, but their analysis does not always indicate just how the waves will turn the corner to the north of the landing and whether or not landing will be safe. The Skelligs landing, I would come to know, expresses itself in many ways and is not easily interpreted. The small entranceway to the island can shift moods.

Each day, I would open the door, look out at the condition of the sea, walk down to the landing to see if it was fit, return to the hut, and prepare to rise up the mountain.

I would climb from the huts and rise the first hundred steps, coming out from the shadow of the rock and onto an open space where the Wailing Woman stands – one of the ancient Stations of the Cross on the island, bearing an uncanny resemblance to a human form, jutting high above this little promontory. From here, suddenly, the open sea on three sides ahead stands clear. From this place I would be stretched, grabbed, pulled upwards by an inversion of vertigo, inertia, wind, light, and some internal gravity, or centrifugal force, pulled into higher light, to an open and less fettered vision.

I would sense my spine stretched in the air, dragged up along the reaches of the stairways overhead, almost suspended above the island. The closed circuits of my thinking and breathing and seeing would appear opened, as, on the one hand, my own inconsequence was made so clear, and on the other, my life became for a brief set of moments intricately intertwined with the life of the air: the birds were almost running through me, taking a part of myself into far distances, then returning them again.

These brief epiphanies would be repeated daily until I would sense the current of my own flight churning ahead through empty air, in some human approximation of a fulmar's suspension upon emptiness, drawing me up and down within its slipstream. I could

not help but sense this close association with the emptiness beyond. I knew that isolation and removal could affect the imagination. People, spirits, arrived out of the air; birds spoke; I would learn the mathematics of things materializing out of an empty sky.

I would arrive, then, at the open expanse of Christ's Saddle, and it was if I had arrived upon the central axis of the island, standing upon a stark crossroads, the sea stretching north as well as behind, the two peaks of the island rising steeply on either side. Standing at the heart of a compass rose, and my own heart planted there, day after day, year after year.

Tarmon

Suddenly, at Christ's Saddle, I was penetrated with light and air and wind, rising over the crest of the valley and on to the central crossroads of the island. The fulmars would sail by over my head along different planes of flight, reaching up to the ridges directly behind the monastery where I had watched them, even from my very first days on the island. I would see the Blaskets stretch ahead; Beara and the Bull behind me once again, reminding me of the connection of lights, spanning far horizons, for ships at sea – of that network of silent communication casting beams upon the darkness for more than two centuries, reminding me always of my exposed and vulnerable position.

The peak twisted behind and over my head to a dagger point. And I would be surrounded, and upheld, by two great wings of rock. At times it seemed these pinnacles lost all connection with the sea below, that they might float upon and above the entire extremity of the continent, subsiding slowly to a close from the east.

My feet would rise up further steps, up the narrow way and precipitous last flight to the monastery, exposed to the winds whipping against this last unprotected chain of masonry, and then I would know an immediate change upon entry into the Monk's Garden. I would arrive there after a windswept climb to see whether it might

be safe for visitors to travel. In the early morning air, surrounded by wind and mist and perhaps with no visibility at all, I would be suddenly nowhere and everywhere.

The platforms, built as they are in the air on man-made terraces, can seem disassociated, even from the supporting rocks directly below. All places, all time, and all events of personal life can of a sudden register here, and be quickly drawn out once more in the little quiet spaces along the dimly lit avenues. All things can be remembered and imagined; long-forgotten events may be revisited, exhumed and exposed along the scuffed flagstones beaten by the feet of thousands of visitors and other travellers and pilgrims through centuries. And now, these comings and goings, bound up with the passing of feet and time, would come to leave me stripped bare, high above a roaring sea below.

~

I had to balance along suddenly appearing and intersecting lines of memory, experience, and awareness, drawing out the boundaries of my soul, attempting to keep the boundaries of my life open so that I could breathe here, so that I could function in this different air.

Here, the monks made their own 'tarmon': their sanctuary, their safe haven.

I have mentioned the secret places that I explored during my first years here: the monastery, the road behind the lighthouses, the bottom South Steps where I fished, the cove at the bottom of the North Steps, Blue Cove, the East Steps, from which the Little Skellig would hang suspended in my arms. But the secrets of the monastery were always unfolding before me.

The monastery actually floats. As it is built upon man-made terraces, when I enter, I am standing far above the actual and natural fall of rock. It is as if the ladders of stone I have climbed have brought me into a solid place that is suspended from above,

not supported by the earth from below. These monks wanted to be isolated, close to the heavens, cut off from the world. Similarly, St Cuthbert, on the Farne Islands, built a hermitage, or a 'small city', as it was called, where he could see only the sky.

The different atmosphere, and the isolation, play tricks here. I have stood on the paving stones and thought that if they were lifted I might see the ocean directly underneath and far below – something that is of course impossible. There were old stories telling me that the birds would not fly above the monastery, as it marked a holy space. Another told of water from the well, or cistern, on the Skelligs left outside the oratory at night, magically filled with wine for Mass each Sunday morning. There were legends, too, of a tunnel directly under the monastery, leading straight to the mainland far away.

The monks had to be practical. They faced severe physical challenges: the place where they established their community, though high above the sea, is actually one of the most sheltered places on the island, perched and protected below the ridge of bedrock. It is often in stillness (unless the more rare easterlies are up), even as the fulmars dangle against high gusts far overhead, dancing in the updraughts lifting over the cliffs behind the stone buildings.

One can struggle up the steps in south-westerly gales, fearing for one's life, as the side bursts of wind push crazily in a thousand directions, only to then find that a finger of the wind has been caught between pinnacles and is knocking from a different direction again, falling across the way in short but searing attacks. Visitors often ascend and descend sitting down in places, thrusting up and down, frog-like, on their rear ends. I, too, have many times resorted to this.

The shelter upon reaching the monastery, though, is felt immediately. In strong southerlies, leaning over the supporting wall, it will actually rain upwards there, and against me, instead of falling down naturally from the heavens. On stepping back, the shelter is sensed once again.

To the monks, the ground within the enclosure was holy, sanctified, a place where normal conditions did not apply. After all, water was changed to wine there, and angels descended over spots where men would pray.

The cells are corbelled. They are built on platforms of flagstones hewn from the rock of the island, suspended, and upheld, by the massive retaining walls. The paving stones, though worn, glisten in the rain. The light shifts upon them over the course of the day. Though the place can seem ragged and dishevelled, it actually comprises a tightly woven, intricate lookout, opening upon the deep beyond.

Corbelling is achieved in a gradual layering of stones over an open space. No mortar is used. The domes rise upwards and inwards very gradually, in order to close over empty space, and they are almost woven together, quite tightly, into their characteristic beehive shape. Some have fallen in, in places, and have been rebuilt on different occasions. Even though they have been worked on over the centuries, they retain a strange integrity from antiquity. At least half of them have seen very little extra repair work. Inside, in what can at times be a profound darkness, the domes seem to stretch upwards into the heavens' emptiness. Pinpricks, beads of glistening damp, become starlight.

Even though the entire space is restricted, hours can be spent there, moving over the little avenues, up and down over pathways of levels between terraces, and delving into the darkness of yet one more darkened room.

The cells are spread in a semicircle against the slope of the rock. What are supposed to be dwellings, five of them, all face southwards. The main axis, the little 'street' of the compound, runs between the largest cell, A, and the main oratory, directly in the centre of the monastery. From the anchor of Cell A, which has a loft, I can see the South Peak to the west through the highest window and then turn to look directly to the east through an opposing one: on to the Little Skellig, the mountains of Iveragh, and the holy places of the continent far beyond.

The oratory is placed directly in the centre of the platform. If common tradition was followed here, the monks would meet in this central structure regularly to recite the hours of the day. Before the entrance to this place of prayer, there are glittering paving stones of white quartz, quarried from elsewhere on the island, setting apart this particularly holy place within the site. They glisten and sparkle in sunlight. An early poem, dedicated to St Michael, speaks of how the 'twelve' should have organized themselves for prayer in a place just like this: six on the north side, six to the south, singing psalms, reciting prayers and liturgy responsively. Beyond, there is a little raised graveyard, and then the open sea falls ahead.

The High Cross, standing in the middle of this space, marks the progress of the sun across the course of late spring, summer, and early autumn. An emptied soul will be reseeded here, appropriating the rhythms and movements of light that have been brought into focus by the design of the island – by its height, its isolation, and its plan – in such a way that the shadows and orbits of movement are caught, and captured, in the eye of anyone who is alone here for a brief while. The light falls before me in narrow darts, is shot at shifting angles through windows and between the domes of the cells, and I am opened to these silent movements, sustained by them while walking what is the only thing like a cloister here – the narrow pathway circling the monks' graveyard, in the part of the monastery most exposed, the furthest out upon the air and over the sea. I must work out my life on a stone platform over noth-ingness, sending up prayers into the high empyrean, up into the nothingness above: for my loved ones, for those imperilled, for all of us. Learning the lessons of empathy from containment, from loneliness coming to confront a sense of pointlessness, and, beyond it, coming to understand the natural geography of the place, stretching me out over wastes beyond and into far, distant places.

How many times I have walked this way I do not know, but this rough and irregular and narrow route is inscribed very clearly

in my mind, the monks' graves on my right and the open ocean falling away to the left. Some rhythm, some motion is established here by which my vision is cast over far distances.

Some deeper identification was always tying me within the different levels of the island – in a justification, an understanding reached by attempting to establish continuance here, binding the layers of rock within myself. Re-establishing, participating in a further lookout; learning its ways, discovering even a different chemistry of breathing in an altered atmosphere.

Knowing that when a map is made and inscribed, travel becomes possible. Knowing that when an internal balance is struck, registered, however briefly, forward progress becomes possible.

I came to know, as second nature, the shapes of the cells; memorizing, without thinking, the different structures: the oblong of the main oratory, standing directly in the centre of the monastery, with the High Cross to its north; the little oratory terrace, built by itself, housing a small separate place of unknown dedication. Cell A, the largest cell, its doorway giving way to the main avenue of the monastery ahead, in an opening leading directly to the oratory door at the opposite end and twenty paces away. The high dome of Cell A would circle into the dark over my head, having been erected as a combination of corbelling and balancing against the steep incline of the bedrock: making a shell, a spiral, containing both bright light and dark, with its windows strategically placed so that moving light would roam through its interior. And the Little Skellig was always in focus through the windows overhead on the one side and the South Peak on the other.

After some time, the interior of this particular cell came to reflect for me not only the interior of the soul, but also, in some physical, tangible way – in its darkest nooks and crannies, in the sudden revelations and sweeps of light – the movements and activities of the skies overhead. And the air inside came to move in song, tearing my soul open, rendering it there, as all music may do. So that, in the interior, the light would live, and empty my soul at will.

And though it seems strange to express, I was led on here –
somehow ripped open, slowed down – by the progress of light
across the stones at this highest place. At each climb here, the
soul might depart into thin air.

That strange moving music of light I heard here brought me
into the cells, which at first seemed dead, silent, empty. Over
time a map was drawn, indicating the depths of the cosmos;
inscribed, implanted here, enlivened by the beat of every heart
stepping within this often damp, uninviting place. In a continual
transformation of that light.

9 September 2006

Up in the monastery, all is quiet, the mist whirring by with
little fingers, the oratory opening to the mist. Even though
it is day, the interior of this darkened dome is spread with
constellations of glistening light. Each little panel of stone in
the outer courses of wet masonry bristles in the light, just as
the mussels shine, aglow, stretched along the lower reaches of
the pier at low water. As the tide withdraws at the landing,
they crackle and fire silently upon the air. There is all of life
to play for – here, every day, along the heights and depths of
this island, in this strange music of moving, and then held,
light that is weaving in and out within the labyrinth of the
stones.

We go down into the silence to find things; we find that the
silence is alive.

And here, this evening, upon the empty platforms of the
monastery, all is imbued with the magic of soft colour, colour
which breaks in prisms through the mist, dancing through the
soft damp and within the grey and wet which plays down the
avenues and over the walls of the cells, and is woven within the
fog hanging over the water far below.

Images come and go suspended in this mist; they become
briefly real, then they pass away. The things they represent may

be distant, but the vividness of images depends only upon how they pierce the heart within this deep silence.

> As the first petrels came to the cells on Skellig
> Michael,
> The light fell through the veils of gossamer,
> Resting lightly upon shifting heads,
> Gliding over white avenues, suspended
> In glittering iridescence upon emptiness;
> Giving an edge, a surface, to walk over
> The dark, where light might briefly
> Hold, even by the simple turning
> Of a human head, or through a gesture,
> Or by the passing luminous extremities
> Of the birds moving above against
> Empty light, into a comfort of landings –
> Those little friends which wandered into
> The cells at night, beginning to settle there.
> Beginning to bring the distances within.

16 September 2006

White ridges of angry froth rear from the grey curtain of the sea beyond this rain-spattered window. The wind buffets the road; the gull stands on the outside wall pointing his head at the oncoming gusts, his feathers tossed in an electrical current which shifts upon the outline of his form, in fibrillation over his dark and inscrutable core. He gathers all the shifting light within. Now his chest sinks upon the wet wall to rest, his legs are tucked underneath himself, his shrunken body dims, white-grey, almost transparent upon the snaking line of glimmering flagstones.

His time stretches outward endlessly in this no man's land of weather. Keys rattle against the doorway, the temperature drops within the boxed huts; the light rises in pale white transparent sheets within my small quarters.

My own time is an accumulation of these things. My time is an engine working upon them, grinding at them.

Another gull materializes out of the storm, flailing violently just above the wall in a great effort to control and settle its feet in touching down, attempting to gather itself so that it might briefly rest. The bird shines by a ghostly light of the same frequency as that of the mist beyond. He hangs, suspended briefly, frozen in the air for a moment, then dispersed upon the arm of mad wind to fall out upon the raging elements beyond.

> We too will spin to the extremes
> Of existence, toward the edges
> Of what we can know,
> Finding there fluid light
> Dancing upon colour and line,
> Lifted upon the risen sea,
> Distilled in small beads
> Of quivering water upon
> Our hands and windows, in what
> Is breaking out everywhere here.

> What we see changes:
> Here, along the roadway, light becomes
> Perfect, snaking within verges at furthest
> Places, held within stone troughs in living
> Rivers: setting free the light of an abandoned
> Place, whose light will always return
> Upon itself, so that it heats to the
> Point, so that it becomes briefly visible,
> So it is held, alive, within our hands.

I finger the flight of the gull as it crosses before my window. Shapes are reduced in the mist, leaving only the lonely cry of the bird. This cry is heard reverberating along the perimeter of the

island; there is nothing else to hear or see. Here the light rises as if it had great hands, reaching along vertical shafts, into bends along the contours of the rock, sometimes quickening over little pools. The pools shift along, lanterns suspended along elevated, empty plinths. The wind sculpts shapes from the light and seems to drop them upon platforms and into crevasses where they take on further form. I rise along the steps, sensing other presences with my fingertips: spirits of people far away are present for a moment, then they disappear. The houses above – built by prayer, dedicated to contact with the beyond – are shaped themselves as vessels, and the whole rock bristles with movement. The air shifts in gusts, weaves along the platform of the deserted cells and travels out to sea, moving towards the mainland.

24 August 2007

Grey wedges of sea-cloud;
Thin fingers of land, far to the south,
Unfold pale gems within this shade.
In obscured light, lines to the mainland run
Unusually clear, steady. The light is polarized:
Filtered from life through a silent afternoon.
Far hills stand bare, unpeopled: each ridge is
 now
A stripe ready to shape and support new life,
Each plot of land unfolds in new livings we must
Plumb. We must place our hands firmly
Upon that emptiness beyond us, absorb move-
 ment
Within the turbine of the far deep earth, so that
Our dead skin will peel and be stripped away.

I know that the land beyond looks no different than it did a thousand years ago.

 I stand in the centre of the oratory, my eyes closed, and slowly

I am swung about in the darkness, held within the arms of the
dome which surrounds me: first slowly to the right, then to the
left. A bell of prayer rings: silent, pealing rhythmically, holding
everything, everyone, within its outstretched hands, within its
silent tolling. A bell of greatest amplitude: the strands of this music
whisper quietly, profoundly through the empty platforms. Just
outside, on the pavements, the birds dance furiously in the wind,
toppling over at times. The light flashes, changes colour in quickly
shifting atmospheres; it can turn blood red. Every stone placed
here, and over which these colours and this silent music run, is
sustained by the efforts made over a lifetime. Many men's efforts
react in unknown ways in these dark spaces between the stones.
Their efforts reverberate at a high pitch. These efforts are the
portion released in giving everything away, the total abandonment
which stands behind setting the stones in place, of sustaining them
in their places. I hold in my hands here the people I know; and
I have to release them, over and over again, into the emptiness
beyond.

29 August 2007

Torrential rain pouring off the mountain down the gullies and
drains. The whole island is an engine: balanced, charged, and
wound within a great clock of water, shunting between different
levels and speeds. Pockets of brighter grey cloud shift quickly
southwards. The sea teems, brims over, turns in front of me; gusts
bring up white heads upon the wavelets as they cross from the
lee. Just beyond, there is a pale silver swirl on the water running
from the loose orbit of the rock, changing shape beyond the dark
line of the tide, moving slowly southwards.

Thin white snakes of water are reaching down the ravine below
the monastery, falling beyond the last rocks of the terrace for a
hundred metres in free fall, obscuring the pier below, hiding access
to the island, casting a veil upon the place and enveloping the
heads of the kittiwakes as they wait below, resting on their cliff-

edge nests. What is moving behind this thin shifting veil of water, suspended just beyond the contours of the rock, glowing within the emptiness there? The island tightens beneath and behind this veil; it becomes another place, a different field of action; the rest of the world vanishes.

> Those crossing from the mainland knew
> That their lives would be hidden here,
> The place would be cold and exposed
> To storms. Some had read and knew
> Of the frozen north, of ultimate places:
> Of such states of mind. They prepared,
> They changed even their names looking
> Toward an arrival, and when they looked
> Out, when the winds came, they knew
> That they must cover each
> Frozen rock with heat flaring
> From their shared language
> Of prayer, love, desire. Fires
> Began to burn along outcroppings;
> Stones glistened upon human touch;
> Rough trails were etched over the cliffs.
>
> Then their little boats pushed to other
> Uncertain landings. And the first night,
> Sleeping upon cold stone, they knew:
> 'We are here at the hard wall of the sky.
> It winds its way through Egypt, Scythia,
> Europe, and through very time itself, along
> Boundless seas which lie impenetrable
> Before us here. And we know the demons
> Which haunt these walls: they travel
> Along the ramparts at great speed,
> Encircling us to declare grim sieges

Of welcome. And we cannot ignore
Them: we must batter the wall of the wind
As do these small birds before us we daily
Feed with meagre crumbs, with fish offal;
We must learn every dodgem, track of sky
They follow, write their trails within,
Watch our hearts expand as lizards might
Upon the stones bathed in cold white light.
To heat the earth below; warm, incubate
Roots of movement: the roots of light,
Searching, released upon the open air.'

The monks made their first landfall from uncharted waters, such as the ones which stretch before me now. Thin lines of haze suspend above unusually stark, pronounced ridges – of the hillsides to the east, marking Beara, the Bull, Scariff, the Blaskets – this afternoon. Mist descends upon them and they disappear; the island is cut away once more. There is no one anywhere. This cell is hidden now just as the one the hermit took upon the peak long ago, invisible by day – perhaps at times his dim firelight glinted over the sea by night. The gannets slowly pull the island around westward on their long golden strings. It goes its own way. We live in a small sunlit terrace; to anyone ashore it is an empty rock.

23 September 2007

White light: a great white light circling out towards the horizon again after a cold, wet morning. The door stands open, and there is a wall of silver seething water rising to the horizon beyond. My colleague goes out to feed the gulls, their calls and cries descending out of the emptiness overhead. I see her, and the flocking birds, black in shadow against the strength of this light, moving and separating in a shifting series of shadows, converging beyond me out upon the stone roadway. The flakes of the crackers she is feeding the birds briefly catch the golden light as they fall

onto the wall separating the lighthouse wall from the sea beyond. Then she goes back in, her glasses glinting in the light for a moment. Now the only movement is that of a little rock pipit dancing along the wooden porch.

The only other creature here is the Manx shearwater resting in a box at my feet. I found him along the roadway under the canopy this morning, perfectly whole but weary and disoriented. If he recovers equilibrium, he will hopefully fly out on the sea tonight.

He reminds me in an indirect way of how we have been gleaned from the water, of how we have been thrown here, and of how we have survived storm upon storm. How we have remained here. Little messages from the world beyond are stretched out upon the table before me, little items of newsprint. A copy of a newspaper appreciation of Canon Robin Richey, sent to me on the post, reminding of my friend who knew 'no borders', serving a God of 'no borders'. And all borders fall apart here, as we are engulfed by, and stretched over, the rippling tides of light and water. We are led to a space beyond where spirits fall, cross before us, and are regenerated, to appear again from nowhere. We see the spirits beyond, standing in whorls of light upon the air outside, beyond and above the still sea. We see their faces form ahead of us.

What spirits? Those that tear the ocean apart along its open seams, those turning and plunging in the depths below. Those which lift open the stones upon the platforms above to reveal the darkness of the rock underneath. All of the events, the persons from past lives, come before us now, set to confront, entreat, engulf us.

> From this place spirits travelled alone,
> Despite any training, regime. They took
> Their way out as vagrants; the birds
> Crossing upon a wilderness beyond
> Solid ground. Their movements seemed

Aimless, honed towards mere survival:
To follow fish upon desultory,
Changing routes into far extremities,
On chemistries requiring distance.
The spirits of this place
Moved out upon the great lit wall
Of the horizon; the fountaining air,
The oxygen, continuous there. At every
Departure taken, quietly, and undetectably
The earth would shake. For there, these spirits
Intertwined themselves with the white birds:
Expelled from the rock, they were flung directly
Forward. At the very departure of the Earth
From its own atmosphere, at a place
Ahead and above the last point in view, each
Bent itself forward, creating shadow, a mooring:
The light onstream, continuous, the soul now
A sail in rigging, a mesh of congealed wind.

CHAPTER EIGHT

Architecture of Light

For many years I have had the privilege to observe light steadily passing above and through the monastery of Skellig Michael, high above the ocean upon this mostly deserted rock, eight miles out at sea. I have seen how the light stretches over the platform terraces and avenues in a series of regular progressions, following the daily and seasonal rounds of the sun. Over time, I have come to sense that an awareness of the rhythmical movements of light within this isolated and confined space is inescapable: as inescapable as an awareness of the movements of the birds in the surrounding air.

Alterations and renovations may have taken place here over time. As far as is known, though, the most basic plan of the Skellig monastery remains as it was in the twelfth century. After this, the community of monks seems to have changed, conditions on the island may well have altered, and a removal toward the shore was undertaken. If these buildings have retained their basic outlines and alignments over the centuries, then the progressions of light that I have observed over the past thirty years must be very similar to those witnessed by monks over a thousand years ago. The shafts of light that suddenly appear as the sun rises or sinks across a window or doorway, as well as the arrows of

brightness that snake across the monastery floor throughout the course of a day, will still follow the same routes as long ago.

The monastery evolved over centuries and represents a tremendous technological accomplishment. This is obvious, considering its precipitous location and the forbidding topography of the island. It seems almost certain that the structures within the monastery were positioned and aligned intentionally, even if the enclosure developed over a period of time. In some places, it is clear that a great degree of effort was required to bring about precise orientations. Light is not simply brought into the monastery in random fashion, it is channelled by the positions of doors and windows. It runs and spills over within the confined avenues of stone. In a way completely different from a Gothic cathedral, the Skellig monastery is a temple of organized light.

I have been free to spend a considerable length of time within the walls of this monastery, and I have found it impossible not to be aware of the movement of light there. But I have especially observed this movement of light in the largest of the beehives, Cell A. For the past thirty years, in late September – for a few days before and following the autumn equinox, and around the Feast of St Michael – I have seen the late evening sun rise along the interior walls of the cell and implant its light upon the lower stone above the doorway. Just before sunset, a small square of light rises and rests in the space between the two lintels over this door. I was overwhelmed when I first began to understand what I was seeing and to realize that I was sharing a visual experience with monks who had used this cell centuries before. My apprehension of space and light upon the island was utterly transformed.

In the second half of September, in the late afternoon, Cell A comes alive with moving light. Shafts of evening sunlight rebound upon one other; veils of green and white glisten upon the walls enclosed within the darkness. The interior of the corbelled dome is clearly visible high overhead when low angled light enters the space, and coloured ridges of rock will rise suddenly in sharp

relief out of the damp and dark interior. In the early 1990s, I began to notice that rays of light cast through the western window would spread over the floor ahead, move across to the eastern entrance, and rise along the cell wall, just north of the doorway. Over the course of an hour, these lozenges of light would creep upwards along the wall, disappear through the open space of the doorway ahead, and then rise onto the lintel. Then, finally, this light would rise a little higher into the cavity of the 'light-box', directly above the doorway. This rising continued in a steady progression, moving a little northwards every day, throughout the last two weeks of September: a time when the light was otherwise dying on the rock, the days were shortening, and the birds had mostly departed. Over the course of a half-hour, light within the cell would become radically changed, and the cell would be beautifully transformed. An indelible mark was inscribed on my mind's eye by the progress of an arc of light within that remote, dark chamber. This fine ray of moving light penetrated my personal interior, as well as the interior masonry of the cell.

My thoughts during these September afternoons turned to other cells: to those far away, in Egypt, where the Desert Fathers secluded themselves before monks ever arrived on the Skelligs. Stories were told of monks of the east, hidden deep within the darkness of their desert cells: it was said that they engaged with demons; that they fell, during their life of seclusion, into both despair and ecstasy; and that, partly because of their struggles, they were given abilities to heal. Their desert homes were said to be centres of spiritual power. On the Skelligs, as well as in the desert, monks moved within dark interiors and upon remote terrain. And the monks in Ireland would have known from their reading, and through word of mouth, of the life in the Egyptian cells.

I knew that I brought my own late-twentieth-century perceptions to my experiences of the island and to what I had discovered there. I remembered how early man, across many cultures, had

ritualized the movements of heavenly bodies, and of how light and the sun had been deified long ago. I thought also of that belief, so central to Christianity, that God is light: a light that shines to those in darkness. I recalled the shafts of angelic light that were said to have fallen on St Columba at his retreat on Iona. (His biographer tells the story of Saint Columba praying secretly in a corner of his monastery when he is spied upon by a fellow monk. This man, hidden from Columba, observes a tower of light resting above the saint's head, proof of the special favour God has bestowed. This 'hidden light' is a common theme in much Christan literature.) The Skelligs cells, filled as they were by roving shafts of light, might easily have been seen as similar places to the Egyptian desert, or to holy places described in the Bible or found in other early sources. Putting all together, I could not help wondering what the monks had actually thought observing the same things as me, the same movements of light across this doorway in Cell A.

I soon remembered the story of St Brendan again, and the account of his voyage. I thought of his arrival at the strange and peaceful island of the monastic community of Ailbe – suspended somewhere in the Western Seas, just as is the Island of the Paradise of Birds. The monks he meets on Ailbe seem to Brendan and his men to make up a perfect community. After Brendan's arrival, his monks eat and go to bed, along with the other monks of the community. But Brendan and the abbot sit up through the night in the oratory. There they observe, as they sit alone in the darkness, a miraculous sight: torches are lit spontaneously, by no apparent human hand, within the darkness of the room. Once again – as with the white birds – Brendan is filled with wonder, and he asks how such a thing could happen. The abbot explains that the light is 'spiritual': it occurs and appears on 'holy ground'. It is similar, he says, to the light from the bush that burst into fire spontaneously before Moses in the desert, and it is a sign of the nearness of the Lord. The light appears as if from nowhere,

providing a visible sign, for the two men sitting in the darkness, of unseen activity all about them.

Here, on Skellig Michael, the returning light, working its way into the darkness of the cells and oratories to rest in soft flames upon the walls in the late evening at the equinox, must have also been spiritual light – light returning along its own ways and paths, moving 'as it will', as the Gospel says of things of the spirit. To observe this seasonal return must have been not so much a celebration of a once-off event as a reaffirmation of belief about everything. How spectacular that these cells on Skellig Michael were specifically designed to incorporate this yearly passing of light! And it is simply marvellous that this display has continued uninterrupted, if undetected and unknown, over the intervening centuries.

For many seasons I checked to see if the light would return in the same way. Sometimes I sat for hours on end within the cell only to have cloud cover cancel out the possibility of illumination within that threshold, and just at the last minute. This happened on more than one occasion, and I wondered what the monks would have made of such interruption. I also considered the fact that there were three other windows in the cell. (Cell A is the only cell with windows, apart from the two oratories at the monastery. After climbing a ladder during my first summer on the island, I knew that one could view the higher South Peak on the island through the highest window facing west, and that the opposite eastern window framed the Little Skellig. Given that a loft probably existed in Cell A, it would have been possible to arrive at these viewing points more easily during monastic times.)

The windows in the two oratories in the monastery face roughly eastwards, towards the Little Skellig and the rising sun. The doorway of Cell A also faces eastwards – the doorway I had been staring through each September while sitting in that cell, waiting for returning light to rise above its threshold. From there, I would sit, looking past the doorway, through the line of the central

oratory, and on to where the sun woud rise in the early morning, at midsummer, three months before. These glimpses of monastic orientation showed me, ultimately, that much within the organization of the monastery remained still unknown.

Because of these things, I remained wary of coming up with a scheme in which to force my observations. What is irrefutable is that, over the past thirty years, rays of sunlight have been channelled and directed so that they have progressed up the walls of the largest cell on the island in exactly the same way each September. The light has entered the space above the threshold, between the two lintels, at the same time and in the same place each year. This seems to have continued unobserved for hundreds of years, and it is wonderful, and most fortuitous, that the cell has remained undisturbed so that this re-entry of light might continue. It seems inconceivable that these displays were not meaningful to the monks who bided here: the visual impact of this movement of light is very dramatic, and its organization required planning from the early phases of construction. Surely these displays played some part, if unknown, in the yearly rituals of the monks who spent their lives here, in their celebrations and observations of the universe and its creator.

For each September, the monastery comes alive with the movement of light. In the late afternoon, the sun's rays are harnessed once again along an ancient track. Something of the builders' vision continues to be recharged within this space. In a similar way, and throughout the monastery, when the sun floods the interiors of all the cells upon its rise at midsummer, or as the shadow from the High Cross slowly turns in an arc across the pavement outside, marking the turn from summer into autumn, the monastery becomes visible as an engine of moving light once more: once again, we enter within the same light that men came to know, and then to organize, in this space long ago.

The return and passing of light is concentrated within a small, clearly outlined shimmering presence, high above the ocean, eight

miles from the mainland, resting upon a recess of stone otherwise dark. And it breaks open the darkness of the cell, further exposing it, establishing a further passage for sight to pass through, beyond the one that is obvious there, as well as reopening a doorway into the past.

You Ask

You ask, what do the messages
And signals from these far places mean?
We do not know, as we record the strangely lit
Passing clouds, the way the light comes to sit
And roll across the land beyond, the passing
　　hands
Of brilliance spread upon the sea, the showers
Of starfire upon the surface of the water
And the friendships of the birds observed:
This wall of light and dark we finger here.

What are the signs of eternity we come to know?
The human heart, my love, the human heart
Builds the deepest stairwells at this place,
Reveals the final door upon a dark casement:
A window receiving only emptiness, receiving
A vacuum from great depths and heights,
Beginning just beyond our outstretched hands.
We will give to these extremes, at the furthest
　　places
Of our knowing. We are emptying ourselves out,
Taking this further joy, the joy of the emptiness
Moving on stone floors, across raised cells
In shafts that glow across the bottom rungs
In hidden darkness, just even as our bare feet
Will touch water down at the darkened pier

When we come back in again, in the evening,
From the further places, turning once more
Towards the rocks along the shore.

How many rooms reach upon the air beyond us?
How are they ordered? What are the languages
Spoken and written there? Only the languages
Of thin and utter silence, and of written light.

17 September 2008

Lights flicker on the flanks of the passing birds as they move out to sea and away from the Little Skellig. The chevrons of flight they form – some ten, twelve of them – connect and flow in shimmering white necklaces, clustered together at times, glistening and then interwoven with other lines of birds across the sky. The extremities of these necklaces fade into nothingness in the distance, while their outlines are replaced and renewed by other birds, reilluminated by new participants. On the raised water, in the open troughs, shifting peaks fill with sparkling lights; they glow from moment to moment across the afternoon sea; they disperse, shifting along the agitated surface.

I see a skittish, small yellow bird pass before me as I sit on the floor of a cell in the monastery. He is not one of our resident birds; perhaps a migrating warbler. He passes quickly as a leaf driven swiftly and purposefully across the doorway ahead, then he vanishes. Nothing is left of his presence; only the stones remain, absorbing this grey light once again. The place is empty. The wind is driven toward the shore, dividing around and above the rock. I sit in the high and quiet lee, and the sun falls in long fingers onto the pavements, falling from behind the cells in the late afternoon. It is quiet and sheltered here within these shadows. My eyes rise to lift with the disappeared bird, following its imagined flash of colours in my mind's eye southward and over open water. He is merely a speck now, tossed in the movements of the wind

beyond. The island is released from its moorings, pulled away upon these lines of departing light. It stands on its own, insubstantial, unrelated to anything. A lozenge of light begins to take form ahead, on the ghostly and unreal pavement, stretching forward from the cell towards the oratory, straight through the centre of the compound. It slowly lifts itself; it becomes a lantern glistening upon the stone.

> Slowly, slowly we accumulated the light
> Falling upon these extremes; we watched
> From the cells on platforms where we might
> Stand to observe the little showers of light,
> Immediate, falling all about us to disappear
> Once more within the darkening walls,
> Glimmers of the interior, glowing eyes
> Watching us. Watching us even by day,
> In the tears of silver rain falling between
> Timbers, through the slats of the canopy
> Which shelters the road far below: each plank
> Light as a feather upon liquid, the unit together
> A wing lifting the island away; our hands,
> Our arms raised as the bones, the stretchers
> Of our flight. We became small engines within
> Great wings working to lift the island away.

18 September 2008

Up above once again today; a little pipit, one of our island birds, wanders along the pavement and begins to bathe just outside the door of St Michael's Chapel in a rain pool.

I watch from the darkness, sitting within Cell A. Slowly a rectangle of light again stretches up the left side of the doorway and falls forward as the sun declines, casting three oblong windows of light ahead, divided upon the steps and pavement. For a few moments, the light reaches almost imperceptibly forward, towards

the dark door of the oratory; and my soul stretches with it, with this slow movement of light, within the slow movements of the music formed out of utter silence.

There are only a few visible signs of these movements; they seem disconnected, indicative of the time slowing all about me. The occasional bird bathing, the specks of dust gently carving the air, the random falls of water droplets, are transfixed now and again in a sudden crossfire of light. I am aware of the light harnessed by silence, held within this silence, its music playing only against the ear of the soul. I am stretched ahead upon the pavement and held within this movement of light. I am broken open by this dissolution of light, divided into bird, stone, and dust: those aspects of the light beyond. A part of me stands there within these pale lozenges of light, suspended upon the stones ahead and exposed to the heavens, as I sit in the darkness of the cell.

There are no words for these fleeting movements, for this breaking of light within silence. There can only be an inadequate description of a soul carried away and stretched out upon an open space. The walls of the soul retain through time this confluence – retain a record of the movement and division of light within its own walls. Of how it has been so exposed. A map and representation of these things comes to life on the walls of these cells; over time, these re-form within the heart. Platforms, pavements, and cells become parts within an intricate engine as light enters. It is an engine by which light is caught and then distilled within the soul and cast into the distance. This whole place becomes that perennial crossroads of light we must travel through, holding before us those spirits we must meet. Then something of the soul is left behind here, wrung out and left upon the pavement.

> We are very near the white face of fire
> The birds shoot by before us, across
> Our way on their narrowing arcs
> As they fall along the paths ahead,

As they draw us on; drawing us very
Near to the wall of fire of activity, life;
Very near to the interface of all our being;
Our faces very near to the screen before
Us, everything coming here, bending
Towards this refiring, charging of light.

A Spiritual City

Arrival at the pier may not provide much comfort: the wind can whip in from the north-east directly into the landing cove, haranguing those disembarking with gusts of spray. There is shelter to be found under a wooden canopy further along the road. This road was built in the 1820s and leads along the southern flank of the island to the lighthouse. Earlier men had to scale the heights directly overhead without any such shelter. Eventually, they erected a steep set of coursed stairways leading to the monastic platform, six hundred feet above.

No one really knows how the monastery and the steps evolved, how long it took, or what was the sequence of building. Tantalizing portions of wall remain: perched in a nook high above the landing or hidden in corners not usually in view. Eventually, intricate masonry came to support steep, crafted ladders of stone, snaking back and forth on steep and difficult terrain. Even by the main ascent, there stands a ruined cell upon a terrace clawing into the rock, standing only by compacted earth and vegetation.

It is not possible for us to say how each structure was designed to be used on the island. Yet something can be said about what was done here generally. The monks would have believed that all building was to spring from, and be informed by, an act of prayer: 'Except the Lord build the house, they labour in vain that build it: except the Lord keep the city, the watchman waketh but in vain.'

Irish monks knew the psalms by heart; they would have been regularly recited on the Skelligs. Exposed as these monks were,

as removed from the shore, these lines must have challenged, haunted, and sustained their daily activities.

The island falls away below upon all sides once more. I stand on each step as upon a tiny platform, a foothold over the nothingness below, which falls more steeply away as I climb. On these same footholds, the psalms were daily intoned to the background of the crying gulls, resonating upon the empty air:

> Great is the Lord, and greatly to be praised in
> the city of our God, in the mountain of his
> holiness.
> Beautiful for situation, the joy of the whole earth,
> is Mount Zion ... the city of the great King.
> God is known in her palaces for a refuge...
> God will establish it for ever...
> so is thy praise unto the ends of the earth...
> Walk about Zion, and go round about her: tell
> the towers thereof.
> Mark ye well her bulwarks, consider her
> palaces...
> He will be our guide even unto death.

These verses from Psalm 48 refer to a physical city, but also to a spiritual one. They refer to a protection recognized at the very extremes and limits of living. In building such a city, the placing of each stone became fundamental, critical. In one of the lives of the Desert Fathers, a story is told of monks being troubled at not finding proper direction for their work. They are told by their spiritual father to spend their time weaving baskets. This would have been quite naturally expedient, as the baskets could be sold or used domestically within the community. However, having woven the baskets together, their counsellor then tells them, to their surprise, to unravel them again – to take them apart. Tales such as this give clues to a primary concern of monastic life: that

the motive, the attitude of heart, behind every action was the most important thing – even more important than the outward production itself. Otherwise, they laboured but 'in vain'.

The psalms were recited throughout medieval Ireland at the observance of the canonical hours, eight times during the day, from before dawn until dark. Verses intoning the majesty of creation, the protection afforded within God's fortress, within his 'rock', under his 'wings', provided the spiritual skeleton for everything done on the Skelligs. Physical buildings erected would, over time, crumble; the abandonments of self, the gifts of the heart, would remain. Images suggesting the bright kingdom of God stand behind the construction of elaborate stairways, behind the extension of platforms and terraces into the air and over the open sea. The idea of a spiritual city dictated that each stone should be placed as an effort of love and devotion. This would ensure that the city, so constructed, would in essence remain permanent after its physical demise. What was being constructed was, as well as physical shelter, a spiritual fortress.

The monks built on sheer, inhospitable terrain. It seems almost impossible that they might have imagined a monastic complex six hundred feet over the sea remaining essentially intact some thirteen hundred years later. Their only concern, at the beginning, must have been to see if their community could survive. Whatever their fate, the goal of their building must have always been this: to facilitate their abandonment to the love and care of God. The structures they built were the shells and adornments of this vision in practice, the physical representations of this ideal. The monks were its instruments.

St Adomnán of Iona, when writing of St Columba, speaks of other early Scottish monks also looking for a 'desert' in the ocean to the west. They wished to follow the call they understood those early fathers and nuns in Egypt and the east had followed, to find and sequester a holy place, a desert in the wilderness. So, it is said,

they set sail from the western Scottish coast and disappeared over the horizon, trusting that God would take care of them and lead them on. Some were not heard from afterwards.

The blades of stone glisten and cut the air with the spiritual clarity of such visions. This ladder stretches into an unending climb and descent of the spirit, endlessly repeated by a continuously changing line of people. At any time passing along the ladder on Skellig Michael, a life may be stripped open, ripped away and exposed to the passing elements.

In summer, out of these vast plains of the sky, the birds descend and take up their stations of flight over the island – weaving against the wind before alighting, swinging into their tunnels to incubate eggs, to feed chicks, to rest before the long sojourn out at sea that will last throughout the winter. Puffins are spread on either side as one ascends the stairs, moving out upon the late-evening air. They rest underfoot in the soft earth, rising with the dawn to make their display just beyond the rock. They fall away in a kaleidoscope of quivering wings before disappearing over the sea again. The island and the surrounding skies come alive within this network of activity. Layer upon layer of these experiences accumulate over time. Year by year, human society is diminished, and the vast plains of sea and sky stretch overhead; the rhythms of bird life form and re-form ahead in the air. I know these things because of the amount of time I have spent on the island. But the emptiness, the isolation, and their effects upon a lone and unguarded human spirit are all discernible, and often during a single brief visit. Suddenly, as if from out of the arms of the empty Atlantic, an image from the past returns with a shocking intensity and clarity.

Climbing the stairs in brilliant sunshine, and surrounded by others, I suddenly see before me the image of my dear aunt, long dead, very much alive, so that I can hear her voice quite clearly, hear her conversing naturally with me. I hear a voice again, the sound of which I had practically forgotten.

Returns overwhelm in diminished and altered human inter-course; they become woven into the physical tapestry of a place. Aunt Sarah's stone quivers within the grey light where I heard her voice and the circling, spiralling birds call, whereby the image was ground into my consciousness and sprung upon the sea before me to return at any time, and when I least suspect, over and again.

Other steps become haunted by the calls of lost loves.

Dreams return.

I hear voices of people long dead, as well as those of people alive and far away.

There is no counselling, no admonition, except from the sheer weight of the accumulated voices.

Eventually, each returning element of a lifetime, memories encompassing evil and good, are knit within the fretwork of the stones.

Each ascent, descent becomes an acquisition, as well as a relin-quishing. Our lives, too, are pressed into the stonework, just as those were long ago.

Memories, sacrifices, voices come to haunt this place, come to inhabit the rooms, the platforms that divide the island and which the monks established long ago. The exhilaration one might sense upon arrival presages the dawning realization of such things, presages an awareness – which deepens over time – of the continued vibrancy held within the ways carved out on the bare rock of Skellig Michael.

> The slow caravan proceeds – over a million
> Accumulated souls, over a thousand shards,
> Countless episodes dividing every life etched
> Within the arc of flight of circling bird,
> Climbing the stairways upon Skellig Michael –
> We put our feet upon the first step of the way
> Hauling up from the lighthouse road, hauling
> Across the lines of disappearing flight,

Disappearing in a briefly separate world.

The web of dressed stone steps propels one upwards, through the calling voices and into the upper open air, into the emptiness overhead, onto the platform over the sea where the stone structures silently speak their unknown tongue, calling down the light.

CHAPTER NINE

Journey to the Otherworld

S o many images have appeared before me as I have walked
the pathways of the Skelligs through the years. Sometimes I
have felt plunged directly into the past – into the landscape of
myth and fable, or the hermit world of medieval Ireland – while,
quite simply, I was only inhabiting an isolated corner of the
modern world.

Watching the boats converging on the island from the mainland
and then spreading out upon the ocean in departure, they are
easily transposed in my mind's eye into the little hide-bound boats
that the monks would have used to row here – and then, by
extension, into the similar boat that Brendan built for his voyage
on the magical Western Seas. After all, it is related that he built
his boat under Mount Brandon, which is easily visible from the
Skelligs on clear days.

Other magical tales have been brought to mind over the years,
such as that of Manannán mac Lir, the Irish god of the sea, who
is said to have driven his chariot across the waves, as he had turned
the surface of the sea into a meadow. Such a vision instantly
struck a chord in my own mind, when standing above the clouds
in the monastery, feeling that I might walk easily onto the summit
of the Little Skellig ahead.

Long ago, before the boats had satellite navigation, I remember standing on the wall of the monastery in the evening, in thick fog. Boats were due. Banks of mist were running very swiftly across the island, in such a way that I might very occasionally have a clear glimpse of the surface far below. Running lights were turned on because of the poor visibility. I watched as one boat, which had been heading correctly straight for the pier in one 'window' of the fog, missed its mark altogether at the next; I could see the little dim light atop its radio mast veering northwards, obviously temporarily lost and off course. The mistake was soon rectified, and I could hear the mutual hailing between boats in communication below. But for just a moment, I saw those boats, centuries ago, that were said to be sailing aimlessly westward: to the Promised Land, to Tír na nÓg, to the magical Island of Women, to find some personal desert in the open sea.

And from the beginning, I was often reminded of that day long before when I had been entranced by the patterns found in sea-bird flight above the Scottish coastline. Tales unravelled in the sky overhead. It was easy to connect with an ancient mindset where all natural features had spiritual dimension, where there were spirits in the sea, in the mountain, in the air.

A Flying Man

During my first years on the Skelligs, I became familiar with the story of Sweeney, an early Irish chieftain who is turned into a bird because of wrongdoing and arrogance. In the height of battle, and full of swagger, Sweeney is said to have insulted a cleric, killed one of his entourage, and damaged his bell. In a moment, he becomes half-bird, half-man; a flying man, banished from human society, outcast to haunt the natural fringes of Ireland: the wilds and rocks and waves of the coast; the hedges of the interior. For the rest of his life.

He flits from rock to rock, tree to tree, up and down the hinterland, and along the coast of the entire country, and some-

times across to Scotland, scavenging upon bare rocks, scratched and harried by thorny woods in the interior, and peering through the hedges at the human society he has been banished from. It incenses him to see this life carrying on without him. His wife is entertained by new suitors. He encounters, and is harangued by, madmen in the countryside. He bemoans frequently the fact that he has been made bereft of all his previous privileges and protections, left to forage for watercress, for fresh water, and living a haunted, frightened, furtive life.

Year after year he haunts the coasts and wildernesses of Ireland, learning the ways of nature from a perspective he has not known before. Learning, through arduous and painful instruction, of the vision that life exposed to wilderness provides. In a series of poems, Sweeney enumerates the beauties and delicacies and nourishment to be found in the wild foliage of Ireland. He praises the trees individually, in turn, he reflects on the flashing running lights found in rivers and streams, and he praises the loftiness of the mountains.

Originally terrified – when he is first cast into all these places, first transformed into a bird – in time, he becomes changed, transported by the life he has experienced, by his complete isolation from human society. All wild displays come to thrill him: the deer running through the woods, the stags bellowing, the lonely calls of birds at night.

His life – already forfeit, already abandoned – becomes, after so many trials and desolate and lonely experiences, not just an embodiment of his curse but a pursuit of a route followed to its bitter end, enhanced by the insight into the natural world he has been afforded in exile. He is transported by seeing the running deer, and he comes to run with them, perched astride their antlers in the woods. And, after some time, he deems the natural sounds he hears – in the woods, along the coasts – to be more beautiful than the sound of bells tolling the hours in monasteries, which he also hears, off in the distance.

Finally, after all his experience and hardship, he comes to the realization that human hardship and antagonism have no point. In fact, they are no longer possible, given the new vision of the natural world he has been given.

He is often at the point of death as these realizations are slowly worked out through his pilgrimage. Yet this wilderness, though hard, becomes also a bright one.

Sweeney's is a story that resonates with all times. The story of the balm and insight to be found in the natural world – particularly when that world is harsh and untamed, and inhabited after disappointment, disgrace, or error – is universally human. The lure of crossing a border into a different order is always before us at different points in life. There is another order, we sometimes say: a wider order, a more expansive one than the one we know.

Marooned from time to time in bad weather on the Skelligs, I could not help but identify with this story. Sweeney enters a different world of time when he is exiled from that which exists in the society left behind. It is a time now ordered by basic immediate needs and is structured by the progression of the elements in the wilderness about him. Sometimes, I might even imagine seeing him, half-man, half-bird, hopping up the steps before me in the mist and rain.

There are other insights into this 'other' order that come out of the early Irish monastic writing. They come from the so-called 'nature poems', mostly written down by monks during the time the Skellig monastery was in use. Among other things, they give a picture of an ideal world, where men and women live in harmony with nature, and use it in the service of God.

St Ciaran's first disciples are said to have been a fox and a badger. Foxes, badgers, wolves helped to carry out domestic duties. Saint Paul of Thebes and Saint Anthony of Egypt (the 'first' hermits) are said to have been fed by ravens in the Egyptian desert. Lions protected monks in desert cells. Monks prayed with outstretched hands so that birds could come and build their nests there.

These little tales speak of the natural energy released by a total abandonment of the soul, and of its ravishment – of the soul bound within a vision of harmony with the wilderness around it and beyond.

The Promised Land of Saints

When journeying to the island, all travel to a place that offers a far perspective, a place that opens upon the unknown, in the sense of a changed or altered vision. In a wide sense, that is the call of the Skelligs, though it is heard in many individual ways.

We read of Brendan embarking on an element in which the plenitude of nature is overwhelming. He hears, on the arrival of Brother Barrind, of the Promised Land of the Saints, a magical land of ease and wonder, just at the gates of paradise, and he is immediately eager to depart. Barrind advises that the place is a day's journey away, but of course it takes Brendan seven years to get there. For they embark upon a sea that is otherworldly, where time is measured differently; they are immediately caught in mist; the mainland is left behind; time and distance are radically altered. And their journey becomes a cyclical one, for these men are led to stop at the same places each year of their journey. Their voyage, their test, becomes one of endurance, and at each step along the way they encounter marvels of nature and creation.

They make camp and start a fire for cooking on a landing place that turns out to be, not an island, but the back of a great whale. They land on other islands where magical fruits grow, where unusual creatures live. They venture near an island that spits fire and where large rocks are hurled high into the air, putting them in danger. They encounter a beautiful crystal pillar. And while voyaging between these various stations on their yearly cyclical voyage, they encounter storms, raging seas, and gigantic sea beasts. All these encounters prove their faith in God's mercy and support. They are reminded that they have thrown themselves upon God's mercy, and by so doing, they

have been allowed to experience miraculous adventures, in a timeless zone beyond the pale of ordinary life, and to pass safely beyond them.

Brendan and his men have experiences that are not encountered ashore. On leaving Brandon creek, they are on an element where the otherworldly – or supernatural – is immediate. This world is suddenly numinous. It is an element full of potential danger but, paradoxically, it is also one where the strength and power of the Creator and the natural world is most evident. Brendan and his men get a clear view of majesty by exposing themselves to their own imperilment, by casting their fate completely upon the mercy of God. Their faith is severely tested, and it becomes obvious in the narrative that one reason their trip is successful is that their leader's faith is exceptionally strong. As much as anything else, Brendan and his men travel into the unknown – where anything might happen, where anything the human mind might conjure exists in reality, and where the line between the concrete and imaginary dissolves. He travels a realm where the miraculous becomes the fare of everyday, once one voyages beyond the pale of the safety of the shore and of the familiar.

In an earlier, similar tradition, 'The Voyage of Bran' relates a different journey to the otherworld: to the Islands of the Blest, undertaken by an Irish chieftain, who is visited by a strange woman as he sits in the company of his men. She tells him of a magical land far away where there is no death, sin, or pain, and which he might visit if he takes the silver branch she holds and accepts her challenge and her invitation. Like Brendan, this chieftain is immediately eager to depart. Once he is under way, the sea becomes a flowery plain, the elements are transformed and magical creatures are met, just as in the account of Brendan's voyage.

Brendan and Bran are led out into uncertain territory by a challenge. The idea of embarking upon a voyage into a world where the usual is undermined, where dangers and marvels are more clearly visible than in ordinary social life – these are ideas

which recur in Irish monastic lore. They hark back to the deserts of Egypt, where the miraculous was everyday, according to the tales passed down to Irish monks. As noted, Columba's men living on the island of Iona off the Scottish coast, and contemporary with the Skelligs community, sometimes set sail to find a 'desert' off to the west – such was the pull of empty spaces, of removal from society and encounter with the beyond. The desert was also that spiritual wilderness where Christ exiled himself for forty days. In fact, the desert might be any wilderness: the open sea, or any secluded place on the mainland.

Miraculous stories from monastic Egypt and Ireland came to interwine: for it is told that lions came to rest near the cell of Paul in the desert in Egypt; similarly, Columba is said to have calmed a wild sea serpent, so allowing his monks to pass over the open sea. Egyptian and Irish monks pray, and storms and demons are calmed. Light rests upon the heads of monks in both places. Wolves and wild animals come to the cells in Egypt to be blessed. The desert in the monastic imagination of both Ireland and Egypt, looking back across the centuries from our perspective, was a place where anything might happen. It was most of all a place of spiritual confrontation. Demons were said to be attracted to monastic outposts; at the same time, the strong men of God who resided there called down angels in their struggles against these same demons. So with the desert, so with the open sea off the west coast of Ireland for Brendan and his men, and for the monks embarking for Skellig Michael.

Such stories have at times haunted me through my years on the Skelligs. I well remember bright afternoons during my first summer on Skellig Michael, watching my friends or family members departing for the shore as I stood high on the monastic platform to see their vessels grow ever smaller, curving for the coast. The greenery in the monks' garden was on fire, and the cells appeared to sail off into eternity, high above the departing

activity below. I remained frozen in isolation, stunned in the silence. And I might wake to find myself fogbound, the mainland disappearing for days. Only a small hand-held VHF radio; only, at times, the company of puffins and one other human soul, similarly dwarfed by our surroundings.

And then, suddenly, I would realize that I was well able to breathe, well able to move up and down the magical stone ladder between the sea and the platforms of living prayer high above. And able to stand at the pier, the swell crashing against the small cove, making it impossible for any boat to near, and seeing the light fall in bright cascades upon me there, in what appeared to be wave upon wave of brightness, accumulating in the cove as I stared out at the headlands far away. Or I would take in the light striking me in the face as I turned each corner of the lighthouse road, rising westward toward my hut and knowing there would be no other arrival on the gale-swept days, and knowing that my life here would be stripped bare. And with this, some strange feeling would be internalized that it was absolutely appropriate that someone should be here, and knowing the responsibility of that, while at the same time feeling the exhilaration of the new day here, of the slate being wiped clean by the onset of elements, one upon another, day after day.

A Steep and Precipitous Landfall

The island is suspended at the horizon, floating mysteriously with its sister rock, breaking the seamless line between sea and sky. The far light glistens from a tiny distant magnet following the vagaries of Atlantic weather. The eight miles of open sea might appear unmarked but for whitecaps, or a rolling swell, or flotsam from the fishing trade – maybe an odd buoy, or net, or a floating timber – yet this has been a well-travelled sea road for many centuries.

The Skelligs were listed in annals as places of refuge for early

kings; they formed a setting for mythical invasions. They became well known to fishermen and traders; they were marked as reference points on sea maps. The islands, set at the extremity of sight from the shore, provided a backdrop for tales of the otherworld: for stories passed down by word of mouth, from generation to generation.

The lore of this place, over time, became entwined with the lives of the inhabitants on the mainland – with those who daily observed the islands, hanging between sea and sky, at the edge of their vision. From St Finian's Bay or Valentia, from far to the south on Beara or north on the Dingle Peninsula, the Skelligs glistened before those passing by along the shore.

In early history, men seeking the refuge of silence and solitude were called here: called to pass over the uncertainties of the weather, and the dangers of the crossing, to begin a permanent habitation. Those first hermits, or that first group of voyaging monks, set out from the shore to engage in spiritual warfare, to claim what is sometimes known as a 'further battlefield'. They, too, established themselves by travelling the Skellig sea road. By doing so, they established a toe-hold on the edge of their known and settled world: they edged closer, they may well have thought, to paradise.

A local tale has it that fishermen could hear the monks singing at night as they passed by below the monastery, reminding them of the danger nearby. Over time, the way to the island became marked with different reference points, with marking rocks leading to the mouth of the harbour, guiding mariners safely through the channel, leading them away from the mainland and out into open sea. In recent years, fishermen have told me of their fathers steering near the Skelligs at night, safely monitoring their journeys by the cries of the birds heard coming from the rock. Features of the physical landscape also came to signify spiritual concerns: the Bull Rock, to the south, was also known as the House of the Dead; Mount Brandon, on the Dingle Peninsula, was known as a place

to which the angels from the Little Skellig might resort. Through this numinous seascape, within this weaving of language, lore, and folk knowledge, a path out to an island on the horizon was inscribed within all voyagers' minds, on the minds of men pulling against the oars, casting nets, drawing the ropes of a sail and learning to leap from their vessels on tricky movements of tide and swell safely onto rocks at the little cove on Skellig Michael, to haul their boats up quickly behind them, and to climb upwards into the sky.

Each local sailor has their own way of interpreting the signs within the channel to indicate how safe the landing at Skellig Michael might be, though it is eight miles away. At times, you can hear the gannets crying on the Little Skellig from a great distance. Through the hubbub of conversation, standing in the monastery over a mile away, I can often hear them and can discern the steady rhythm in their gathering call across an empty sky. In spite of modern navigational aids, the ancient way to the Skelligs remains part of local marine lore, mapped out in a sailor's thoughts, in an awareness of the way the fetch of water might bank off an irregular coastline or how the swell might divide on a far rock. This way out – under the migrating birds, along the channels established over the centuries – continues to guide travellers. Passing through the gates of the last remaining rocks of the mainland, compensating for the tide and swell, different routes converge upon the islands from several points of departure along the Iveragh Peninsula to find within the arms of raised rock a tiny narrow landing pier, within the cove at Skellig Michael.

Those making the journey are accompanied by the voices and spirits of the dead. They are accompanied by the images of men rowing out against the tide in small boats and by the voices of those who perished and drowned in the waters between rock and mainland. Only shadowy reminders remain from a relatively recent past. Few have first-hand knowledge of tales no longer passed on: of how Skellig Michael was known as sanctified, holy ground; of how lighthouse families eked out a forgotten life on the island in

the nineteenth century and how one or two keepers disappeared suddenly in unknown ways; of the tales of Skellig 'lists' and of going 'Skelliking' – referring to the magical charms of this place, however endowed with humour such tales might be. For a while, in the eighteenth and nineteenth centuries, even a different calendar prevailed on the island, as Lent was postponed and marriage was still permitted during the weeks when it was banned on the mainland.

The way out, haunted as it is by the past, still regularly vanishes. The sea, as of old, threatens destruction, as well as remaining a safe conduit for travel. Gleaming surf rises on shoreward rocks, pushed by a menacing and continuous swell, smiling back upon a traveller, brandishing a curved row of white teeth. Fishing trawlers sit in port for days; the light, the life upon the island becomes trapped, cut apart, fomenting its own weather systems. Fog and brightness alternate quickly upon this fulcrum of rock, unseen for days from the shore. The sea road becomes high and wilful and released. Intending passengers wait on an eternal engine of spread white, sweeping over the drowned, cutting off the shore-bound.

I have often been marooned on the shore of the mainland, waiting for safe passage. To the uninitiated, the prospect of the sea ahead might seem safe, but the gentle ripple seen from shore is indicating high waves on the horizon, making a landing on the Skelligs impossible. Waiting on the beach at St Finian's Bay, behind Portmagee, the road to the island glimmers invitingly along moonlit bands of the sea, snaking towards the two dark angular shadows at the horizon; no passage might be possible for days.

Early voyagers believed that they sailed upon the very foundations and outposts of the earth; these realms were full of danger, both physical and spiritual. Demons inhabited remote islands; they might suddenly appear from sea-mists. Beyond the sight of the obscured mainland, any shape the human mind might conjure might appear. On many occasions, St Brendan's men are overcome

with terror; they urge the saint from their storm-tossed boat to pray for God's deliverance. The faith of Columba, Columbanus, and many others is invoked in early literature to secure deliverance from the terrors of the sea. Holding firm to these beliefs, men were required to abandon themselves utterly, to rely completely upon God's mercy. The nature of the love of God, the love of men, was defined by this relationship.

Egyptian monks before them had also made their way upon a wasteland, crossing an empty and terrifying landscape in search of the solitude of the desert. Their roads lie hidden now, and the sea washes over the route to the Skelligs, stretching beyond the cliffs at Portmagee. But something unites these routes: they were established to reach the unknown and the uncertain. Regardless of whatever monotony or discomfort might be experienced on the journey, that impulse is always tugging away, underneath the boat, forming the currency of the voyage. Suddenly, coming away from the safety of the channel, it becomes clear: this is the impulse of setting out into the unknown, on a lifetime's pursuit.

What lies ahead, when turning the corner out from the channel, is exactly the same prospect that would have unfolded in early medieval times. An instant connection is established, particularly in the silence that descends upon a boat as the first tug and crash of the deep-sea swell is felt against the hull underfoot, fifteen minutes out from land-ties. Ahead lies only one steep and precipitous landfall within thousands of square miles of the open sea.

> We travel to a far point, to see
> A vision of the door into emptiness
> Standing beyond, in flashes of silver
> On the flanks of bare rock.
> The white light draws us further ahead:
> The swell rises, to cut new lines into the waste of
> water,
> Carving those lines upon our astonishment and fear,

As something strange will enter us, and return
 then with us;
This white light which is covering everything,
After we have left the shore, after we have
 returned.

In the story of the fantastical journey of Saint Brendan, the Promised Land of the Saints was said to be very near the coast of Ireland; yet for Brendan and his monks the voyage lasted years. Even today, eight miles of the open ocean stretches for some into an eternity. As the boat slowly moves away from the mainland, glimpses of the island appear ahead, then disappear once more. Dolphins or whales sometimes appear alongside; banks of mist come and go. For a time, the mainland simply disappears.

Some four or five gannets – and then a stream of twelve, in a glistening necklace stretched low along the water – begin to accompany the boat, apparently moving faster as the islands near. The boat is pulled ahead in their slipstream. Little liquid pearls glisten on the backs and necks of these huge angel-birds, now alongside, at arm's reach. Overhead, along every cliff edge, innumerable creatures of white down hang, balanced upon eternity beyond. We are surrounded, thrown within endless rhythms of flight. A small vessel is swallowed up within the swell, within the swinging rings of white birds.

Once more we ride the ghosts of the first crews.
Many embarkations merge into one. We pass,
Threshold upon threshold, minute by minute,
To enter opened realms. Under the scattering
 birds,
In this bleak setting, we move out within
Realms holding different light and vision.

PART THREE

CHAPTER TEN

The Weather is Changing

16 September 2000

There is very fine weather.

A mild, breezy night; petrel chicks whistle in the walls as I make my way by lamplight down the lighthouse road. The road is dry and cool; the stones underfoot glow for a moment in the light and disappear. Here in the hut, the small heart of crystal I have hung in the window slowly turns; the sea rustles below.

A few hours ago, all was very quiet when I was in the monastery. Just beyond, the Little Skellig was suspended at a mere arm's reach: a jewel, absorbing rose and cream and ochre lights, glistening upon the crystal-clear water, standing proud from the sea in the fading light. I looked up to see a fulmar, his flight cutting through the air, releasing a barely audible, highly pitched whine as he passed overhead. My spine quivered; the bird's flight stretched ahead on empty air, slowly unfolding in spirals above the water. A ghostly smile, made of these dissolving movements, materialized within the emptiness, above the far headlands of the coast. Within this smile made only of clouds, the Little Skellig approached and receded in my mind's eye.

The lines of flight cross upon one another at tangents; they illuminate and divide the pathway leading ahead of me into

darkness. They divide the entire sky and reach upon the vastness beyond. They hold my entire life before me. This empty road upon the sea before me stretches as wide as the world ahead; but it is cut through and framed by these lines of bird-flight.

Though I've been here several days, a further sojourn stretches before me – out along the road of bird-flight which reaches, from the mainland to the east, into the eternity beyond.

17 *September* 2000

Rain, mist falls upon the Skelligs, and a soft grey sea is rustling against Blue Man's Rock below me. All is very quiet, empty of humanity, as the fulmars stream by overhead, far beyond arm's reach.

Gifts are presented here: I receive the sequestered air and light, and the new and daily formation of the rock: the shifting expansive skyscape; the sudden arrival of colours and of sounds. They are marvellous and uncanny blessings. And yet, after the passing of night, as I cross in my mind's eye beyond these lights which stretch before me upon the open sea, I experience a spasm of enervation, emptiness, and abandon. I ground myself between the emptiness before me on the one hand, and the solid rock reaching behind me on the other, and follow the ring of road unravelling ahead and around the rock, a ring which circles and is suspended above this bare place, this almost-empty island.

Everything is broken apart within this light; broken apart, emptied into nothingness, brought together again, dancing upon the edges of a great solitude.

I hear something like a seal moan below, but it is the sound of twisting elements, the sea sucking in shifting water-bottomed caves; strange sounds stop me in my tracks; but human voices sound the most unnatural. It shocks me when I hear a colleague call across the way.

The island road stretches in silver ahead, glistens in the rain

when struck by the intermittent light, and when small clouds of dust are stirred up by my shoes. It lacks all embellishments, suspended as it is between bare rock and the sea.

We Throw Our Words Away Here

We have come to throw our words away,
Our names are cast off, everything
Is abandoned. We cast ballast aside
In the rough weather, and the names
Of our sons, daughters, and families
Rise within a lightened atmosphere.
Birds swing in from the fog: and a trail
Forms within the emptiness. We move
Upon fresh and emptied roads, reaching
Into spaces where acquaintances dissolve,
Into a core of being which pushes us further
Ahead, sending back names, identities
From places beyond and unknown.
We raise all of our voices, yet each
Earnest aspiration erases all our speech
Once more, and we can only sign, or gesture
Of the mysteries of our survival. Words exist now
Only to invoke the rising levels of oxygen
Within a channel, or to describe singing elevated
Within the cells: we hear, speak only the words
Which express release of signals upon distances,
Signals that return again so that they bind,
Under my skin: these words which shadow
Us, enchain, impel us forward, to walk now
Emptied, nameless, unmarked roads.

The seas and skies around and over Skellig Michael have changed considerably over the last hundred years, and more. There are not as many fish; lobsters, crayfish, crabs are not so plentiful. The gannet nests on the Little Skellig are littered with plastic; seals and birds get caught in drifting line. But there are other signs, too: the sea-bird colonies on the island seem, for the most part, healthy. There are not the numerous 'schools' of basking sharks that were seen in past decades, resting on occasion in Seal Cove, on the seaward side of the island, in still waters on summer days, but they are today spotted regularly at sea. I did not see a whale for the first few years I was on the island (or, if I did, in the distance, I was unaware). Suddenly, they seemed to be more plentiful, around ten years ago, and they now regularly roam close to Skellig Michael. Humpbacks will on occasion, through the summer, breach in the water nearby. Six years ago, during a warm and very still spell, the water was like glass. Minke whales seemed to be everywhere. A mother and calf would regularly surface just before the landing. Through the open door of the cabin I could hear the whales, their continual breathing punctuating the becalmed night air: the sound of their breaths steady, magical, pulling me out to see their dark shadows occasionally taking form on the surface just below my feet.

The island generates its own weather; sometimes it appears to me to set its own field of gravity. At times, it is very clear that we are living on a point of the far periphery, at the final extension of a country that is itself an island, balanced at the western edge of Europe.

Oceanic weather passes overhead. Clouds race by, and huge plumes of dark mist gather and take form, against the summit of the high peak, in the lee of the strong winds. A great finger of island vapour reaches over open air to the south. The same happens on the summit of the Little Skellig, a mile away. It can seem as if signals are being sent between them, when approaching by sea.

I can stand at the top of the final flight of steps, just below the monastery, to look out over Christ's Valley, and Blue Cove below, watching hands of dark mist being thrown up the funnel between the two raised peaks of the island: the ragged white hands tossed into the empty sky, bringing a draught that is freezing cold from the north, hurling rain upwards. Strange light breaks through these driven mists. Little circular rainbows multiply over the cove, and down at the landing. On some days, the light is constantly changing.

Occasionally, fog sits upon the island for days on end. At times, I can sense this ship of rock being cast adrift within a sightless element. We edge against the coast of America, wind through the Pacific; completely lost, rambling upon endless empty water. The visibility ahead fifty yards.

Sometimes it happens that I walk up the steps through cold drizzle after days of being fogbound; two-thirds of the way up, I will emerge into sunshine. Standing at the far end of the oratory terrace, I stand over a pavement of white cloud. Beyond, scattered high peaks break upon this surface, protruding above a thick blanket, a snow-field in the air. The very tip of the Little Skellig glistens, surrounded by a handful of circling gannets. They lazily circle around the summit in the morning light. The Reeks, the highest mountains in Ireland, seem very close. Mount Brandon peeks above this cloud to the north, the place from where St Patrick is reputed to have called to St Michael and his angels on the Skelligs for their assistance. It seems as if it would be easy, in such conditions, to stroll from peak to peak. The world below simply disappears. It becomes easy to see how extreme places such as this were known as the habitation of spirits, both angelic and demonic. It is in places like this, cut away from the world, that Brendan is said to have prayed for hours over the soul of a recently departed man, only to come out into the open air and see angels and demons in the sky, fighting for the soul of the recently deceased; the angels pulling the soul to heaven, the devils to hell. There is only emptiness around now.

But it is precisely in that emptiness that St Michael is said to have taken the form of a bird, and sung to Brendan when he was disconsolate. The possibilities for the inversion of assumed natural order are continuous in these rarefied conditions; sometimes anything seems possible. At times a vision descends of a place where elemental forces pass overhead; this is a place where the weather first breaks from the sea upon a far rock, before the mainland is struck beyond, and the elements have occasion to settle. This movement of natural forces is continual through the rock, overhead in the sky and underneath, isolating this island, yet also bringing all passing things before me. Each person I meet, coming up the road in the morning from the shore, becomes everyman, everywoman. Each solitary creature encountered, however insignificant, becomes every other living thing.

In this charged atmosphere, there are visitations from the dead, the disaffected, the angry, the distant. Events from the past will return to haunt or encourage. A murder, read of in an old and yellowed newspaper, placed on the floor for days in an attempt to keep driving rain out, suddenly comes into focus so clearly before my feet, its details stark, very real. So that murder is played out upon the corner of the lighthouse road again.

Within natural upheavals, and in an uncertain and unstable position, I must learn to communicate over distances. I must put faces on the voices that I hear and animate disembodied screams and calls heard on the night sky. I foist myself on the dark through imagined stories, and, by them, I reach to communicate with those passing on the dark outside, or on the far mainland beyond. The stories, the communications succeed – and make their contact, and have the ring of truth – only as my eyes have been cleared, and my spirits strangely honed, by the exposure here.

The sole headlight cast into the night sky upon a mountain road on the mainland, as I watch it turn and disappear, becomes a movement upon the night sky I follow with more than passing interest. I concentrate on what are usually mundane signs of life: I enter

through the dancing cabin lights into the musty damp wheelhouse of a passing trawler. Trawlers and tankers are often balanced at night on the horizon-line, just upon an edge from which the curve of the world falls away. Their lights twinkle at the horizon, the erratic swinging on rough seas detectable even far away. Their lights are spread unevenly on the dark, a ragged chain of humanity, buoyant yet very vulnerable, passing over the brow of sight, into further deep and endlessness. Sometimes, on their way out to sea, they pass so near I pick out the shadows of men moving in companionways, or hovering over the vessel's table in dim light.

The marine radio, in my early years on the island, on many days provided the only other human sound beside our own. I am sure that there were days when, besides a very brief morning or evening greeting, the only voices I would hear would arrive upon the static of the VHF airwaves.

A yachtsman is arriving to the coast after a long crossing. The craft, somewhere out there beyond the horizon-line, is beginning to pick up the welcome voices from Valentia Coast Guard Radio. A Pan-Pan call comes over the radio, signalling a sea warning. A yacht is overdue. A buoy or light is not signalling properly, or is not holding its position. A dangerous net is adrift. Rushed intimate messages, in many languages, pass cryptically through the static.

18 September 2000

White light rises, plucked from a fierce blue sky. White bands stretch, curve overhead and rest upon the horizon. This light falls, gathers, intensifies here in this small cabin this morning. Below, there is white water over Blue Man's Rock and a quick movement in the swell up from the south-west; a little finger of white water reaches insistently eastward, pressed from the lee beyond the Washerwoman's Rocks.

The place is emptied; the light is palpable: I feel it in my hands. It balances against the skin, against the rock, in the monastery, in the lighthouses, in the little huts below. My life, a sedentary and

solitary form touched through the window by this white light, opens again this morning, is pulled out into an empty gradient. It wakes to the surge against the rock, to the indifferent roll of the sea that is, just here, a form of promise. This is a promise realized as the place is released, as it is continuously filled with full darkness, with full light, for whatever length of time. A promise of raw energy stands – the energy that descends upon this bound and confined space and is held here. We are bound by the white light that works upon us, just as it works upon the ocean: sculpting the water, driving it ahead to push up against the shore, forming its continuously changing, charging, then dissolving walls.

The full light here voids interiors; it leaves us weightless. It stalks us, grabs at us, striking through to the very heart of our person.

> Here light is embroiled in white
> Surges on the sea, small rainbows
> Cut the table, the still room; in our
> Silence and stillness light settles
> On ridges at a violent pace so that all
> Buckles upon every advance; one soul
> Falls upon another. Careening suddenly
> On endless ways this sea forces us
> Against and within a white wall –
> The wall of divided light we stand
> Within, a ridge of shifting water
> Marking division from the shore,
> Forming us
> Anew out of every prospect open
> Ahead, making the emptiness within
> Ourselves certain.

> We put our fingers on nothingness,

Which stands now, before us, under
Trade routes, under all departures: our fingers
Are set to reach through that light by which
We turn to stand, within this emptied time.

20 September 2000

All paths stand open upon the island: the ribbons, the chains of steps that are spiralling up to the monastery, glisten in the rain at dusk. The rock seams of this island, and the one beyond, glow in a living system: arterial red, venous blue, charging the coloured mist on a darkening sky. The paths ring, quiver this nightfall, bathed in the rich purple, the darkening light. Little Skellig stands above the surf beyond, a mile away: a living sacred heart, a volcano of the spirit.

Up in the monastery all is silent, washed clean after the pouring rain; the strong southerlies of this day have died away. Beyond and nearer to the land, ships of grey cloud shift to the south and the horizon, and a bright strand of late light is gleaming, on fire over the empty headlands.

Earlier, I sat in the drizzle for a while, up in the seat between Cells B and C, where I often come to sit. Just at that place, I am enclosed within a point of the walled monastery where I can see nothing beyond, except for empty sky and a small wedge of the distant peak of the Little Skellig. Here, even as the boats are passing below, their engine sounds can seem to come from far away.

A young raven crossed the empty space overhead. He moved back and forth in the air, suspended within the confined orbit of the place; a time or two he descended just before me. His tail feathers shivered in the breeze and they stretched briefly into a wide fan as he alighted and then was still. In a moment, he was joined by another, and they stood together awkwardly for a while, at rest on the pavement. Then the pair rose and curved out in their flight over the water. For a moment, before disappearing,

they were suspended in the far distance: they formed small islands, little shadows caught above the sea's horizon. It seemed they were not moving, that they were holding the world still.

I thought of a story told by John Moschus, who visited the Desert Fathers in the fifth century, concerning a woman who, in order to avoid tempting a young man who was infatuated with her, stole away to live in the desert for seventeen years, subsisting on bags of soaked beans. During this time, it is claimed, she was never seen, although she herself 'saw all'. Here I only see all, or see anything, through small events, small visitations. This must be the case with all who live in empty or solitary places. Small events will sometimes tear the night away. These empty spaces are filled only by activities of mind or will, and fed by the smallest, most insignificant of events. The little birds cross into nothingness. Islands suddenly loom ahead and disappear; we glimpse each other only momentarily, as the boat pulls away from the landing, and then travel apart on separate roads. The emptiness looms large, stretches in every direction, unfolds its arms everywhere.

Up above now, the water drips down the interspersed layers of thin building stone that organizes the oratories and cells into an elaborate clock of falling water. This clock tells time through the sequences of falling rain: it tells the times of quiet giving, of unseen sacrifices, of losses, and of the tiniest, almost unregistered acquisitions of the spirit. This running water speaks of travel within the mind's eye into the emptiness beyond. It repeatedly, steadily tells stories of what remains unseen, lost within the sense of abandonment that haunts this place. It tells of what has been given secretly away. It tells of the spirit that was established here, over a time measured by the lives given and spent here. Each drop of water signifies one of these things.

My vision of this, though partial, gathers and builds and I see a flood of light falling ahead along the island's paths, climbing its stairways. A platform stands upon these curtains of stairs, upon this glistening river of light: an altar rises upon the accretions of

time, upon each drop of falling water, the water leached from stone to stone through the centuries, gathered anew in glistening pools on the monastery floor, hurling sight beyond that which is present and visible.

Our time runs short here, but in another way it only begins as the everyday clocks stop ticking, stop registering as a sequence for a short while. Time is interrupted, and the old time stops. We begin to signal, and receive, only by the rhythm of slow drips of water falling over the stones. Pools gather at my feet in worn cups of the rock and chest-high along the plinths of the oratory. My breath is held within the rhythm of the falling water, each drop a bead of light glistening upon the walls of the cells. I hold the birds' wings within the space encompassed by outstretched arms; reciprocally, the edges of the space I encompass are bent and curled by the movements of the birds, as they spiral away at its edges in the empty sky towards the Little Skellig and disappear.

I rest for a moment in this silence, listening to a call to embrace the abandonment that defines this place. Just outside, the little petrel chick's insistent whistle is steady in the new rain. His song is intense, much more so than that of a few nights ago, as he calls for more food – as well as, I suppose, for his first flight, for his first drop over the sea. His piercing cry is rebounding within these corridors of stone. As well as his, my song or flight or sojourn builds toward its terminus, its station.

Here, little petrels come and go, but only in the night, rising from the shelter of the darkness of the cells. Thousands of them hover over the monastery in the moonlight. There is no sign of them here by day. They are gathering now – some resting in the cells, some gathered out on the ocean just beyond – preparing to embark for the equator, resting briefly before their departure. The balance of living things on the island changes.

I am marking my own departure, embarking at the gate that divides the island from the mainland, in moments such as these,

moments when my time is suspended. The sea, the air are running through gates that suddenly swing open, hinting at the time ahead. I abandon my easy, imperfect words, laying these, and then myself, on the wet oratory floor. The shafts of light are long, grey, dim, steady, as they absorb and reveal the oncoming night, as they stand within the silence; they form transparent columns of darkening light, aglow across the enclosure – they sequester this place, they create a prison of ordered light where I stand. Everything comes and goes through the cages, the rooms that form before me, stretching ahead into darkness, into the emptiness beyond.

By the summer of 2000, I had spent thirteen seasons on Skellig Michael, from May until October. I often reflected, while I was there, and during months ashore, on my station and the unique perspective I was afforded by staying for prolonged periods in a relatively exposed place. Given the uncertainties of the Atlantic, there would be times when no one could set foot on the island other than the staff resident there. Often I would share the island with only one other person.

Since then, there have been many changes in island life. In 2000, there was no phone coverage – certainly no internet. For most of the preceding thirteen years, the place had existed well under the radar of large-scale commercial tourism and marketing. Numbers visiting the island were much smaller than now. In general, the boats (usually the traditional timber fishing vessels of the coast) took much longer to reach the island – typically ninety minutes, sometimes more.

The impression received, when going out to the Rock in 2000, remained one of travel to an extreme place and being marooned there for an agreed period of time. I had responsibilities for the island; these were extensive at times. And yet, as is the case now, these responsibilities were rooted in the awareness that I would

be spending a great portion of my time alone, or with one or two others.

This became a lesson in seeing a landscape of abandonment, of coming to understand new ways of responding to the world beyond. Small mercies, small gifts, small interactions came to take on immense significance. I was made aware, in those first years, of the traditions associated with St Michael, the patron saint of the island: a warrior angel, reputed to fight against evil, to haunt mountains and high places. In scripture, he leads the army of angels to victory in warfare in the heavens: victorious as 'they loved themselves not unto death', victorious through abandonment of self. The cult of St Michael was popular throughout medieval Ireland, so it became easy for me to imagine the Skellig monks seeing the saint from within their isolation at this remote and precipitous place – holding the lit scales, the golden gleaming chains by which he is said to weigh souls, and leading hosts of angels through the mists surrounding the isolated rock. The Skelligs presented for me a seascape haunted by shadows out of which almost anything might suddenly arrive, from just beyond the ordinary limits of vision, hidden in mists, beyond horizons.

The autumn of 2000 brought with it most unusual weather. We did not have access to the type of forecasting that exists now, only twenty years later. We had no charts on the island. We were utterly ignorant of how an extensive system of low pressure might be brewing in mid-ocean. On the other hand, we were well used to severe weather and knew we should be ready for its arrival at any time. We were usually given a warning of deterioration that was reliable for twenty-four-hour segments, through the sea area forecast, and we were proud of a record by which we coped with such situations on the island itself.

But drama and tragedy unfolded sometimes just beyond eyesight, and just a few miles away. In September 2000, Spanish fishermen plied the west coast of Ireland in large trawlers built for the open ocean, as wave after wave of gales and high gales built up along

the western coast. The reports came in, sporadically, over the radio, calls repeated over a week of repeated storms: lifeboat calls, Pan-Pan calls stressing emergencies at sea, eventually intimating the break-up and loss of vessels along the Galway coast. Nineteen men ultimately died.

From a sharp, jagged rock at the edge of the European conti-nent, empty but for two inhabitants, the news is followed daily. Just at the cusp of changes in technology, the main source of weather, and weather-dependent news, remains the shipping fore-cast. Every three hours, updates are regularly heeded. Sometimes a call for observation from this outpost is made from the shore: a diver, a yacht may be missing. At this time, the island lighthouse has been automated for fourteen years; occasionally, lighthouse faults are reported back to the shore, to be verified from Dún Laoghaire. Communication is erratic. There is no electricity other than a battery for the VHF. There are no mobile phones, no internet. Yet every day, Spanish voices making broken 'link' phone calls via the Coast Guard station become very real. To lovers, children, wives. 'Cambio. Cambio.' On many days, when the sea is particularly rough, the voices from the station on Valentia, and of the mostly unintelligible (to me) foreign fishermen, are the only voices we hear other than our own.

Suddenly the sea will open. Final communications are vaguely discerned:

> One final voice upon the radio lines, one final
> calling
> Caught upon the wind, on the passing in and out
> Through the doorway on an ordinary afternoon,
> In the emptiness of light in late September;
> The sea raised, arm upon arm of white.
> And hands, at every barrier: the great hands
> Of white spray lifted silently, seen and heard from
> miles

Away, and over the greater distances of time.
The hands gathering the most distant of signals:,
Hands raised high, through which everything is
 seen,
Hands pushed outwards, risen above the rocks
In silent displays, held against the window of the
 sky,
Rising against the borders of the living, the tilled
 earth,
And suffused with countless cries, still-living cries
Carried in gusts to fall back upon the land
 beyond,
Heard at every corner, plotted upon every quad-
 rant
Of that tightly drawn map, the compass of the
 heart,
Known at every corner of this station now.

21 September 2000

High clouds tower overhead and sail away to the south, leaving an empty space in their wake; the light begins to die quickly. The clouds rise over the horizon in pillars of white fire. The day quietens and dies, joining with the departed light of the other recent days.

The world that I see spins ahead between the barriers of darkness, between the barriers of the past, falling rapidly as darkness rises: once more, I see the gannets advancing, turning slowly in the pale light above the horizon. I stand upon this ridge of rock, staring out upon the glowing rim of the earth – a tightening ball, cobalt-blue, in its final blaze in the far distance. The birds glisten, suspended above the horizon-line. The earth sinks below them, leaving a fluid space, marking an upheaval of internal time; all is being remade in the moments before night finally falls again.

Something is happening within the shifting levels of pressure far out upon the Atlantic.

Suddenly, there is a rippling motion across the entire range of vision on the surface beyond; the calm ocean shudders momentarily; a great waving begins across the face of the sea, as in the shimmering upon butterfly wings or the glistening of beads of water along a gannet's neckline in flight. The surface shivers, and the finest of spray rises along a line. Far away, depressions, fronts spread, pull against surfaces with irregular tension; the body of the ocean rumbles underneath the surface to an unseen engine in repeated transactions of water and heat and light.

Banks of grey light rise now, one upon another and almost lost within the sky but for their clashing outlines, strung in quick series, the signs of their moving at different speeds, partaking in a dance unravelling over the course of the entire visible sky, and then beyond, here as the sun sets behind this part of the world.

The weather is changing.

Suddenly the weather is changing.

22 September 2000

All is silence here, but I'm acutely aware of inhuman sounds within this silence tonight: the gas lamps purr loudly in the huts; the sea sizzles in the darkness on the rocks below. The lights from the trawler that steamed closely by at dusk disappear into darkness southwards. This is the period of equinox, and I am aware of the earth tumbling through its passage: so much is dissolved through the heat of this day, through the roaring lamps and shifting seas; so much falls upon, is channelled through, the arms of the dark pinnacles above. All seems harrowed upon the rack of this place.

This afternoon, uncertain sunlight broke through the banks of passing mist just at the right time, and long enough, to see the lintel in Cell A illuminated once again. When I entered the cell I saw a pale rectangle of light rising slowly upon the walls of the interior. A hand of light fell over the dark gaps between the courses of stones, knitting them briefly together, sealing the inside of the dome. Slowly this hand, this window, rose and

curved upwards towards the open doorway. All the light falling onto the bedrock from the west in the late afternoon stood channelled into the small opening behind me and was thrown onto the glittering wall ahead. Then, all at once, this window of light was hidden by passing clouds; it was absorbed into the dark spaces between the stones. The light came and went within the room, concealed from the world beyond, stored within the cell when the sun shone, then obscured once more when hidden in passing clouds. The cell had become a glistening jewel, an observatory, a powerhouse.

Coming from that place, I stood outside the walls of the monastery, looking out over the ridges of the sea, and at the peak directly ahead, and down into the valley. I stood at the top of the steps above Christ's Valley watching the folds and fissures of rock, the deep, almost vertical indentations of the peak twisting upwards against the open sky, rising straight from the cove far below. Fulmars were slowly turning upon this strange hollow of the land, upon a ridge standing above the sea – playing on the movements of the air, balancing on the stark topography. Falcon perch, fulmar ledge, prayer station, lighthouse enclave became illuminated in turn, each caught by the late light breaking through clouds, moving swiftly over the island. The landscape was divided; the ground became activated, living. Though few birds were present – the puffins long gone and the shearwaters invisible underground – the terrain of their activity was awakened suddenly in their remembered presence and by an awareness of the travellers who had climbed to this valley over centuries. The valley glistened and came alive; levers in the earth seemed to reveal the full vision of the ranging birds, flung from here to every corner of the globe; levers opened, as well, to a full vision of all lives passing through these raised crossroads, high above the sea. The ground was opened to the light and then sealed once again, and the landscape acquired its ordinary features once more, becoming rock, running water, and held by ordinary sight. The world was broken open into ridge,

peak, track of flight, and sudden activated glory of light; then the valley and peak were darkened. My life was held there, in a balance between two ways of seeing, within the clear and empty light of the place that afternoon. My life was balanced, tossed, like the lives of the little birds flung above the monastery wall into the updraft within this sculpted playground of the wind.

The structures of the air, the lines and circles of bird-flight, and the soft and curving green slopes come alive again under my skin, which seems no longer mine and is only the air that fulmars bump against as they circle upwards into empty space above the cliffs. They stare into my face, as if from within. I watched a peregrine resting near here today, on a spit across the valley: his mask down, his wing feathers tousled by the wind, his breast of ivory poised upon the peak where he was perched; his eyes dead-level, keen, searing the air where I stood.

Brief spurts of light are spread below within the valley: they mark his territory, the launching points from which he will rise to pierce neat holes within the island's atmosphere. These disappear and remain unseen. Flashes of light settle through the bowl of the valley, land on soft growth and are absorbed and hidden, just as the light that has fallen upon the lintel stones is hidden within the darkness in Cell A.

Vice-grips of light tighten, turn
All appendages open, split the skin,
So that suddenly a body is raw, on
Reduced mobility and learning new
Outlines, a new skin marked only
By little flames puffed up within
The air. We listen in the glowing dark
To our lamps shimmering under a skin
Stretched carefully, taut, between each
Peak, standard, and rock so that
Our form now echoes the space below;

It becomes the air, compresses the air
Others, or perhaps no one, will breathe.
Within us, the white birds hover, circle,
No longer their own within this territory.

A peregrine balances upon a rock, just as if I
Were not there: staring through me, looking
Through a sensed presence. So the figures add;
The reasons for staying, for weighing
Light, become obvious, then are vital:
We breathe the deep air stirred within
An engine marking only ocean time
Upon the dark, within the heart. The table
Lamp is so placed, and so staked, it is tuned
To purr upon a line of further darkness,
Against the ordinary air in which
Everything else has been shorn away
Momentarily, so that we remain
Nothing now, but for someone
To breathe this other altered air, ciphers
To register, note, absorb its movements.

The gannets circle low over the water beyond Blue Man's Rock
– spinning quickly downwind, stopping, then turning slowly back
against the storm, swooping in low swags against the force of air.
Each one gleams, transfixed momentarily in passing, its outline stark,
suspended above the running force below, its dark wing-tips melding
with the sea, stirred by the active swell. The coiled bodies scare the
running fish beneath them, herding them, culling silently, inexorably.

And within the low circling of the gannets, I am held within
a void framed by this thin and whistling box that is the hut.
White knobs on the cooker loom out of the dull light before
me; everything is still within the room: the artichoke flower that
retains streaks of past living colour; my nails, which seem to grow

visibly here. The froth is active, the pressure of air is sinking
outside, the barometer already low.

> For the gannets bite
> Hard into the wind, swallow sea music
> Which is funnelled through the spires
> Of stone. Shimmering in the morning
> Light, their bellies glance upon hands
> Of spray; they swoop low
> Over water, propelled to fall downwind,
> Their wings outstretched upon honed tips,
> Upon blackened diamonds shot far distances
> To Biscay, then returning once again.
> But today, equinoctial turning in the earth
> Keeps them on tight and confined planes,
> Low on the tossing water, their mustard
> Beaks barely penetrate the surface now
> As they dive and disappear through
> Disembodied trails, vanish in froth
> In rapid, low, celebratory hunting;
> Not far from soon-abandoned homes,
> Making do with beauty at the wild turn
> Of the world, these kites of heaven pull
> The strings of flight out of the sky,
> Changing the pressure, releasing localized
> Sound, controlled explosions within
> The pressed air, their premature snow
> Pressing, pushing the light through these
> Rocks onto, and within, every dark surface.

Saint Michael, a Mighty Warrior

Since very early in the history of Christianity, Michael has
been known as the highest of the angels. He is the leader of
God's army in the Revelation of St John, where the final

conflict between good and evil is described. There, Michael leads the forces of God in the defeat of the dragon: the devil, who was the deceiver of mankind from the very beginning; Michael and his host of angels cast the dragon down into the sea, 'as they did not love their lives so much as to shrink from death'.

Because of these references from scripture, over the centuries the traditions of Michael as a mighty warrior, and the protector of those engaged in spiritual warfare, has emerged. The monks heading out to the Skelligs, and to other similar and exposed places, saw themselves as soldiers in God's army. Monks were to fight through prayer for the souls of all mankind. Just like the earlier monks in Egypt, it was said that through their efforts the human world would be sustained. So closely associated with the fate of men's and women's souls, Michael is often depicted as a winged spirit carrying a bright sword for battle. He is also shown as carrying golden scales to weigh the souls of mankind at the point of each individual death.

As the Skelligs monks came to a dangerous place, they looked for protection. They were to live exposed lives here. The sea could be treacherous. Marooned at times by weather, supplies might run dangerously low. Invaders might appear. In fact, Vikings attacked the Skelligs in the early ninth century, perhaps more than once. It is recorded that they carried away an abbot, Eitgal, and that he died from hunger and thirst at the hands of the Vikings. Standing upon the parapets of the monastery, looking out upon the crossing to the mainland, it is easy to imagine the terror that the sudden appearance of longships on the horizon might have inspired in the hearts of the men standing there. The monks would have known well, through reports from the heartlands and along the coasts, of the devastation that the Vikings had visited on monastic foundations throughout Ireland.

Given the hardships that life on the Skelligs imposed, these men must have believed that their endeavour was absolutely necessary that they were following a summons that they could

not deny. They followed an inner call pushing them to a further lookout, to a spiritual battlefield, to a place like the 'outer desert', the 'terrible' place that St Anthony had found in Egypt. Though the place they were called to was dangerous, though they required spiritual assistance to survive there, they reached and survived at a place where the glories of creation could be perfectly revealed. Cut away from society, with all of the natural world spread before them, they established a little foothold at a place that, while dangerous, was poised at the edge of paradise.

In this 'other' world, they encountered an order of danger, of exposure, but also of rapture. A sense of profound abandonment is suggested by description of monks in the desert, on secluded islands, or on mountaintops. Men arrived at extreme places and experienced life in a different and rarefied atmosphere, and as they made landfall their sight, their experience, was altered as they were immersed in the movements of the sea, the air, and the weather. Looking back at the mainland, the Skelligs monks must have eventually looked back upon a place that had become alien and distant, a home that had nurtured and supported them in earlier life, but from which they had been set loose and untethered.

It is uncertain when the dedication to Saint Michael was made. The earliest references are to simply Skellig, but from around the tenth century the island is known as Skellig Michael.

There are stories of St Michael that are particularly associated with the Skelligs. In one of these, St Patrick is called upon to assist the people of the Dingle Peninsula, who are beset by demonic activity. Patrick climbs to the heights of Mount Brandon (the highest mountain on the peninsula) and from there he calls for assistance from the Archangel Michael, who resides with his angels on a bright white shining rock, some way off at sea. The Skelligs gleam brightly when seen from the mainland; as they are the only islands breaking the horizon-line beyond the Blaskets, it seems clear they are the islands indicated here, in this tale, as Michael's

sanctuary. Michael and his host of angels arrive from the bright rocks at sea, then banish the demons from the area. Michael protects the coast and the remote high mountaintops. In another story, he is the one who secretly changes the water in the monastery on the Skelligs into wine for the saying of Mass every Sunday.

———

Visionary light reorientates topography and land and seascape. I stand at the parapet on the eastern edge of the monastery and pick out Mount Brandon to the east, as I rise through the fog cover into the sunshine and see the mountains of the coastline beyond. A few other peaks are spread before me above the clouds, while the rest of the world underneath vanishes. It seems as if I might walk there: to the Little Skellig, to Mount Brandon. Angels were said to associate with the high places where holy men prayed. And such places were said to be bathed in spiritual, holy light.

The brothers of a community were said to peek from shelters to see hidden light resting above the heads of the abbots, who were engaged obliviously in night-long vigils. Monasteries were said to have become, through the efforts of these men, citadels of light, beacons at the edges of darkness. Holy mountains become lookouts upon the wastes beyond.

Through the years the island has retained its association with St Michael, like its counterparts at Mont Saint Michel off the coast of Normandy, at St Michael's Mount in Cornwall, and at countless other sites throughout Ireland and Europe. Modern travellers puzzle over lines drawn linking these sites of dedication, heading on to Rome and then Jerusalem and the Holy Land beyond. There is even an official St Michael pilgrim route linking these places, which has developed recently, with the Skelligs as its point of origin.

I was flustered when, a few years ago, I was asked by a young pilgrim if I might stamp her St Michael's Pilgrimage passport. I was

forced to hastily draw in miniature an unrecognizable archangel and wish her well on her way. During my time, the traditions of a local pilgrimage to the island have continued, if sporadically. These can be very moving, with people from different parts of the south-west travelling to the island, saying Mass at its foot, and progressing up the steps in a relighting of an ancient route of faith. During these processions the steps are brought to life in an old way, a way very much in keeping with the original purpose of protection and with thoughts concerning the welfare of the entire world, I still treasure the unsought, and surprising, blessing I received from an 'Irish Elvis' (Presley) at one of these events, when I was suddenly embraced and greeted with an enthusiastic 'God Bless You, Son!' in a very credible Memphis accent.

I sit at my desk now and look at one of the St Michael medals given to me by a pilgrim long ago. There is a card accompanying the medal with a drawing of a youthful winged Michael slaying the dragon once again, and on the back is printed this prayer to be repeated daily:

> Saint Michael the Archangel
> Defend us in battle ... Do thou, O Prince of the
> Heavenly Host,
> By the power of God, thrust into hell
> Satan and all evil spirits
> Who wander through the world
> For the ruin of souls. Amen.

Times change. Some balk at the language of spiritual warfare and the imagery of angels at war with demons for the soul of mankind. Yet everyone knows too well of inner demons, and the literature of warfare against them fills modern bookshops, and we all know personal stories of the ruination of souls, and of fears and hopes for the redemption of those endangered ones we love.

Mountains have been lookouts against the unknown beyond

since the beginning of time. And holy light, holy ground as a feature of the mountains, and of high places, is common in religious and spiritual thought in many different traditions. After time, after centuries, some may still see holy light here on Skellig Michael – and the light associated with the protection offered by St Michael – but most will see and understand the world differently. The language of these things changes. The monks have departed, their views of the world and nature have undergone innumerable upheavals, and the whole world has moved away – for better or worse, or both – from seeing an island fortress such as this as a citadel of protection for the soul of the entire world, and from seeing its few inhabitants, though there are none now here, as warriors engaged in fighting for the protection of all humankind.

Today there is a slightly different light that seems holy, special, blessed, and a balm for the spirit. But it is a balm that depends upon knowing of the movements and upheavals in the great world beyond. At times it seems they are inescapable. I think of that, as I look out through the soft air, the softest of lights here today. After days of storm, the briefest of Indian summers descends upon the island. The surface is still, almost oily. It slowly undulates upon a seamless skin and finally, quietly, fondly slaps against the rocks. I can see down through depths, see the fronds of seaweed slowly swaying in the movements of the tide: pea-green, orange in the rays of penetrating light. There is a sudden gleam of silver from a thousand tiny fish, turned for a moment into sunlight. I am overwhelmed by these gentle but far-reaching movements unfolding before me, and far away from the island.

Suddenly the surface breaks, not twenty feet ahead, as I stand at the bottom of the steps, with the fins of Risso's dolphins. These are larger than bottlenose dolphins and marked by great splotches of white pigment along their flanks, each configuration of colour unique and distinctive. I have watched them from the monastery at times, nosing into the landing far below me, appearing as white

ghosts or as belugas misplaced a thousand miles too far south.

There is a sense that this calm will not last. Off above the western horizon there lurks a wedge of uncertainty, a presence forming in pale grey and yellow light and spelling the demise of the high pressure over our coastline, centred out at sea. We sense the onset of further storms. We do not know this yet for certain, but if we had a glass, the barometer would be inching down towards bottom levels. As it stands, we have only these markers of temporary and poised perfection: dolphin fin, dancing seaweed. And the white and holy light covering us here.

26 September 2000

Fog suddenly arrives, reaches in cold hands over the rock, descends through levels of the Skelligs sky, passes down its peaks in rings of mist; it falls upon us here in dark, chilling shadows, weaving a garment falling upon our heads – a garment that ties us into the rock. We are tied within the lives of raven, passing gannet, gull. And the gulls just outside, wheeling out towards Blue Man's Rock and away, tear open holes of light in the veils of the sky: ripping the mist open, slashing to the ground as they pierce the fog, feeding fresh light into the side of the mountain; making up the thick atmosphere, freeing a newly formed dark rock of the spirit to steer upon an unknown sea.

This ship of the spirit is being cut loose by hard weather. The ground underfoot rumbles, shakes, quivering in the sea's nascent movement against the rock far below. The ground lurches, balances against the rise and fall of raised waves slowly passing by against the island.

And the surf steadily works against the pistons of this island engine; the wheelhouses of the monastery, and of the little oratory at the peak, tighten course upon the air. Energy-drills – from the High Cross, from raven backbone, from rabbit skull – wind to spring and release light and thrust; they adjust themselves almost imperceptibly, but steadily. The island balances, stands stock-still.

There is a quiet eeriness here this evening; rock walls shimmer as I pass.

The steps shine in the fog; their hard teeth bite against the island's atmosphere, spiral upwards into the mist. But every night a new demon arrives and surrounds the suspended rock. There is some new aggregate of evil always lurking ahead and reared against the island; all that is past, all that has come this way before, stands ahead, imminent, gathered at the interface between island and sea. An aggregate that is both general and particular stands against us, made out of individual weakness and that of all humanity. The cut stones chew against, taste this air, strip us clean, release the stairs to spring upon the emptiness beyond. Over and over again oncoming storms lash against the rock. Layers of experience crumble, are ground into the stones. The island is torn apart, night upon night. A deep hole in the earth is torn open as the island churns and steams into the dark.

> The sea rises above me at every turn;
> Ridges tower behind this hut. Every raised
> Wave, every indentation of the surface
> Is gathered in the rain standing
> Shunted now, in an instant, halfway
> To distant Scotland. But the room is full of light,
> What seemed lit dust is risen spray: released
> From the ocean floor, pressed into the cells
> Which wheel in the light on the terraces.
> For just a moment, walls of stone will open, light
> Will stream through porous timber. We see why
> We have come to be here and why the light
> Is shimmering on the table ahead just now:
> We, too, are on the point of flight, of immersion
> Into a final sea, repeatedly. Here
> There is an island made only of such fleeting light.

We know this only once. We know once
The continuous whipping, the agitation
Of light wound within the skin; the shadows
Rear and slap down upon us, hard and fast,
So that we hold them, we tie them down
With every sudden flash, so that we weave
This darkness and this light as one.

Radical Transitions

That autumn, in the year 2000, the weather changed frequently.
It wasn't just the effect of the equinoctial gales or that two hurri-
canes might have come together to cause a repeated series of
weather surges against the western seaboard. There were periods
between storm days when the sea would suddenly calm in an
uncanny way, when visibility through the surface was heightened,
when the air was crystalline: then there would be a lull between
systems; during this time there was hardly anyone on the island.
The sense of, and need for, being able to hear and communicate,
over a distance, and from a besieged place, became very real.

For the last two weeks in September, and on through the first
days of October, there were extreme fluctuations in the weather.
Sometimes the air would be perfectly still, even as high seas
divided around the rock, pushed along by storms in mid-ocean,
cutting the island away from the mainland for days. Then, caught
between the shifting weather systems, the sea would turn a strange
colour, almost green, and become perfectly still and transparent.
For a day or two, it seemed that we were in the tropics. The
water was still warm, and it would lap lazily against the pier in
the early morning, radically changed over twenty-four hours.
Lines of harmless white 'froth', left over from the storm of the
previous day, would be stretched over the still surface in the
morning sunlight. I could see deep down through the seaweed
rooted on the bottom rocks, just away from the pier. I walked
around shirtless in that beneficial light.

But during the last few days of September, around the 29th, the Feast of St Michael, massive gales struck the west coast of Ireland, and trawlers were lost.

On some afternoons, when the winds weren't particularly strong, I struggled to the monastery to sit in the strange, eerie stillness there. Other times, I was unable to leave the hut, as everything loose was being cast away into the air, and it was difficult to stand outside. The waves would come around the far point, Pointaweelaun, beyond the landing and explode as far above the road as I have ever seen, and then run back, down through the chains and over the pier in a white boiling river knee- or even waist-deep. There is a little hut about thirty yards up and away from the landing; sometimes the water would reach over its roof. The spray could be seen passing far above as I was climbing the steps to the monastery, in running clouds, hundreds of feet above the sea.

Blue Man's Rock, jutting from the sea just below my cabin, was often awash during those days, and it was easy to see how the lantern of the lighthouse, 150 feet above the level of the sea, had been cracked open during an earlier storm.

And then, finally, after three weeks of radical transitions and extremes of weather, of strange sequences of changing light, weather, seas, and wind – and dead calm – the sea settled and I left the island at the end of the first week of October. I had not seen weather like this before.

There were tragic consequences of this running upheaval in the seas off the western coasts of Ireland. Marooned as I was, I felt keenly for the sailors tossed in waters to the west and the north who had not been able to reach safety. Daily I imagined the tragedy being played out in the sea just beyond sight, and I knew and recognized the fears expressed over the crackling radio waves.

27 September 2000

The seas will combine, the rock will be lifted against high water, the heart will be ripped open. This will happen only once.

Hands of weather skirt round and round the edges of this place, the teeth of rock singing as if its chains were loosened tonight, wiped clean of any standing rainwater by the whips of the wind. Dark forms beyond spread in fantastic shapes, moving across the sky quickly, at times luminous with bright starlight. And all here is held and moves within these sounds and shadows, is held within this constant battering of the walls of the hut – so pale, the light so dim within here, the walls glistening by lamp-light, the light fomenting the little visions of the night and the images of all past life, of all potential, at whatever remove, on the point of appearing – in every shimmer of the wall, in every darkened corner of the dim room.

Here in the engine room, set for the clean and complete combustion of the white light.

Today the sea was wilder than it's been all year. Up to force 9 blowing from the south-east, stretching heavy waves to curl slowly around the lighthouse point, reaching to Blue Man's Rock, overwhelming the south side of the island. A white cauldron of water ignited; regularly, low and direct sunlight pierced the raised sea, eyes burned through drapes of quickly passing cloud. The vision stretching ahead seemed altogether unnatural: white towers rising upon the banks of the Little Skellig, resting in mid-air for several moments, suspended above the repeatedly fed, repeatedly cascading spray. The white mist a flowering vapour; water in torrents through the deep cuts and channels in the rock. Occasionally, a perfect rose would rest in air, soundless, suspended off the nearest spur, caught within the sunlight. And lingering for what seemed too long.

The Little Skellig remained a separate world for the afternoon, a register of other-time. Arms of cream, of foam, were stretched in swags in the lee of weather from both islands, reaching across

one another, heading southwards. The gannets were beating through the grey skies, lost at times behind high troughs, wheeling backwards and forward against the gusts. I watched one for several minutes making circles and dives, never finding rest, struggling against the released strength of the weather. The birds gathered in clusters and briefly and repeatedly formed low, angled towers, momentarily flaring with light against the storm. They reformed themselves just above the water, gathering near the crazed surface, stretching out quickly in the gusts of wind, searching to find places to dive from again, giving their strings and loops of life to the low grey air, to the maddened sea.

Up in the monastery, small streams spread along the pavements, shifting in little surges gust by gust, even in that high and sheltered space, just in front of the doorway of the oratory. All the island's vitality, its story, combined there in the running water, in a concentration of power and force, pressed from pounding currents besieging the island from every side. The bursts of swell, the cloudbursts, the low pressure zones juxtaposed across the North Atlantic, all were held within a press, a distillery, created this day from all incoming waters: overflowing through high cisterns, dispersing in the open air beneath the monastery and falling seaward, issuing in a flowing river of sparkling light. Raising, into open sky, the human hearts passing upon worn stone pathways below. The spray lingering as cannon shot upon suddenly empty air, and then brief silences.

The weather is briefly becalmed on the Feast of St Michael.

29 September 2000

A swallow appears in front of me and runs the gauntlet of the lighthouse road, down the river of air between wall and rock face, in the sunshine. Two falcons chase and strike against one another high above the monastery.

There is the softest of lights upon the stones. I planted the lemon thyme I've had in my hut for weeks in the garden and left

the artichoke flower in the open air above. There will probably be no one else here for months.

Over at the smaller oratory, on the tiny terrace beyond which faces the Little Skellig, soft white light falls from the window and onto tiny closed buds of pimpernel. The light inches slowly over the pavements, following routes it has followed for centuries. I find myself singing; brief bursts of human airs tangle with crow call and gull cries. The strange and interwoven cacophony rises to linger and echo above the rock in this brief and quiet window of weather.

The soul is stretched and dissolved within this open empty place. As if it were nothing, made out of nothing. Then it is remade, briefly holding the speech, holding the light found resident here – the light moving, rebounding within my skin. Over and over again this happens: this light must be wound into the heart.

I am passing these little stations of such dissolution for the final time this year.

'And they loved themselves not unto death' I read today: the paradigm of St Michael; the paradigm of what is struck, and resolved, within the abandonment of the soul. 'And there was war in Heaven ...': that war that splits the soul open, exposing it to the empty sky. The war between light and darkness, bound within the soul, allowing its continuing existence.

Once again, we are nearly becalmed, and two beautiful days pass.

The energy gleaned from abandonment fills the rock, the air: from each high point of the island, from each lookout upon the sea, it spreads out towards the chaos of the world beyond. This energy, stored within this rock over the centuries, falls through the air in the unearthly song pressed through hidden rock, pushed through the openings through which the light is forced about me here, throughout these autumn days.

Here at the cusp of our time, light hangs
In mist strung between hands and arms
Of the weather, between the fingers
Of the rock. The light is golden,
Soft toward the mainland, and the birds
Dance, they twinkle repeatedly in flight,
Illuminated against the purple hills which buckle
Between sea and sky to the east. Above my head
And down the flanks of rock wings spin slowly
Within the golden light. The air divides
Into rooms they are passing through;
They near, they pass quickly before me,
They flicker past my face and veer away
From this high platform, trodden summer-long
Into near-perfect emptiness. The air is whipped
Into a state of utter emptiness. I stand within
A place of raised stones: the huts, the roads,
Are struck in Braille, release small flames
From ordered light set
To channel air which passes overhead,
To make it sing.
The huts and roads are empty,
Dazzling constellations of light
Move along undeciphered tracks
And fashion unspoken language. Little birds
Dance along drawn-out rhythms of time;
Gather, hover about these stations: the light
Plays just beyond this platform
Of raised masonry, just beyond its edges,
And all of time here is broken open.

And all of life begins once more.
 Dark, wonderfully starry night; sliver of a new moon hanging
low over to the west at sundown.

We are shifting slowly into the dark time of the year. The light balances, holds back in moments; the progress of time slows. Bright shafts of light seem to hover within the cell as the lintel is illuminated for the last times this year. The light is golden on the lintel, is stationary momentarily, then slowly, almost imperceptibly, it disappears into the recesses of the masonry.

The light is rising over to the northern side of the lintel of Cell A now, a few days past the equinox. Its position at sunset shifts slowly within the dark room each day this week. The light rises golden on the jambs of the doorway this afternoon, finally appearing back in the gap along the lintel top, slightly away on the left-hand side. I have passed through a final crossroads of my time here: that is what I thought, sitting in the darkness of the cells as evening began to fall. The water, the air, perfectly still.

I'm down in the hut by the gas lamp now, and the stars stretch overhead; the sea sizzles quietly below. The hut stands perched within the twilight. Its lamplight stretches dimly ahead upon the dark. It is surely undetectable on the sea beyond. Up on the peak a short while ago, I could make out the ridges, chains, the steps and ladders that were falling away below me, down to where my lit hut stands and where I am sitting now. I had climbed earlier along the rough path to the west of the saddle, rising on a pathway marked by white lichen, which was glowing brilliantly in the afternoon sun on the rocks. Near the highest point on the island, on a narrow ledge on the South Peak, suspended beyond the monastery on the opposite peak and above the empty valley far below, I crossed the threshold of the tiny ruined oratory.

Evening was closing in, and the hidden terrace floated high above the sea, at one with the rising level of the fading light. Shadows began to darken the higher ridges. Edges of the peak unfurled in petals of slate and shale, coalescing in the outline of a flower: a flower resting upon the curtains of mist, dividing the obscured valley below from the empty sky ahead and above. Small

patches of golden lichen, and little Kerry diamonds hidden within the rock face, retained uncanny brightness within that tiny and sequestered place, scattering small flames here and there within the sheltered enclosure as the light came and went. A wren hopped ahead, the only living thing, exposed in the light along the line of ruined masonry.

I move now along this unfolding river of stone, seeing the face of that little wren – bobbing ahead of me, its tiny brown form shifting in the half-dark. I follow that grey rose of stone as it floats out and disappears into the emptiness – bright, high above the water. Nothing is visible below now.

I saw a petrel flit out from underneath the rocks where I had climbed, on the steps coming down from the saddle, and I have heard three or more chicks out by the wall tonight, shrill and insistent on the warm, quiet air, so they are still out there.

The place is drawn and stretched; the few birds left here fire away on the evening air. The island is clear of life and sound.

Along the edge of the horizon, a new dark line of cloud forms, a pencil line in deep violet, very low in the sky, merged with the far rim of the ocean.

Another wave of very low pressure is imminent.

1 October 2000

Repeatedly through these days there are radio calls signalling danger.

This morning, severe southerly winds harass the hut once again. The sea is tossed, active in an intensifying swell like the one of a week ago. Ridges run one after the other, rising ever higher in a flow of molten, released movement. Very dark here this morning, and the forecast up to force 9 again; yet now a wave of blue tears the sky open, hurries across overhead, and there is dazzling brightness suddenly; this angry, isolating wind slams yellow light on the table before me. The light lands and stays and increases in solidity. The room slowly turns through the morning on this axis of fallen

light. Outside, the doors and barrels bang and rattle in the blustery gusts.

How can it remain so still within the shivering walls of this place? Within this tiny enclosed prison of light, there is relative silence, in comparison with the increasing level of natural violence just beyond the paper-thin walls. The glass in the window bows; my footsteps, when I cross to the cooker, echo eerily, as if catastrophe were imminent, as if the walls were on the point of crashing in. I know that will not happen. I have experienced much stronger winds here. It is just the radical divergence of pressure, of noise, inside and out, that makes it seem as if the hut is untethered, when I know it is lashed solidly into the rock.

Last night, the stars revolved overhead on their ever-turning candelabra, in their steady sequence, leaving pinpricks of clustered light to fade into the far corners of darkness, to be replaced again within the great procession of the constellations, rising and declining steadily through the course of the night.

The contrast could not be more marked this morning: uneven shifting light, a medley of loosened waves, a chaos from the charges of wind and water at opposing angles; yet the light still marking time, harnessed to move northwards across the floor of Cell A and be released away into the wintertime. Shivering unseen upon the floors of the cells overhead. For a thousand years.

8 p.m.: Ghosts rear in the twilight outside, raised high above the wave-heads on westerly gusts. The wind shifts direction all the time. Very strong and high sea, wide and quick-moving troughs; very disturbed, agitated water, shaken into stillness in moments in the lee of the island, then forcing hand after hand of white upwards in darkening light: these cross upon themselves in towers that hang and fall. Silent, high plumes reach up into the atmosphere. Down at the landing, spray rears in white hands twenty and thirty feet overhead. Mountains of water peek from time to time around the corner at Pointaweelaun. Small fires of white burn all along the slopes of the Little Skellig now; some-

times waves converge, rush instantaneously up remote flanks of the rock.

The roar outside is continuous and, beyond the immediate din, huge paws glow at random in the heightened darkness beyond – off the Little Skellig, off the Washerwoman's Rocks.

This chaotic march of weather passes overhead, and this has kept me here in this cabin the whole day. Raised hands of the sea, appearing from the corner of my eye, parade across the full range of vision. Now the wind has increased a bit but has gone further westerly, so it's more sheltered here, though the rock whines as much. Coming back up from the landing just now all the pinnacles of this place stood clear, rigged to catch this weather just at its first contact, at its first break over the land. The Wailing Woman – that naturally carved, imposing rock brooding above the pavement of the lighthouse road – is suspended, rigid in supplication, her hair streaming, glistening in the dark grey light, keening for all of us, it seems, for all the men out there, imperilled on the sea. The little turnstones dance and are tossed quickly down the road, living, skittering shadows moving within the darkness of the rock.

Ridges of white fire along the water, endless symmetrical lines reaching ahead, and the light all day dim, as dim as I've known in daytime along these roads and in the hollows of the place. All is still, apparently inert, within this room where nothing seems to move; all is very still, all elements pulsate on very low, very broad waves of light, catching signals from far away, catching glimpses of running lights veering wildly upon far horizons.

2 October 2000
Luke 14: The Salt of the Earth
These gales return endlessly.

Another wave of storm this evening: outside this window, as I write or read, I stare at white explosions suspended in the fog – starbursts worked by the surges from the south-west, hands of

spray that reach completely over Blue Man's Rock. The world is being worked loose. We know there is probably trouble beyond. All is picked clean here: the bones of the place are exposed and set against the sea. Eleven more fishermen are presumed drowned from a trawler which struck rocks off the Galway coast last night – nineteen now over the last three days.

I write and read of the white tide moving under the world of these monasteries and it has reached now out under the hand of the Atlantic and taken these men. They have moved over and into and through the rock; the monastery has been grabbed, shaken, moulded, and finally released. For this day time has stood still. Through this rock has passed another configuration of light, pulled in and pushed through by intense pressure from beyond: the pressure from every soul passing nearby or standing just beyond this border, those both living and dying, washing up against the rocks of the Skelligs tonight. An agent is eating into the rock, undermining it, setting it adrift. Every passing soul has been rendered; they have been brought in and passed through the rock below me here. The challenges from the wind and the weather here are eternal: they never stop; this whiteness is oncoming, falling upon this place from beyond the curve of the globe in the songs, the rendering of every passing soul.

> There was another wave to come which was
> A final wave, was always near and on the way
> To its appearing: the interval
> Before its time narrowing in raised arms of light,
> Quickening pressure, making our step give way
> In the heavy air. For the rock falls from under us
> And opens to thunder, to the fierce roses
> Of spray creeping quietly around the back
> Of the island in a hundred feet of high
> Imperial skirts, worn by tall starlets
> Working it here and there, and rarely

Quiet. But the loudest rustling is that
Of these terrifying flowers, pale lilies
Of the sea, one for every drowning man,
Their petals uncurling continuously,
One upon the dissolving other: the stamens,
The pistils of their submerged anchors
Holding them, but only to let their stalks
Shoot skyward. Mesmerizing at times
Is the green stalk in my mind's eye
Holding these water lilies far above
My head, and poised like thunder.

For the sky
Is full of flowers deadly by their intensity,
In the sheer force of their arrival, sprouting
As the sky clears at day's end. Lost men
Are retrieved tonight; these lilies retract,
Unfurl upon water, extend over the dark.
The poundings continue into night.
The white petals spread and thicken,
Rear upon each other on the darkening sea.

Far above, I see other flowers stretched upon
The high unreachable monastery floor, the pools
Of disturbed water spread here there at different
Levels, in the dying light which opens stone:
The grey cross is a man-stalk holding up the sky
And tying it down, and the petals and avenues
Which double back, retrace themselves again,
Break open the light from its monotonous
Confinement, stir up the fragrance of roses
From the sky and earth, suck the winds down
From overhead. I know that underneath
Each chamber lies a man resting there,

Nurtured by the spirit of every trodden and
 raised space,
The spirit released through the compression,
Which has been building over years,
Of the sprouting flowers of the heart:
By which these open chambers stand on rock in
 air.

They have touched these fields tonight
In rough weather; massive petals of storm
Rise, fall, and hold them there: they batter against
Our walls, our rock with their arriving souls.
Hear their thunder, the thunder of Jesús, Juan,
Andrés? The rock shakes below as you pass
By here, as the ocean sprays high into air
And repeatedly ties, battens this world down
Where so many are dying tonight
In repeated seethings of water, mud, hatred, fire,
Its lotus of white fierceness aspiring unto
The far extent of the universe, stretching
Through leaves, petals, forests in its continual
 rage.

4 October 2000

4 p.m.: Lovely pale, warm sunlight coming out. It is difficult to
describe how wonderful this feels. The pale sea seethes so much
more softly than even this morning. The gold sprays of lichen
run along the top of the lighthouse wall; the fingers of white
settle more quietly upon the headlands of home. The Lemon is
still half-covered, and skirts still rustle loudly and regularly below,
but the world has turned back from rough white chaos; its colours
break into wider prisms. I stretch into the pale light overhead.

And into the field of white lilies, into which men have disap-
peared, above the field that subsides under the surface of the sea.

Many men are swallowed up in uncertain light. At the little oratory terrace on the peak I watch the fulmars circling below the monastery, and they were carrying all this light with them, were manifestations of the light falling across my face. Below me, to the horizon, stretch layers upon layers of softly rippling petals, of water carrying light through all roads, through the channels that we ourselves become for light, channels that are each a part of light broken, dissolved, and remade. We have been taken along these channels into the furthest places, on into the houses of death. Channels which are etched upon our faces, which are etched upon the surface of the ocean, which push light onto the rocks of the far shore.

Small buntings – snow buntings? – scatter through the monastery and over to the bottom of the peak in beautifully crisp, white displays, cutting the air with their brief trills. The ravens croak madly over the pavements of the monastery terrace. There was still one petrel left, whistling insistently in the wall as I stood in the middle of the enclosure.

Once again, the whipping light divides around us and at the same time enters and entwines itself with the bare bones of our being, creating a pressure of light from within, shining against the walls of the heart, creating the need to be at a far station: the light of this world sprouts ahead upon white branches, superimposed over the water; and our skeletons, our bare bones, are suddenly illuminated, glowing on the suspended platforms of the monastery floor, cast out upon the sea beyond.

The Ravens
The surfaces stand, but slippery as ice
And it is hard to gain any traction.
The air steams high behind the huts,
Rises in shifting towers.
The sea is mountainous;
We stand breathless, the emptiness

Pulling us to further destinations,
Coming now into view: everywhere
Pitfalls appear; endless horizons strain
Capacity and engines falter, overload.
Now the rock falls before our feet.
Craaa! They suddenly call from every
Pinnacle, every stone. Each bird is
A messenger, a marker, touching us:
Real, unreal; alive, dead. We disappear
In the lit beams of dust held in gloaming
Light this afternoon in the cells,
Moving in and out of other forms,
Other bodies in these empty rooms,
Confined where white light hangs
And sweeps across the windows,
Heeding calls that someone should breathe
This white light, that someone stand here.

One, two, three ravens shift
At the tip of the pinnacle above.

CHAPTER ELEVEN

Unexpected Encounters

E vents from different years run together in altered sense of time that seems to register when I am on the Skelligs. Some highlights strike so deeply into my consciousness: my first rising onto the peak, first watching the fulmars below the bedrock, and the phosphorescence on the surface of the sea. And then the great storm of September 2000, that caused such loss of life. And the deaths that occurred on the island in 2009.

But underneath all the other events and all encounters that I have experienced on the Skelligs, I hear the rhythm of footsteps, walking out of the door in the morning with the ocean spread before me, going down the road to the landing alone, and climbing up and down that ladder of stone steps, always seeming to rise at an unnatural angle, suspended just off and above the natural rise of the rock.

I walk down to the pier in the early morning light to have the world made new once again — an old phrase is apt here, for the world often seems literally remade on these early trips down to the level of the water: the Little Skellig floats ahead just beyond me, at the end of the road going down to the sea; and even though I am remote, and isolated, the living potential within the world dawns anew, beyond the headlands eight miles away, wound

tight with potential for the thrust of new life. The days of such apprehensions combine, one upon another.

I set out, relieved once more of old, worn ties. The temple of living before me is torn down and replaced by a new one, rising seamlessly on the surface of the water ahead. And I am called to embark, to enter into the great structures of the open light. To embark within the traditions of abandonment, of disappearance, within which so many have embarked before me. And in doing so, refit the worn skin of this rock-ship.

The birds glisten all along the cliffs in the early morning sun. Just off the rocks, razorbills and guillemots quiver in shining communal rafts on the lit surface; in sequence, they dive fifty or sixty feet, leaving ghostly white trails under water. A bull seal submerges; his shadow slinks away from me under the surface. I sometimes come down at high tide to find a young seal asleep on the pier and, if I remain quiet, undisturbed by my presence.

One summer, we arrived a little earlier than usual, before the continual droning of circling boats was to be heard around the island. In the weeks before our arrival a young seal had taken up residence on the concrete pier. At high tide, he could slide easily onto the surface and bask comfortably in the sheltered sunlight there. Arriving at the landing, I would try to quietly descend the twenty or so steps to the level where this young seal was resting, and I would see if he would respond to my singing and not immediately disappear. His huge eyes would warily scan my actions, until I could stand about ten feet away or sit down on the last step for a few minutes. I told myself that he enjoyed my repeated rendition of 'Swing Low, Sweet Chariot' (I have no idea why that was chosen, except that it was one of three songs I would sing to my daughter when she was small, to rock her to sleep), but of course I have no idea. At least he didn't slink away, or hiss and spit and lunge as he might have done – and as a parent certainly would have done – had I come upon him unawares.

This landing provides an interface with the world of the shore, but in the early morning its presence is otherworldly. Whether it is agitated by a sea that is raging just outside its rock shelter, or whether it is flat calm – when I can see the woven movements of the birds, diving and swimming below the surface, or the sudden flickering of silver from thousands of tiny sprats – the landing is a vibrant place. In the first months of the summer, if I jump in, there is a sudden explosion into flight over my head: puffins, guillemots, razorbills rise in a great wave all around me. Kittiwakes scream overhead. The shadows from the surrounding pinnacles divide the waters of the little pool off from the pier into rooms of dazzling brightness and dark shadow. The birds land again, on the water by the rocks on the opposite side of the pool, and beat their way furiously on a stairway of air to find their little resting ledges in the sun, and cackle in response to the sudden disturbance. They toss spray from their furious wingbeats into the clear air of the morning. I rest quietly in the water for a moment; the Little Skellig dances on the surface before me. Though it is a mile away, I can hold it with outstretched arms, floating in the mouth of the cove, weightless. The gulls, the ravens beat out in circles from the monastery high above.

This is the place of beginnings, where the world is remade daily. But it is also the place where access to the island might be comprehensively denied. Light falls in torrents upon this little cove. I do not know what I will see when I turn the final corner on the descending road. Sometimes, what has seemed to be only a gentle rolling swell when viewed from up at the huts causes the waves to meet just beyond the pier, to come around from both seaward sides of the island, to suck the water repeatedly, erratically on the rocks in the cove, in a wild display that no boats may near. Many have wanted to make this landing and not been able. I have waited for days, on occasions: waiting on the island, waiting on the shore, waiting for the landing to subside so that passage might be possible.

In the first years I worked here, my wife once travelled down the western length of the country to visit me on the island, a trip I only came to know about at the last minute, as the boat was leaving the harbour. She boarded on a bright and beautiful day, only to have to sail by the island altogether, as the sea had roughened since her departure from the shore and the landing had become unapproachable. We had communicated by erratic 'Skelligs post'. I had no certainty that she was coming. My heart wrenched when I saw her pass, a hundred yards away, waving to me as she was carried across the mouth of the pier and back towards shore, after all the arduous journeying. After the excitement and anticipation of the sudden summons by radio, and the walk to the landing – down the bright road, with the light trickling through the slats of the canopy, the sea dazzling below on my right as I descended – I turned to trudge up the empty road once more.

This is where, and when, the otherworldly light of beginnings and endings strikes upon the mainland just beyond.

> That singing heard in high places woven into the
> light of the morning;
> She was just there upon the coloured glass of the
> water
> Rising above the froth of the landing, without
> preamble
> Or definition. Immediate.

A few years later, two of my professors from university days brought postgraduate students on a trip from the United States to visit monastic sights. John wasn't much older than me, but when I had been a student in the 1970s, David would have already been an elder member of faculty. He would throw pinecones for his corgi to fetch in the university yard; to those students he latched on to, he was incredibly good. He gave me undiluted –

and, I thought, unwarranted – support. He was huge, with a shock of white hair and an Alabama drawl. To me, he was a paragon of sanity in a puzzling university world.

When my mother was dying, in 1978, and I had returned from Edinburgh to care for her, David turned up at my flat looking for me after I'd left. He wanted to do research at the Library of Scotland and thought I would be company. Finding me gone, he rented the room where I had been a lodger.

But I was to miss him once more. In 1990, he came to Ireland with John and some students, determined to get to the Skelligs. For two nights they stayed on Valentia Island with my skipper and his wife (as close to the Skelligs as it is possible to be, but still eight miles of an ocean crossing away), hoping that Dermot Walsh would bring them out to see me on the island. A swell was up, and it was impossible to cross for days.

I was well used to hearing Spanish, as well as the voices of fishermen and sailors from Kerry and Cork, calling to one another and to Valentia over the marine radio waves. But that first morning when David and John arrived on Valentia island, I was utterly shocked to hear a voice from Alabama on the radio – one that I knew very well and that I had not heard for years. And it was coming from a home on Valentia that I knew very well too, only a few miles away, but in real terms as distant as the moon.

'Bob – eee! Diar-mee says we can't get over THERE! What do YOU think? O-ver.'

I could imagine Dermot chuckling beside him, and I imagine that they would have got on well. But there was nothing to be done. The sea was high, and set to continue so. I could only advise these friends to travel north to County Leitrim, to stay with Maigread and young Daniel for their remaining Irish stay. I was not to meet David – or John – after all their efforts, on this second visit across the Atlantic.

About ten years later, David died in a nursing home in the United States. I had, thankfully, been able to visit him twice in

the intervening years. During the last years of his life, he suffered from natural forgetfulness. When he passed away, there was a commemorative service for him that I would have loved to attend, but I could not go. Something strange came out there: I was later told that, during the last years of his life, when he was in the home, David had told people that he had come out to visit me on the Skelligs, that he had actually made the crossing. He firmly believed he had set foot on Skellig Michael and that we had walked the island together.

Some others arrive on the island only to find that they are unable to proceed beyond the bottom of the steps. At times, they might try the first few flights and, from below, I can see their knees and thighs begin to quiver, and then watch as they stop, stock-still. This is not always caused by vertigo or a fear of heights. For some, this journey has become magnified in importance because of the length of delay, or the frustration of circumstance, that has made their arrival to the island difficult. My first year on the Skelligs, I met an Australian nun who had visited Ireland on several occasions with the specific desire to come to Skellig Michael. Weather had frustrated her at every attempt. By the time I met her, she was quite elderly. And she found out at the bottom of the steps that, because of fear or imbalance, she would be unable to climb the steps in the natural fashion. Undaunted, she crawled slowly, often on her knees, all the way to the top, and descended again, after an hour above, in the same way.

Some will come to the island as a final or further extension of their life's path. I have met visitors over the years, some walking quietly for an hour or so around the area at the bottom of the steps, who have told me they were unable to climb because of a serious and terminal affliction, but who were absolutely delighted by the opportunity simply to set foot upon the Rock and to gaze back at the mainland from the perspective provided there.

Sweeney, mentioned before, flits from island to island along the coastlines of Ireland and Scotland, only able to rest upon crags and in bushes in the peripheral wilderness. He is cursed by a cleric, he watches from a distance his wife courted by suitors, he is unable to find any steady supply of food. But over time, he is overwhelmed by his natural surroundings and is ravished by the beauty of the world beyond the world of men, which becomes his only home. He comes to live in a natural cathedral where light is breaking all around him in sight-changing ways, until he is finally brought in by St Moling to die in peace, a dying bird-man in a monastery once more. In a way, in the story, no one really knows about Sweeney's transformation until it is written down after his death. But in the account, the trail, the arc of his flight is vividly depicted, and that line − of a legendary man-bird − remains on the horizon out to sea and haunts the coast still.

There are so many reasons why people might visit the island, and each person will have a different story to tell, standing trans-fixed by the light coming and going at the bottom of the monastery stairs. There can be, at that place, a sudden realization of common humanity, allowing strangers to speak almost spon-taneously to one another − whether they are at a personal extreme or simply because they have arrived at a last end of the land, at a lookout upon the endlessness beyond. Many people come to understand the sharing of sentiment that becomes possible when each in his or her own way reaches this last border between the land and the open sea: a physical border, which, for some, is a final or difficult or personal one.

Maybe it is because of the view that catches one suddenly, and without any external interference, when turning a corner of the island road, or because of the raw exposure to the wind that has been travelling over the open ocean for hundreds of miles.

After a while, the light takes form here,
Inhabits men and women, and speaks

Aloud: for the men who had set sail
Into the western horizon, steering upon a sea of
 crystal,
Gazed upon the Paradise of Birds, and their light
 became
All living things. They climbed the ladder of light
Spiritual, along the walls of high and hidden cells.
And earlier, crossing into the deeper desert,
Following no known route: fed by ravens,
Protected by lions; they would calm the waves
Of even the furthest highest seas
In the service of that light. Developing distant
Vision, so the story goes.
In later years, these men and women
Would gather light upon the high rocks,
Learning of the ravishments of the deep
And lost places, of the birds who would come
To rest upon their hands, their feet, making
Their ways in an endless succession
Into the mountainsides, into the farther depths
 beyond.

After a while, all this activity was simply about going up and
down these stairs, ascending and descending this ladder made of
light, daily retracing the routes of the island – since ancient times,
walking the perimeters of endlessness, staking out the boundaries,
walking the parishes, following a cloistered route in the empty
air; defining something central; looking out.

2 August 2010

I walk down to the landing in the morning light, and then again
late in the evenings over the course of these days: dead young
puffins are spread everywhere along the road before me. Only a
small percentage of chicks hatched this summer will make it back

to land next spring: that is the nature of the cycle of their lives. Many fail even in their first weeks, before having the chance to swim out on open water, to run out over the sea upon a life that has been poised to last for thirty years and more. I turn the corner of the road and walk under the shadow of the wooden canopy which protects the way under the steep cliffs of Cross Cove. Ahead of me lies yet another broken young Manx shearwater: injured in his first attempt to fly, a casualty of last night's strong wind. His wing stretches awkwardly outward. He stares straight ahead at my approach, acquiescing with a little reluctance as I lift him up, as I examine him, as I place him down once more within a sheltered place. I return a few hours later to see his body picked open, only an assortment of entrails remaining on the road; they glow eerily in the late light of falling evening. A gull rises from the carcass.

Over and over I find such signs strewn before me on the road, like dice, or conjurers' bones, or leaves of tea: signs that reveal a multitude of lives broken open prematurely, and suddenly. In dissolution, their sustenance is taken up and passed on into other creatures upon the narrow road, snaking along the rock and its tight confinement. The surface of the rock, the way along its paths, is littered with these stranded and dying forms: grey, softly glowing embers, they are weights under the skin, magnets that lead on, along the road, in a sequence from one empty place to another. These cycles of living and dying become a part of my own movements. The birds struggle, some pass away; and then, some rise, tearing away from my hands, lifting away from me; leaving me here, stranded upon the road. They carry me off, into the emptiness beyond.

> We knew at once the exultation
> In our skin, lifted and ripped clean,
> When we arrived out in this weather,
> At the bare rock. We hurled ourselves

On unseen things; our souls were filled
With an unfiltered light;
We had been cleansed, emptied,
Marked in this depth, of this field.

After we stepped out upon the dry ground,
Added light was being tied within our skin:
We were breathing altered air.

Within this place of shifting light,
Within ourselves, small things remain
Hidden and unseen: but still alive. Within
The mountain as we approach, they sit, wait:
Light shifts as they move upon a floor of stone;
Little birds tumble through sequestered air,
Enter through the skin as we stand in the cells.
They land upon the floors of our souls.

Small things remain, and come alive there,
Perfectly still, spread through the green air,
Stretched upon stone platforms, suspended
Over, and within, the sea. Unrecognized, tiny
Birds pass in and away from the rock – they
Return through masonry, and enter within.
We cup our hands over these little creatures,
We carry them down the road toward the sea;
And we release them, into the unknown.

Each year, through the midsummer months, we meet young live
birds, as well as these dying ones. Young puffins, shearwaters,
petrels, fulmars regularly haunt the road at dawn and at dusk,
hiding in shadows on the road leading down to the landing.
Usually, they have fallen prematurely from nests on the cliffs above.
I often stumble upon them. For some, nothing can be done. The

few intact ones that we can reach we scoop up, hide them away further from daylight, from hungry gulls, and carry them down to the landing for release at nightfall.

Storm Petrels

The storm petrels are the smallest sea-birds nesting on the island. But there are smaller birds: land-birds from the mainland and those passing regularly in migration. At times, in September, the monastery will come alive with a dozen snow buntings, on their way south: little white-breasted presences fluttering through the empty air between the cells. Very occasionally, a tiny goldcrest might take up residence for a few days below, near sea-level. I pass him on the road as the bird rests there at my head height: his glistening eye the size of a pinhead; his little yellow cap aflame in a bright golden spike.

Once, my colleague told me she had seen a robin on the island, but I didn't believe her. However, on the last day of the summer, in pouring rain, as I passed down towards the landing with our little tractor filled with supplies for departure, there he stood, his red breast glowing in the dense fog of the lighthouse road. On another occasion, a corncrake was wandering around the monastery in the late afternoon. And I have seen a heron returning from the sea, heading east to the mainland. Where he had come from I do not know.

Many people never see storm petrels, yet thousands of them nest on the island. Along with Manx shearwaters, they are the so-called 'night birds' of the Skelligs. While both these species are vulnerable and awkward on land, they are able to migrate thousands of miles southwards when they leave the island in October. The shearwaters release eerie calls upon the night air; they depart and arrive in the darkness to their burrows and to other homes on the monastery floor. They stumble along clumsily over the rough terrain of the southern slopes of the island as I climb the steps in torchlight in the evening. But they are not

idly called shearwaters, for their long flights depend upon skimming movements in the troughs of the great Atlantic winter waves, through which they navigate southwards for the winter from the Skelligs and then return again to their burrows in spring.

The little storm petrels are most amazing creatures; they are very small and light. They squeeze into the tiny spaces of the walls of the monastery, and along the lighthouse road, and between the stones of the steps. Along each extension of masonry, at every level of the island, their soft whistling call can be heard coming from within walls. They quiver in little clouds overhead on summer nights. They can appear to be most gentle as they wander slowly along the lighthouse road in moonlight, as they come to perch and rest.

When Maigread came out to visit me during my first summer on the island, we stood at the wall against the lighthouse road, looking out at the night sea. We noticed that one of these little birds was wandering down the flagstones toward us: his little black shiny eye glistening in moonlight, his white rump a dimly shining, slowly moving lantern. He walked right into my outstretched palm to rest there. Such is the strange connection between people and wild things in this place.

Apparently docile, these little creatures flutter their way across the equator once they leave the Skelligs. They carry the name 'petrel', as they are said to walk upon the surface of the ocean as St Peter did, trailing along behind fishing vessels in mid-ocean. Old tales have it that they harbour the souls of lost seamen. After thousands of miles of flight, these tiny creatures work their way across great sea wastes to find their little crevasse in the Skelligs walls. Some will live to be forty.

Beyond our living space, these vulnerable creatures hatch, fly out on unknown tangents, and pass away – repeatedly, endlessly. Their movements illuminate the flight-lines stretching into darkness. These tiny black petrels hover in thousands above the monastery in the night at midsummer, a continual wave of dark,

fluttering forms, butterfly-like, darkening the almost-bright midnight air above the cells. The white circles on their tiny tails fill the sky with what seem to be small moons, circling and hovering in the night sky overhead. Thousands of these tiny birds are tuned to home in on South American seas and then to return to a tiny crevasse on Skellig Michael.

They rise and fall in the night sky: quivering, hovering on their regular oscillations, which multiply out beyond the lighthouse wall where I stand. We release them, sometimes in handfuls, these tiny creatures, as we move ahead and down the road late at night; they are cast beyond the curtain of the rock. They carry us into the darkness. They move out beyond the horizon. Their movements are wound into our vision and mapped within ourselves, yet they stand away from us, utterly enigmatic. We give accounts of how their movements have affected us and how they have inscribed their trails within our consciousness, even as they are disappearing from the island. We catch the glint of their eyes watching us in lamplight, the living and the dying ones hidden in the burrows, hidden in the rocks along the road, and thrown far into the air beyond our sight. All their mystery held within the small frame of their utterly fragile yet resilient existence.

> I greet a little bird, stretched beneath
> My feet, stoically awaiting passage.
> The headlands glimmer in late afternoon;
> They flare with pale light momentarily.
> In the air a fountain,
> An empty space shifts
> And dissolves through the afternoon
> Unseen, disturbing the balance of light.
> As evening approaches by ebbing tide
> The breeze rises; seals trumpet below
> As the surf is struck by light, one

Moan giving way to another
In a broken arc of repeated sound, rising
Between open rocks where the birds pass
Homeward across the mouth of the cove,
Their collected notes riveting the singers,
Holding them briefly in the arms
Of a deep and spontaneous calling:
Their sound verging on unbearable
Frequencies, almost unregistered,
Striking within the empty cavity
Where a sequestered place is stirring
With the rhythms of unfolding light
The currents of continual flight.

All along the coves, the ridges, the indentations of the island, the calls and songs of the birds and seals echo and build and linger. Song builds towers within these empty places: where these rhythms are held, where they are played and established, within the hidden burrows, and upon abandoned glistening stone floors, and within the heart – and where these rhythms change the light and where they change the outline of the world we see.

Natural Rhythms

Natural life unfolds in the air and seas about the island in rhythms that often go almost unnoticed. Petrels and shearwaters slip away from the island, unseen, each September and October. They take much longer to prepare for departure from the nest than do puffins or razorbills. A chick sits quietly for weeks on the floor of Cell A, hidden in a corner behind rocks. One of the parents arrives with fish under cover of darkness. By morning, he or she may well be gone again. But the little chick remains, a ball of grey down, quietly, gently heaving with each breath as the unsuspecting human visitors wander by, a few feet away. Then, one morning, they are all gone.

The natural rhythms I have come to understand in my years on the Skelligs must have been ingrained in the consciousnesses of the men who lived here long ago. What rhythms marked these human lives? Survival must have been precarious, particularly at the beginning of the establishment here. What would they have eaten? Surely they depended upon the sea. We know seal colonies were used at some Scottish coastal monasteries. Closer to home, the middens from monastic foundations not far away from the Skelligs show the bones of many of the birds we know from the island – puffin, gannet, shearwater, razorbill – as well as fishbones. There are tales about the monks of the coast being allowed to eat sea-birds, even in fasting times, as they were considered part fish because of the birds' diet of sea food. It's easy to understand the rationale for this line of thought, watching the puffins diving far under the surface, using their whirring stubby wings as flippers to reach sprats, rising again with mouthfuls of quivering silver.

The monks always had to catch rainwater, as there are no sources of fresh water. They organized cisterns for collection right under the cells where they lived in the monastery. At first, though, they would only have been able to collect it running off the rocks after rainfall, down the slope of the bedrock.

By any standard, this would have been the most basic level of survival. Supplies must have often run low. On a few occasions over my time on the island, I have watched our own water supplies starting to dwindle. This is a most disturbing sight when accompanied by the knowledge that storms are queuing, one behind another, out at sea and that relief might not be possible for several days.

But this community survived and, after some time, a rhythm to living here must have been established. Codes and practices known at other sites were adopted. On the Skelligs, these must have been intertwined closely with the rhythms they understood intuitively from living the exposed lives this place demanded.

They regulated their days by the monastic hours, rising early to say the first offices of psalms, responses, prayers. There would have been the work of simple survival to be done: fishing, tending a garden, with difficulty, building, collecting water, fulfilling basic needs.

We are told that small bells were rung in most monasteries to mark these hours of human endeavour. But natural rhythms were of necessity bound with human ones: returning birds in spring must have been the cause of great delight. Imagine seeing the first colourful red beaks of puffins in the spring air, after the darkness of bleak winter! The arrival of new sources of sustenance must have provided the greatest of comforts and reassurance, heralding longer days, calmer seas. Perhaps these also promised renewed commerce with those ashore. Today, even I know that the mackerel will run close to the rock from midsummer on, and fresh fish will be there. Certainly, all kinds of seasonal rhythms were known and appropriated by those trying to survive on this rock at sea.

I think of the ringing of the hours above long ago, of Terce struck along the platforms of the monastery, a sound resonating quietly within empty coves below. An ancient Irish rule book dictates that there should be silence until the hour of Terce, the third hour. A bell would mark the culmination of the time of silence and contemplation. This hour was not set by anything occurring naturally at that moment, for the sequences of nature would always continue unchecked, just beyond the monks' outstretched hands. The canonical hours were a human ritual, repeatedly observed upon an empty rock. They were struck repeatedly as men chanted over darkness and silence. And they were struck on small bells, the sound reaching around the circumference of the island, from ridge to cave, cave to ridge, and dying quickly away on empty air. They were a continual reminder of how lives are balanced

against the waves of the sea, against the winds that buffet the surface of the oceans – against everything that comes in from beyond.

The bells of the hours ring on the Skelligs, against every arrival, upon each quadrant.

The Skelligs monks stand still, observe the cosmos, absorb unfathomable movements beyond them; they see the birds disappear over the horizon and return from unknown places. The chanted hours insinuate themselves into the darkness just beyond. As the day begins, and beyond the hour of Terce, the prayer the stillness stored through the morning is carried through into the action of the afternoon, so the quietude of the morning – that homage paid to the unknown, bound within the chanting of psalms and liturgy – is channelled into stonemasonry and gardening on small terraces high above the sea. Thoughts and images that are the products of silent contemplation have to be directed through the hours into the body of the rock. Prayer enters the stone and roots itself there.

Confrontations with darkness and endlessness inform every endeavour, activate every prayer. The monks walk the steps along a boundary, along an edge between the dark and the light, stalking their pavements, sending messages into eternity. They remake these ridges with every footstep wound into the rock. Their prayer roots them to the rock, to this sharp and empty ridge. It sustains them against the emptiness they have chosen.

Now we perform other, and uncertain, haphazard rituals. Now we take ourselves down to the edges of the running sea at nightfall holding little weakened creatures in our hands, creatures hardwired to leap into the unknown and join flight-lines that stretch away from here to unseen places, so that they might return and enliven the island, to mate beneath its skin of dust and growth each year. The moving hands of the ocean, the lines of flight whereby the birds depart from and return to the island, insinuate themselves within our skin and become a part of us: puffin, shearwater, fulmar,

petrel. We suddenly lift from ourselves as the birds depart. We are carried out beyond the lighthouse wall. A different kind of abandonment takes hold. The moon rises through an almost transparent network of skin and bone that forms the rock which is stretching ahead, carried by flight, far out upon the night. Each departure, each bird-way stretches to touch the water beyond our sight. The island stretches itself even as I stand, stock-still.

The island travels upon a skeleton of pathways that reach into the dark. The shadow of the rock can be seen, dark over the surface of water. The road to the island from the mainland beyond appears again, glistening in the moonlight. People wait in storms on the shore for the ferry to the island. The rock splits. This island of imagination shifts along the edges of darkness, hides and is revealed along peripheries of sight. It moves out upon the ragged intervals of the horizon that open before it. It disappears and reappears again.

> The moon rises through outstretched hands
> The sea shimmering in the night beyond,
> Drawing us out to hover beyond the island.
> This station is our catapult upon the night;
> In a final closing of gannets' wings,
> Our souls are broken upon pendulums
> Of flight taking all our strength, all our
> Running light. The birds strike
> Into the clear ahead out of the shadow
> Of the rock, are scattered beyond,
> Ratcheting the light they have left behind
> And abandoned, high above the water.

> The mountain is alive in the pale white light:
> Each glistening ridge of water shines
> As a hook of bristling silver,
> Connecting one soul into another

Upon the surface of the dark water,
Illuminating a connection of broken souls –
A map opens, written on the water and within
The heart, as the light is taken from the cells,
And from the headlands, and is cast
upon the horizons beyond –
The divided dancing light
Weaving us into one another,
Casting us upon the darkness,
Leaving the rock, for moments, bare.

This is the map that tells how the light will disappear; how it will run deep within the earth. How it breaks our bodies open in a thousand shards, a thousand glistening raised hands, shining upon the surface of the dark water.

⁓

During my first few years on the Skelligs, we usually had, as I have told, little or no idea of what was occurring in the world outside, beyond the Kerry headlands eight miles away. I brought a newspaper with me and read the same one for three weeks. I might in desperation try to remember from associations with friends, who were long lost in the past, what on earth the bridge columns were all about. The death, wedding, and birth notices were particularly interesting. I could make up stories about the unusual names found in these entries. Sometimes even the dry political commentary stirred interest during downpours. But for the most part the only thing from the outside world that really roused my interest was the arrival of letters, which seemed magical and totemic things. The stamps appeared as beautiful artworks. As in teenage years long gone, it was great simply to hold missives from loved ones. Unless, of course, they brought bad news. News of trouble. Illness, accident, unhappiness.

Stephen Roche's victory for Ireland in the Tour de France, the 'St Stephen's Day' in midsummer, was announced by skipper Dermot Walsh as the *Agnes* sailed into the Skelligs pier one bright morning; it seemed to augur well for the entire planet, for some reason, and be proper cause for a national festival. The event seemed to take on cosmic consequences as the orange hull sailed up against the pier. Things might appear extremely bright, or utterly desolate, from tidbits of simple news from the shore.

On rare occasions, in my early years, the lighthouse would still be occupied. Though the keepers went ashore in 1986, this remained a working light; it relied on a diesel engine and a lantern that required regular attendance. Old lighthouse traditions die slowly; regular inspections, naval style, were always a feature of all stations. Standards of presentation remained ideally at military levels. The lighthouse on the Skelligs was still regularly painted and the accommodation kept to a modern (more modern than my hut!) standard on into the 1990s. The Commissioners of Irish Lights arrived regularly for inspections; the flag was raised; diesel was pumped up the road to storage tanks; the catchment banks for rainwater above the compound were regularly scrubbed. All of this took place behind closed gates, as the lighthouse accommodation became less and less used over the next twenty years.

Still, during this time, painters, electricians or service personnel might be required at the light and might stay for a week or two in the course of the summer. There was a television in that compound, taking a signal by a fragile antenna poised above the gate, which would quiver but stand in gale-force winds. It was powered by the diesel-run generator. So, in 1990, my third year on the island, it was impossible for me to resist the enticement leading me up the lighthouse road to probably the most unusual viewing point in the whole country for Ireland's first appearance in the World Cup.

My daughter had been born in February of that year, and she had a little green ribbon tied into her hair for the two weeks that

Ireland were in the competition. When Ireland were qualifying for the second round, she had screamed blue blazes at the roar in Stanford's pub in Dromahair when Niall Quinn scored. Everybody in the village considered her presence good luck from then on. So I knew where she was that afternoon. There were three men there from the Skelligs lighthouse, two workmen from the island, and two guides watching nervously in the lighthouse common room. The match with Romania was tied, full-time. In the penalty shootout, when David O'Leary scored and Packie Bonner saved, Josie Murphy started dancing around the little open space in the middle of the floor. He grabbed me and gave me a big kiss. I knew that men everywhere across Ireland, brought up not to cry, were in tears.

We all walked out of the lighthouse, and I walked by myself down the road. The shock of settling was immediate, as I was taken up after this brief hiatus again into the world of gull and of puffin. I stood looking over at the mainland, aware that – in the way that would have only been possible thirty years ago – Ireland was completely closed down and united in a quasi-spiritual struggle. Banks, businesses were closed for the match. When I went ashore two weeks later, there was still green and gold everywhere.

But the smallest of things could be of immense significance then, and so even now. There would be some funny encounter with a visitor in the midst of the hubbub of people coming and going. There would be a shared cup of tea below, or with a boatman on one of the boats, followed by the solitary walk up the road and the slow ascent through the demarcations of solitude marking off another world, where suddenly the great gyres of bird-flight would descend upon my head over and again. There would be the sudden impalement of direct sunlight, standing on the ridge behind the monastery, as the sun set late in the evening: the repeated falling of solitary rays accumulating over time in a continual hammer blow upon the spirit.

It seemed when wandering alone I was always hearing music
on the island. Over time, little rituals of my own naturally devel-
oped, as they always do with people. I would sing at certain places
on the island when I reached them: the furthest little station on
the far side of the peak; the bottom of the North Steps; the
landing; and the small oratory on the far side of the monastery.
A piece of music returned very clearly to memory from long-lost
years of choral singing, 'Cantate Domino' by Giuseppe Pitoni, an
eighteenth-century rendering of Psalm 149 Canticum Novum – a
'new song', roughly translated. It seemed appropriate. I could
only remember the bass line, but I started singing it at exposed
places on the island. I'm not sure what music sounded like on
this island centuries ago, but that doesn't seem to have mattered
much to me. For some kind of music seems continual on the
Skelligs: seal song, the shearwater cry at night, the gull scream. And
ravens. I have found that ravens love even untuneful human song
if it is deeply expressed. Ravens do not mind shouting, either.

I can see my situation again very clearly, even from the first
years, singing along the back ridge in the early evening and being
stunned on opening my eyes and seeing those fixed-winged angels
of the cliffs, the fulmars, hovering wide-eyed directly before me,
only a few metres away. These sights and incidents are woven
with one another by snippets and airs of music through all of the
days I have spent on the island.

A friend gave me a transistor radio. Once Ireland's football
fortunes failed, I had little use for it until I discovered the magic
of Tim Thurston's *Gloria*, Sunday morning, 8 a.m. Batteries had
to be at the ready. Among other treasures, one year Tim played
a Bach oratorio every Sunday morning. I knew that the gannets,
too, were waiting for this. I have had the opportunity to see the
gannet dance in perfect counterpoint to each chorale I would
hear through plastic earphones, sitting at my little table on these
bright mornings. It is not really possible for me to describe the
effect of this: the shock of hearing this music juxtaposed against

the unfolding rhythms of flight played out just before my eyes, after days of hearing no mechanical sound other than the drone of diesel engines.

Occasional interruptions to an unfolding rhythm of life on the island occurred from time to time, bringing other reminders of the great world outside – not just news reports. A naval vessel or a customs boat might leave off crew on dinghies for a few hours. Perfunctory conversations with visitors could turn by a few words into the sharing of secrets between people unlikely to meet again in the world beyond. And always after, and before, any of these encounters, both significant and insignificant, the great white light of the island falling as an overwhelming presence – sometimes almost taking human form, especially in song and quiet speech, sometimes wrapping long arms around me and saying, always, 'This is your life' and then 'This is not only your life, but everyone's'.

Many who have been imprisoned or isolated in any way for a period of time, for a lifetime, have spoken of the need to develop ways, other than normal channels, to communicate with those unseen beyond and to somehow get some version of their lives, their story, to fall on ears out of reach. Small encounters, small inventories take on unusual significance in such a pursuit: people become friends, acquaintances, in extremities of place and time. Tiny communication breakthroughs with harsh guards, imprison-ments, make days last. Tiny exchanges of unsought-for kindness reverberate through personal darkness.

How fortunate I was! Here, light took form, spoke and sang in the swinging movements of the birds, in the song resident in the steps, opening wide intervals in stone and gully for the music of the spheres to ring through peak and valley, and to briefly take physical form in the sudden cut of swallow flight, in the revolutions of gannet towers, in the thrumming and chanting of puffin wings: all descending over the rock, building in an ongoing mantra throughout an evening, landing upon the walls of the oratory as I sat there, balancing those sounds with the constant roar of the ocean below.

But the heart always awaits further opening; there are further reaches against the darkness and chaos just beyond that the soul is always being required to make.

～

The island is emptying once more for the winter. Petrels and shearwaters are fledging, the final sea-birds to leave the island. They pass through our arms, which we stretch high upon the night sky. We too will be set loose soon.

We call this place holy. This holiness is defined by what is unseen, by the activity that has left behind relics: the cells; the empty pathways that wind on the edges of the island; the flight-lines that glimmer in the sky overhead, marking out the ways of the island. The unseen is tied down onto this bare, harsh rock within these things.

The jagged outlines of rock shift and re-form before me as I move along the road. I know the wall of darkness ahead: poised to destroy my sight, to negate my understanding, to stop my breathing. Arms of flight reach down and descend over the pathway, but then they disappear. Arms of starlight strike across the dark surface of the water.

At times, the darkness beyond provides the only canvas, the only focus here. The darkness ahead, in which we stand utterly insignificant, is the engine that generates all things: the emptiness, sucked clean of all ephemeral things, brings all new things before me. The emptiness of the raised, glistening sea, of the sky, of the hills beyond; the emptiness of the sad passage of time, from which all bright gifts come forth and stand out in sheer and glistening relief.

I stand in a stream of falling light. The birds gather in the sky to form an outline of wings, but these disperse; their lines fray and dissolve into pure air; the falling starlight opens rooms that glimmer further upon the night, opening my sense of time and

distance; but then these, too, disappear. Yet these gifts hold to outline a far orbit; together they paint the grid over darkness upon which the ship of the spirit may move. This light, which shines in brief illuminations, quickly charging across the sky, quickly brightening it, pulls against a static vision of all things. It pulls hard against my own darkness within. All things appear out of the emptiness here. It pulls the ship of the heart out upon the open sea, its wake of phosphorus glistening in the dark. The darkness sings.

> Quickly moving light falls ahead
> Upon the road, quivering brightly
> Around my shadow tonight;
> Reaching for me with soft fire,
> By hands of risen water which
> Snap with barbs against the empty air,
> Hook against my skin upon lighthouse
> Roads where I ascend from the landing
> And see the light ahead broken, divided,
> The seething sea held in the moonlight
> On empty white flagstones. The sea sparkles
> Within its flowing skirts, pressed by endless
> Weather to establish a rhythm, form
> Code by which the sight is cast ahead,
> Funnelled through the night horizons.
> I see the little spurts glimmer,
> Aflame, starlight cast before me,
> Falling upon the wet dust of the road,
> Marking out the darkness ahead
> And overhead: breaking the darkness open.

Once more, a curtain of starlight stretches over the empty ocean. In this utter silence, this light falls through me, picking out every vanity and tossing each away, one by one. The whole vocabulary

of my experience is hollowed, scorched in this light, tossed into
the night. My tongue is taken away. Unlike in the Old Testament
prophecy, there is no hot coal provided here to enable this tongue
to speak. It is stripped of its ability. Deep within the darknesses
of my own soul, at one with the darkness beyond me tonight,
all light, all time, gathers against the coming wall of my departure.
It is an accumulation not only of this year's time, but of all the
years spent here. All gathered light stretches each night upon the
open sea as a glittering field – alternately dark, then golden. A
mesh of glittering movement stretches out along the horizon,
opening beyond the boundaries of this world, stretching on to
the world, and the further darkness, beyond.

Other Voices

Years have passed since those days at the end of September in
2000 when we heard voices calling, when we heard voices straining
to make contact from beyond the horizon-lines, calls crossing one
over another beyond the walls of white light rearing up on the
sea, beyond Skellig Michael. From the confinement of this rock,
we heard cries of joy and cries of calamity and fear. During those
days, the voices of those Spanish sailors, imperilled upon seas just
beyond the horizon, echoed through the island and became a real
presence to us there.

I stand under the stars along the lighthouse road, ten years
later now. Below, the sea surges, casting hands of white surf all
along the rocky shore of the island. Through the sighing of the
sea, I can hear Aunt Sarah's and my mother's voices once again,
and the voices of sailors, coming in from beyond upon the night
sky. But I also hear other voices: I hear the shouts of those
tortured in hidden cells tonight throughout the further world,
shouts that remain unheard. I hear shouts from the dens where
evil is plotted and carried out. Signals that are blocked elsewhere
ring clear here. Others suffering in conditions very different
from mine come to walk the platforms of this empty rock.

Beyond the radio, outside normal spoken voice, there are other lines of communication. Arms stretch above the glistening ocean. They rise high into the night air and draw strings about the island. These clutch at me; they carry me high above the island, so that vision may strike down upon cells hidden and far away. Then they release; they tighten as a gown, a shroud, about the ridges of the rock.

The island hovers just beyond the edge of social gatherings, just beyond normal commerce. Voices come to be sealed within this rock. Everything suddenly closes; night falls. And spirits, people, images, voices, arrive from everywhere: on the boats, on the thin air.

> Skellig Michael becomes a dangerous place.
> It becomes a place of new life, quick passing.
> New lives sprout suddenly, from nothingness.
> They hazard the island's air, haunt its passages;
> They are dashed about the sea in great storms.

Even the huge gannets, which normally only pass by the rock, can be caught in the arms of updraughts and tossed mercilessly against the rocks. Enormous birds that might be twenty, thirty years old.

Long ago, monks and hermits placed themselves here only at the mercy of God. They rested upon a finely carved ridge of sheer exposure, creating a shelter for themselves.

They left behind a vertical ladder of stone, rising to their little abandoned village on a terrace suspended over the sea. This way poses no risk for the very careful. It is the dizziness – caused by the effects of land seeming to fall away on all sides – that terrifies some people. Even the young and fit can be suddenly paralyzed by fear, after climbing only a small portion of the way. And the steps are irregular and broken here and there. When a fine mist falls, when uncertain winds seem to gust from all sides at once,

each step can pose a precarious platform from which one might be tossed at any moment.

In many ways, this is not a demanding climb; it only takes twenty minutes or so. It is the spirit that at times simply becomes fearful. In fact, children and young people can often dance up the stairs heedlessly and with joyful abandon. I have at times done so myself.

Sailors once believed they could hear the chanting of the monks as they were passing on the sea below, long after the monks were gone. Fishermen knew this place as their landmark, by the cries of the nesting birds upon the cliffs, in the mist, at night. And today, Manx shearwaters still utter their eerie calls in the dark night sky, returning, as they have done for centuries, to their high burrows.

Visitors continue to arrive, utterly taken aback, telling me they've seen the place before in dreams. Dan McCrohan, Skelligs boatman, carrying me back from the island thirty years ago, told me of the sanctity, the holiness, of the island. Josie Murphy, island workman, would kiss the ground when he set foot here.

Skelligs: strong winds, dangerous seas, brutal ridges of rock, slopes slippery as ice.

Some combination of curiosity and excitement continues to attract the streams of visitors who wish to climb the mountain. The island continues to touch upon, to suggest, a wilderness; shelter for both humans and for birds; a series of inaccessible ridges from which to launch fishing forays, as well as forays of the spirit. The light shifts strangely, swiftly here, and it cuts the spirit open. Above, the high peak turns in the sky, the last outpost before the endlessness beyond.

For years we thought the island a place of enchantment. For years we dared not mention the possibility of falling.

There have been three fatalities over the course of my thirty-four years on the island, each equally tragic. Two of these tragic accidents happened in 2009. I was very deeply affected, as was

the small community that comes and goes on the island from time to time. In many ways, these passings have become entwined with, and inseparable from, all the time I have spent here.

Now, moving up and down the stone chains of the island, when I am crossing places that remain evocative of what has occurred in the world beyond, where presences from the past regularly appear ahead, I see Karole, Joseph, Christine – and I know their visitation. No more than with my father or with many others – friends, acquaintances, dear ones, those I have ignored or let down, even people perhaps only briefly known, whose faces return with such great vibrancy here – by any of these, I am not directed, I am not told what to do.

> There is no speaking; but there is a silent invoca-
> tion
> Heard quietly, and then in a continual hiss,
> A sigh upon the mountain, a rustling of wind,
> An invocation that runs by the language in which
> The island sings, by which it moves,
> By which it twists against the sky
> By which it draws running light down,
> Striking through me, striking through
> Every word spoken here, at an isolated
> Place, raised against the sea.

In the years since the most recent death, at times it has seemed no man's land to me; both the dead and the living work their ways within us here.

All elements rush over the empty ocean and strike this bare rock. The light is always breaking over us, and it is changing what we see. Oncoming light, from all directions, works against and shatters this rock. Life and death are mixed and become intertwined. No one beyond knows what happens here. Eventually it can seem to ourselves that we are not here at all. Disappeared.

We come to see straight through an empty rock. The island becomes empty and devoid of life to us for days. Then we are shocked, again and again and again. Then, slowly, life begins once more. We can go through a continual sequence of these deaths and resurrections.

And what I see beyond changes too as I follow the starlight falling through darkness, as I follow the movements of the ocean over time. Even the endlessness beyond is changing as I watch, year upon year.

I watch the light intensify in the evening: the birds come together in swirling luminous clouds, which break open over the pinnacles of the island. The gannets pass before me as white snow. The island appears as a fountain of plenitude: an engine of light. Then, the darkness returns, descending in a steel claw falling upon the heart. I remain suspended here at the end of the world, held at the edge of a great emptiness. This is the emptiness that is held within everything.

Even within this emptiness, the light will naturally seek out the dark crevasses. Solitary beams of light fall within dark cells. A million living things strike across empty sky overhead, glimmering in passing. Quivering light strikes through skin and falls upon the floor of the heart. Things I have long held within suddenly rise before me once again.

The latent darkness and the light reserved and stationed here come to swing overhead – to swing near me, to swing away, entwined within a pendulum of radical extremes of shifting light, within the island's pulsating air. Images from the past rise, then depart, leaving me bare, shattered; leaving me only to have to climb this mountain again. All my memories, all visitations, generate my movements as the island slowly shudders and turns again into light.

Since the great storm of 2000, since the night when the dead Spanish fishermen passed over the island, a hundred thousand people have ascended and descended the skeleton of rock steps:

ascending, descending upon this tiny otherworld suspended just off the coast, just above the sea.

The light sculpts the rock, divides it anew, within the heart, within the mind's eye. The island comes to hold many things: every passing event, every passing spirit. New pathways appear within rock ahead, though all seems unchanged. Darkness falls from every newly carved cliff edge. The strange light of the island falls, marks, and illuminates the crags each day.

Life, like the light released and falling here, gathering here, works intently along these heights and within the conflicts of the spirit, against the death that is always returning.

28 September 2010

A while ago I stood at the derrick station, leaning against the chains there. Just ahead, the landing opened and closed in darkened arms, dancing to the repeated surges of the sea. Suddenly, a hill of white water appeared at the sea wall when moonlight broke upon the surface. I stood there rootless. The pathway below and ahead of me with which I was so familiar disappeared underfoot. The way became utterly darkened, its light sucked away in the vision flashing ahead of a mountain of white water, receding before me into the night. Some light, some fragment of my regular vision, was broken. For a moment all was impassable; no route appeared. Light was gathered ahead, above, and underneath. There was no formation ahead of me: no foundation for further movement, no subject for speech.

Jagged fins, sails of glistening stone in the pale light, stand empty and alone, charged white in the sea's movement. The ocean surges from each quadrant. Shadows stretch ahead freakishly.

The road stood at odds with any understanding of the way ahead. I knew no normal time or regular sequence: the sea reached over my head; the rock wall became inconsequential. I stood within movements of darkness, water, and light.

Clouds of golden lichen, xanthoria and caloplaca dance, illuminated upon walls that are almost invisible: they glow along the

rock; they are suspended against the darkness ahead. The walls and rocks they float upon vanish. Starlight continues to slowly revolve and fall upon the surface just beyond, scanning the hills of moving water, ranging over the expanse of the ocean. The lichen, hung in golden spheres, golden clouds, hovers at arm's reach, away from the pitch of the rock. For a while, these spheres provide the only light remaining where I know the island to be. They give the only colour to the night. The quivering of golden light within the darkness stops, and these lights come into focus against endlessness; they shift and rearrange sight. I see the dark jagged shadow of the rock overhead again and the clouds of lit lichen, coming to rest once more, aglow upon the flanks of the island.

A tanker, out on the horizon, steams eastwards on the night and towards land. Its normal forward progress is reassuring as I walk up the road from the derrick, where just a short while ago the road seemed to suddenly disappear. It has been the strangest of days, and I am lost, small, as I walk up towards the hut. I feel chastened in the dark, slowly turning corners of the road above the emptiness beyond. All this afternoon, the fulmars circled in a clear sky, seeming to follow me – eyeing me closely, then moving away, high above the surging sea, the growing swell below.

From below, and in my hut, I still see the monastery, and where I sat a few hours ago: the light quivering along the pavement, reaching toward the oratory. Shafts of light strike upon water; little pools shimmer in an unearthly green light. They shift along the platforms momentarily and are gone. In Cell A, on this eve of the Feast of St Michael, small boxes of light elongate over the paving stones. As the sun declines, they begin to rise up onto the wall, and arc towards the lintel opening – along a trajectory somewhat to the north of that taken a week ago. The sun works as a pulley, hoisting light; the light spirals upwards, casting its rays onto the far edge of the lintel. The light splays itself along the shimmering pools ahead, through the open doorway on the avenue.

Everything is picked out, and broken open, within this soft and quiet bathing from the movements of the light as it glides over the flags and empty pavements high above.

The sunlight falls, gliding slowly along the ridge behind the monastery through the afternoon; it falls further and deeper within the cell. The rising light stretches over the lip of the lintel, enters the dark opening above, illuminating stones otherwise unseen in natural light. The sights of these days – the white movement of a wall of water through the dark, the sudden glimmers in the appearance of the sea road to the mainland, the golden lichen forming constellations hanging against darkness, the island broken and disappearing below my feet – all of these things, suspended ahead of me again, return in these close quarters. The last direct light of the day lingers within the cell.

I still see the remaining snakes of light playing at random across the cell floor: the scales of St Michael, testing souls between darkness and light. My activities are weighed, found wanting. I see the links of chain glistening in the soft crossfire on the floor of the cell. In the hut tonight, I still see them in my mind; I see them glistening upon the cold empty floors, high overhead.

As I left this afternoon, the empty light in the space ahead, and down the avenue of stone, was filled with the movement of birds as they departed. They tumbled in the open air, framed within the doorway of the cell where I had been sitting. I saw them circle out over the sea, falling away across the sky, carrying the light tossed before the dark cell upon their wings, shifting their configurations continually as they flew off into the distance.

It seemed they were carrying a previous vision of the island away.

> There is the fire that appears everywhere
> Before us upon the sky, just as the birds turn
> There at the extremity of their orbit
> Before us, even as their turning blades,

And the blades which glisten upon the stairs
Fall through the night beyond,
Open the sky efficiently, make
Stone edifices active in moonlight;
Cut our footholds loose as light
Falls through fresh openings
Into the rooms we form overhead,
Opening the interiors of darkness.

Shadows move ahead of us on the road, pulling us forward. Spurts of opened light softly caress the stones, leading the way into the door of the oratory, into the cells. They lead on, along every pathway of the island in the darkness, through the grey mists that hold the passing flight of birds, pulling us towards a horizon that is empty of ourselves. Forcing the widened vision from the island upon us. Opening the other geography, the other science here.

A different geography is established here by anyone who stays over time. Here there is a strange combination of the old and the new, the utterly mundane and the profound. I live a life here that in some ways is not unusual, but for being concentrated on a steep rock surrounded by wind and water. My life here contains elements that might resonate with those living here centuries ago, but also with those imprisoned or abandoned in deserted places of the earth; as well as this, it has strong elements of the life of any visitor warden of any tourist centre across the globe, or the life of any nightwatchman.

The beauty of the natural surroundings here, which can be a bleak and lonely beauty, makes the utter uniqueness of the place and the life. All routines, all human rhythms geared towards mere survival, are absorbed within this overwhelming sense of all things unfolding in the air and sea around me here, of an interchange

always occurring between the rock and the endlessness beyond. In a sense, it is the only reason to be here: to see this and to somehow interpret it personally, to appropriate and apply this unfolding diversity within myself.

Even from the first days of arrival each year the island is released, sprung over the water in an endless array of living forms. Suddenly, all along the southern slopes of the island in late spring, the bleak grey and brown ridges of the winter come into radiant bloom. The skies are on fire with puffin flight. And the fleshy-leaved sea campion, which binds and holds the loose earth of the steep slopes of the island, flowers in little white bells overnight, and the island air sings with its gentle intoxicating aroma. The banks quiver in waves of white movement in a sea breeze. And as the summer progresses, and autumn approaches, the sea itself blooms in a thousand varieties of rollers, crests, gusts, swells.

> Glowing rollers cut at once to view,
> Dangerous in their abandonment,
> Which gains at the rock's turning,
> White as the first light strikes from
> The shadow, tight heads, pushed
> By opposing winds into the full
> Spectrum of vibrant spray; violent,
> Pushed to raise empty jets of mist
> From each charge, lifted together
> As presences of emerald, barely two
> Hundred feet away, sustained only
> Within the emptiness above the water
> By the pressure of the moving light:
> Light raised only by its own accord.
>
> There is something here that is only
> Of this light.

Something that is only of this
Abandoned sea, this interval
Which stands, coming into life,
Bringing life before us,
These few empty and uncertain
Days, empty light which quivers
Ahead of us along the road.

By this light
We look into an enclave between
One rock and the beyond: there is no
Speaking under the sea's lips, no ink,
But the white spirit from raised water
Writes in colours broken upon the sky,
Then withdraws its script over
And again, so that what remains
Is merely a green mist standing
Out ahead upon the dark, a globe
Swung upon the chain of wind,
Hovering upon a ladder of swaying
Water, speaking whispers barely heard,
Sprung to destroy a static world:
Naturally, repeatedly.

That shifting light of this place, which sometimes made the rock disappear beneath my feet, which sometimes seemed to tear the rock apart, over time revealed itself simply and quietly in movements and appearances that, after a while, came to seem utterly ordinary, as ordinary as any ashore: in the radiant pools upon the suspended monastery floor, high up over the sea; in the climbing light, day after day in late September, that etched itself over and over upon the darkness of the cell walls, becoming a living spine of light, a set of shimmering lines, an eerie skeleton that would at times entwine with my own, draw my own spine out, speak

within my presence. Which would speak, as well, with the voices of those not present here.

And every day now, I encountered ordinary things suffused with extraordinary light. The routes of falling light had been tracked along the monastery floors over many centuries; yet suddenly, here, in these physical extremes, almost speaking, the light would fully come into flower.

A map, a grid, a chart might accurately present such a flowering of light, might point out things that are not straightforwardly related. Light has moved through the darkness, upon the floors of these cells, for centuries. We still hear ancient phrases, incantations, continuing to resonate on the still air. Some phrases, still uttered, illuminate exposures of the spirit:

> They loved themselves not unto death
> They lost their lives to find them
> Within silent and empty and isolated spaces light
> formed its own visible pattern that became
> visible, was at times close to the pattern of
> speaking

And there were the whispers we were continually hearing, formed from the darkness ahead, resting at the gateway to our hearing: 'Walk around the courts of the city ...' The psalmist issues such instructions to the inhabitants of Skellig Michael. They rise and descend on the stairways, watching from the ramparts of the monastery: their very living stretches out upon the emptiness beyond and reins it in. They swallow its air.

After some time here, the light from this place, working its way into the darkness beyond, became active, even necessary, and responsible for our own breathing; it was feasting upon every vanity, eating away at the intransigence that is wrapped within our mortality. The light was moving, drawing out the faint lines here holding our footsteps, forging its unique atmosphere, making

our little prisons of the light to move out upon dark shores. Working, in its own way, against the intransigence of the earth.

Some part of ourselves, some part of all of us, was always being thrown ahead upon the roadway here and looking back at us. And calling, always calling, over the stretched, charged darkness that was stretching ahead, making real the myriad ways of searching, of telling and speaking through darkness.

> Sometimes the vision of the extreme is very near;
> There is something out there sometimes that
> comes within the room,
> An emptiness that greets us
> On the verge of taking form, uttering a call of
> imminent arrival, and offering an invitation.
> There is something out there, just at the edge of
> things, circling again and again.
> Sometimes taking the form of a woman or a
> man, alive or dead,
> Forcing its silent speech within us, pushed by the
> wilderness, the anarchy, of accelerating light
> which is falling upon empty places.

2 October 2010

In the rain and the wind I climbed up to the small oratory again, carrying those deceased on the island with me; they were wrestling with my soul, admonishing me there: this is a difficult time to speak of. I sat there, the surf thundering below, rising higher even than the grey window beyond – the mist covering the space ahead and concentrating the light within the small isolated room raised above the water. I left them there above, as I left four buntings who have haunted the steps and saddle, enclosure and bedrock these last few days. As they will, they will no doubt appear again, as if out of nothingness.

Gusts, gusts of wind are buffeting the tunnel
Of the lighthouse road, gusts filling my chest
With sea air – hurled down through the trachea
And into depths, reaching out through my skin;
And I recognize these gusts, which buff against
My hair as I walk down to where all land. This
 other wet
October air rakes my head now with its warm
 hands:
My scalp freezes at the touch, then you are
 there.

The sea runs high today: pressure from Iceland
Forms the hills of water which surround the
 rock:
Which you might walk upon, streaked by long
 green,
White tendrils of hair, solid as the groundlessness
Is real below your feet. For all has changed here.
The pale eye of the sun stretches far southwards
 now,
Past the Feast of Saint Michael. The pilgrims
Are gone, the island is deserted. No work
Moves on apace, no controversy rages, no courts
Of law. Just a rock stretching high roads into sky.

I sang from the station on the peak above
Last year, my breath joining with you there
Beyond the rock, just beyond hand's reach;
And yesterday, a handful of passing gannets
Wove your image before me suddenly
Within the empty blue ahead. And now I know
Your hands rest upon my head. The wind bears
Down upon us here, stretching its arms continually

Around the rock, bringing all passing lost things
 near:
Glimmering, flickering here at the edges of our
 vision.

Outside in the storm, outside of the light
Tonight, there is a fire of wind, of rain, of full
Immersion under white hoods of the passing
Sea. These are monks' hoods; still
They continue to come, around the far corner
Of the point, illuminating the rock, casting
An eerie glow down channelled pinnacles,
Catching the quick glimmers of lightning
Which fire in series their stretching arms
Surrounding a small pier, reaching high
Upon blue sky: fanning pairs of wings, their tips
Suspended feathers of falling crystal, and white
 spray –
So that they thunder then onto the steps,
 tumbling to fall
From on high upon the landing, cutting access
Away, and saying through that cascade:
'No one crosses such a threshold for days
On end. Mark your own way out here

And stand to walk out upon the night with young
Fledglings taking their first steps, under cover of
 darkness,
Sheltering on the road, but shivering, stunned –
Their instincts briefly overwhelmed, the wind
Loosened overhead, and their small spirits lifted
Into the dark, and invisible but for the radical
Fluttering of their wings, testing
Themselves within the October air

Where we wrestle
With our own shivering thoughts, impulses;
Where you pull me to the wall to stand
Gazing back at the mainland in the dark,
The car lights, the village lights swallowed
In the mist, and we are left here alone,
At a far corner of the earth, to cast waters
Hard down on these rocks, to sound
And propel the engines sending fledglings
On their way, out to South America, knowing
That very few will be able to return;
Minding the lanterns here within this darkening
Stone which vanishes underneath us
Leaving us groundless, and walking out
Beyond the lighthouse wall ourselves, touching
Our way out over water, playing for keeps,
For the world. Good night, my new, dear friends;
We remain here, wrestling still with your
 breathing,
With this dark air passing over us tonight.
We open ourselves once more into the light
Where all spirits are passing.'
Where everything is always returned.

Farewells from Aboard

More people have been coming to the island over the past ten years, and many have no idea of the conditions they will face. Almost everyone comes now on an official tour boat. That is why it was so surprising to see three visitors emerge from the entranceway into the monastery so late in the day on a summer's evening three years ago. It was maybe seven in the evening, but still bright. I am normally aware of any boats that might be cruising the waters around the Skelligs, but I had not noticed anything on this occasion. I certainly had heard no sound of

engines. That is why, on their sudden arrival all the way up in
the monastery, I was so surprised by these three intruders, larger
than life, jovial, full of good humour, wearing sun hats, preparing
to amble their way through the monastic remains. I presumed
more sea kayakers had arrived, hoping to stowaway for the night.
It was too late in the day for this to be happening.

I recognized European accents – definitely not Irish – when
I spoke with them and knew that they would have no idea about
the restrictions of the island, or the possible dangers of the pier.
They had left their yacht there unattended; they intended to
explore the island, descend later, and sleep at the pier.

I knew that there was no point in being angry, but I was
peeved that they would have simply abandoned their vessel in
such a careless manner. There is no access for other boats when
even one boat is tied up at the pier on Skelligs, so it was foolish
for all the crew to just leave the boat there, but they obviously
had no idea that was the case. Even in the space of a half-hour,
conditions can change radically at the pier, totally hidden from
elsewhere on the island. I had known the crew of a yacht to
be stuck on the island in the past: the sea roughening, they had
not been able to leave, and we had been forced to provide for
a crew of four from limited rations and accommodation.

These sailors had no idea that boats would be arriving early
the next day or that conditions might radically deteriorate over-
night. They were not familiar with the harbour set-up at Portmagee
or on Valentia. It would soon be dark. They were making their
way south, and I could have insisted that they leave, but this
seemed churlish, and I felt a certain sense of responsibility. I knew
that, simply put, the safest course would be to let them spend
the night at the pier. But I wasn't happy about it. I knew that I
would not rest easy through the night.

I followed them slowly down the steps, allowing them time
and space to consider. I also came round to thinking their over-
night stay the safest option, and not that onerous.

Down on the pier, I hailed them inside the cabin, and they invited me aboard. Light was diminishing over the island. The little cabin was cosy, and through the windows I had glimpses of a different view of the island altogether: the rocks surrounding the cove seemed to spring incredibly high overhead, and the little vessel rocked gently underneath us at the landing. The skipper was a doctor, sailing with his daughter and her new husband. He informed me their plan was now to have dinner at the landing, have a rest and make preparations, and depart sometime after midnight, once they were ready. Would that be acceptable? I felt instinctively that these were good people; they were already homeward bound and had planned to spend one more night somewhere along the southern coast. A few more hours on the Skelligs would be a good send-off and would give them time to rest, eat, and prepare.

This was a reasonable compromise. I was invited to dinner, but I knew their rations might be tight. They insisted that I sit with them for a while. A bottle of whiskey was opened, and we each had two small drams over the next half-hour or so. We instantly struck up a friendship, sitting together in these unusual circumstances: a tiny vessel, bound soon for mainland Europe, huge cliffs rearing about us, a deserted ancient monastery high overhead, the four of us sitting together around a small table in the dim cabin light, with the grey light of the sea closing around us for the evening. There was nothing but chit-chat and the sense of the adventure of imminent departure. In a strange way, it seems to me now that we quickly, and for each other, sketched a limited map of each other's lives: that young man and woman, that father; myself, studying a chart, looking at the indentations of the Irish coastline stretching northwards to Sligo Bay and the nearest landfall to my home; and them pointing the route south to the coastline of the continent.

'You should come with us, Bob.'

I climbed back onto the pier and left them to their preparations,

and to the consolidation of plans for a safe journey – a trip of a couple of days, sailing south. I thought of Brendan again, of time expanding outwards without the references of the shore, and of the extension and expansion of life between ports, between departure and arrival. I looked back down at them through the tiny window and for a moment yearned to go with them, as I stared down at that small neat vessel tucked into the cove, surrounded by the cliffs of Skellig Michael in the quiet evening.

I walked back down to the pier at midnight; torches were at work in the darkness, the beams swinging wildly against the rocks as preparations for departure were made. The tiny running lights seemed otherworldly in the normally pitch-black cove. My new friends might just as well have been departing for outer space, given this most unusual sight. And yet I saw that boat as suddenly a very fragile vessel, exposed there at departure – the same exposure faced by all seagoing yachts on the North Atlantic. So often, over the years, we heard distress calls over the radio, when yachts were missing or overdue.

I was hailed by great friendly shouts and thank-yous and farewells from aboard as the boat slowly backed out of the cove. One final wave in the darkness, and the shape of the vessel was no longer discernible; there were only three faint lights steady upon the surface of the dark water, circling southwards. Sometimes it seemed they separated; then they formed a unit once more. I walked again the quarter-mile up to the cabin and watched as the lights dimmed and then vanished within the darkness, swallowed up, heading for dawn upon the open sea.

These people may well have forgotten me by now; I am not sure that I would recognize them if we met on the street. But somehow, that departure made a deep impression on me. I will not easily forget those three apparently disassociated lights bobbing up and down in the darkness beyond: a darkness that seemed both sky and sea. And within that element, a tiny vessel, almost dark, curving upon a planned and mapped route to a distant destination, a foreign land, the crew

resting in the tiny cabin, keeping watch on the exposed deck. For some strange reason, that midnight, the entire earth seemed populated by just the four of us, with no one aware of that small vessel and its passengers but for myself on the lookout station of this bare rock at the edge of the sea and the darkness beyond.

6 October 2011

For centuries, this has been a lookout for moving light, for the movement of spirits over deep water. From this place, one may look over into the endlessness beyond; but also back, into the hinterland, deep within the headlands of the coast.

The light races over the island: it breaks us open with every death and annihilation, with each sharp exposure that it presents. This racing light reminds us of our own demise. At each rung of the rising ladder where we pause, at each interval of the steps, light breaks through: the light cast by the movement of the stars, by the rise and fall of the tides, by the continual progressions of the passing weather. Sometimes it seems this climb, this descent is endless. Yet we continue to climb and descend upon the lines, over the ladder, cut into the slopes of this strange and isolated island. For here, this clear and empty light, falling across the plane of these steps, while it utterly exposes me, will also remake me, right to the point of a final departure.

The early monks rowed to the island, arriving at a place where the lines of darkness and light were broken apart by the necessities of life: broken by the chanting of the hours, broken by the rhythms of climbing the staircase blades which reared in the sky above them. Their hearts were exposed to the signs arriving from all horizons.

Storms gather and light suddenly breaks open across the extremity of the sky. The light falls in torrents here; sometimes it seems we take it up within our arms. It forms an edge against the empty sky as it passes, an edge that gathers to stand against the populated shore beyond and then dissolves. The intense light leaves behind a jagged

set of ridges, which combine to cut me from different angles, continuing to break open accepted expectations, shattering my frames of reference. The continual arrival of this light – which has touched upon the emptiness beyond – changes how I interpret the most basic things: living and dying. Here, and in the life beyond the island, upon the headlands ashore.

Long ago, men created cells here where light was harnessed to their purposes, placing one course of stone on another in such a way that light would fall within the spaces they had secured, where it would fall – however briefly – to etch itself upon the interiors of the domes they had erected, upon their lintels and their windows. And within, a corbelling of the heart was struck, to take the light within themselves.

So many years later, light continues to fall over and through the island in the same ways, along the same patterns. Lichens take hold and spread over the centuries to become lanterns of gold suspended over an empty rock. Life is fostered under the sudden illumination of the returning birds; the shifting constellations they mark upon the air strike the cliffsides as they make their cyclical returns. The road into abandonment still glistens ahead, reveals itself slowly over years and through the course of centuries; islands of the spirit still rim the far horizons.

We board the boat; we become rootless; we leave the mainland behind; we arrive at a tiny cove; we leave the road behind and climb into the realm of air, travelling the ancient ladder; we are shorn of human company, of human dimensions of time. At each station we pass, we are shorn of our possessions, and our hands eventually carry only the air. Ancient speech returns from the empty steps before me; the tiniest of encounters and events take on independent significance. Each small observation takes on new currency; after a while, tiny and mundane things I carry glow within my hands. The air becomes electric around me.

Down the North Steps somewhere there is a large crystal, a Kerry diamond, fitting in my palm, that I once carried with me

when walking up and down these steps — up to the monastery, up to the peak, down the East Steps, and over the lighthouse road — doing the rounds of the island when my daughter Lillian was very young, as a prayer for her and a prayer for Maigread and Daniel, for my loved ones; this little stone came to hold this prayer and accompany my movements. It signified nothing at all to anyone else. This stone was carried back and forth to the mainland during the first year of my daughter's life. That prayer brought me back out to the island repeatedly; almost without knowing, I was carried out by the light striking the hard rock, once again pushed out upon this place of bright lights.

All along the island, other epiphanies, exchanges, quiet vows, abandonments have been pledged under the cliffs, along the edges of this ancient place. Together, they gather to form a presence, known when climbing the lighthouse road, when circling the mountain, when rising from the pier. Experiences remain hidden within the masonry, as the rock crumbles and is then rebuilt or changed, after the original ideas of the monastery have been lost and diminished.

I feel the crunch of the little rock crystals under foot and stand briefly on petrified light. I walk on the lit stones that were pressed into a raised platform, on the hidden places of the peak, and down on the North Steps long before any human stood here.

I see the light stretch its long arms into eternity and endlessness, reaching through becalmed, oily water, stretching through the lip of the curvature of the earth at sunset at midsummer.

'It could go in a shot, Bob,' they told me when they were working on the peak.

Not the outline of the rock flashing upon the horizon.

Not the tiny fires burning upon the walls of the cells and hidden there.

Not while this engine of returning light continues to burn.

The mountains are always falling here, anyhow; this morning, the light is shining through the rain and lingering on the pools

stretched over the lighthouse road. And above, the little slivers of light that run along the gutters of the monastery combine to briefly draw the lines of a different territory: for moments, we know the outlines, the boundaries, the constituents of a soul. For the soul is always being unravelled here and always passing through a series of deepening abandonments and reconstituting itself; passing through on the weather, it becomes suspended in the bright, empty morning air of this place, where souls gather at the far reaches of life.

Light is divided by the flight-lines of the birds that gather quickly together then unfold overhead. A continual series of explosions, of departure and return, take place in the sky and within the heart. Speech is written in the signature of the snaking lines of these paths, which stretch ahead in white sunlight. Light travels along the extremities of an exposed heart, reaching out to the endlessness beyond, taking solid form upon an empty rock standing at the horizon.

Light gathers above this rock, administering a shock to those below, tossing the white light of the sea and breaking it upon the floors of the cells above.

In every act of abandonment, another stone is replaced within the corbelling of the heart; an engine is always at work here, bringing light upon this place.

But here there is always trouble and danger; the exposure that all know here ensures this.

> Every heinous act, committed brazenly,
> Unchecked beyond the horizon ahead,
> Breaks now into these chambers
> As the heart is ever pulled apart. Personal
> Darkness, in full spate, overcomes
> The gates to the soul, closes them down,
> And then recedes once more. Now,
> The calls that are left to us

To receive, calling only upon lowest
Frequencies, urge our clear attendance:
Long shafts bend under the ocean,
Piercing the crests of winter swells,
Skewer the small glistening sand eels
In submerged clouds of gathering,
Returning, liquid light.
Each spring, vessels rise to the rocks,
Magnetized by swirling colour,
By living kaleidoscopes
So that the light dances, is split,
Above an exposed and empty rock:
Red for puffin; black for
Razorbill, black guillemot.
There remains a voice, disembodied,
Calling the registration, the release
Of those honed by deep water.
Their trails are left glimmering
In short-lived flames, flickering
Briefly upon the surface, by which
We map the unspoken, and,
By each silent intimated signal,
Unseen movements of the light,
By the glimmers underneath
Flickering surfaces stretching
Beyond us here, at every turn.

I sit on my own in the hut once again this afternoon. Beyond, there is light glinting upon every peak of the advancing swell; sequences flash in an ever-changing grid over the surface. The mid-afternoon light floods onto the porch, is cast in a broad shaft through the open door. Six small Kerry diamonds are strung along the window; the dried lavender from home brings unusual exotic colour into the room. Each dancing shaft enters the heart in an

acknowledgement, a register of what is going on beyond this rocky outpost: the bird-flight that courses unseen over places beyond the horizon, the riots, the mayhem, the murder, which is continuous, just beyond sight, and the dazzling light that spreads immediately ahead – all are bound together in a presence running near, just at the edge of the ocean, at the edge of consciousness, are gathered in the light striking through into this room.

I stop at the edge of this parapet. Light tracks in through the thin windowpane, illuminating the table, the room, the lintel in the cell above, the oratory, the door opening to the silence beyond the terraces. Each image, each vision of this place, falls upon another in sequence, in gathering light. One layer of rock is pressed, seared upon another; the island is being remade.

These are the ordinary workings of the light here.

9 October 2011

The sky clears and light falls within the cells and within the exposed spirit. One day, soon, I will stand here for the last time.

It is late afternoon on what is probably our last day here this year.

It is this way every year, within the grey mist, this combination of foreboding and excitement, this sense of an ending. There is clear sight ahead: another storm has passed, the sea calms, the pressure rises. The swell, still active, still sprouting its tiger lines all the way to the horizon, has subsided since the wild abandon of yesterday. White paws lift the water sloppily, toss the spray again into the air, then subside, but with diminished and irregular force. The landing remains wildly active, sustaining a great push from behind the Submarine Rock (just southwards of the pier) in this south-easterly wind. Up at the top of the final flight, above the saddle, the updraught is overwhelming. The wind is so strong I have descended, in the past hour, sitting down, pulling myself step by step towards the valley below, with the turrets of the peak beyond quivering in my blurred sight.

The peaks, the towers, and vanes of rock fall away; my flesh seems loose, on the point of being ripped clean. I crawled into the main oratory to escape the wind, and I sat there a good while as the gusts continued to buffet the upturned hull of this ancient structure, moaning and crying within the scaffolding around St Michael's Church.

The large High Cross stands just outside the oratory, dividing the monastery in two, marking off the portion of the platform that hangs over the landing from the part that is rooted more upon the solid rock of the mountain – dividing the monastery grounded on the rock from that suspended by masonry over the sea. Shifting light, throughout the season, casts the shadow of this cross along an unfolding arc over the platforms of the monastery. Its worn shaft is rooted in the white altar connected to the oratory, forming the central axis of the platform around which all light moves, through which all wind passes. The open jaw of built and natural rock, upon which the cross rests, is suspended over the sea, running against the landing hundreds of feet below; over the centuries, the edges of this terrace have fallen away, at least twice, to be rebuilt again.

I was aware of a division within myself as well, as I sat on the floor of the oratory: some part of me was poised against the emptiness just below and beyond the solid rock. It had been a difficult climb in strong winds. I sat enclosed in the darkness within the monastery platform, aware of this carved stone cross, just outside, on the other side of the wall, dividing the raised terrace. I sang along with the continuous whine of the wind in the scaffolding. In the darkness, the pavement beneath me listed; when I opened my eyes, bright silver light; below me, further rock and the open ocean. Pools of light shimmered within the cells in the brightness after the rain as I rose and stepped inside each one. I walked the perimeter of this small and hidden (since the visitors were gone for the year, since the platform where I was standing was now only a dark shadow when viewed from the

sea below) place, subconsciously marking the end of another year.

Now inside the smaller oratory – beyond the main part of the enclosure, on the furthest ledge stretching eastwards – I sat huddled in a corner. The wind knocked against the stones, pushed up against the face of the wall of masonry supporting this small room, jutting out in the air and above the sea. Even though it was relatively still in the corner where I sat, just inside the doorway, my knees were still shivering with cold. But I had come to sit here countless times before. This was a place where I felt I could come to speak with a fisherman I had known, drowned many years before, whom I had last met on unsatisfactory, uncertain, and unhappy terms. It was a place where I had come to face other uncertainties, sadnesses, and inadequacies. As I sat there in the silence, faces from my past began to appear. Images appeared on the walls of the cell, configured on the dark skin of the stone, gathering as I rested on the floor of this small, ancient house of prayer. Flowers I had left as tokens of memory for the dead connected with me, all left weeks before, were withered and colourless now. They glimmered in the half-light. Burned-out candles were scattered on the floor. I saw the little indentation within gathered greenery where a shearwater had tried unsuccessfully to nest much earlier in the summer.

I knew I had been fighting against something all the time I had spent on the island. From this silent place, light and vision would strike into the far distance, to reveal the deepest places, where terrible and hidden horrors were taking place. I sat there where monks, too, had sat, so long ago – hidden as the light moved around them, hidden as the entire world moved beyond them.

Here, people and events from the past and present would come before me: those who had died here on the island, the Spanish fishermen, many others, tied together within the unreality of sheer height and by the isolating wind – appearing together within the continual onslaught of the elements, wound by the thrumming of birds' wings the summer long; all of them returning from the

past to challenge me, provoking silent, unanswerable questions in the darkened air.

Far above the high running swell, beams of the late afternoon light were cast down through the window of the small oratory onto its eastern wall, as well as through the cracks in ruined masonry – casting fine, quivering beams to dance around my feet. A tiny thread shimmied in liquid for a moment on the floor, then disappeared in the grey twilight of the room. Outside, released from cloud-banks, the light swept quickly over the ocean: a sudden hand of brightness moving over grey water. The clouds raced by overhead. In the shifting bright and dark, the room came to hold, and be suspended within, flickering, dancing light.

The light would return to fall at my feet in aimless wanderings, in tiny golden filaments projected across the floor of the cell. The room, the light became inhabited with spirits from the past, beginning to rise from the dark, their voices rising within the darkness. The corners began to glow in the half-dark, where James or Dad or Trish or Andy or others might come and sit, or where Christine might come: people long dead, some still living. As I peered into the interior, the far corners of the room were alive with these spirits conjured from past faces and events and from the voices screaming in distant places in the present, this moment, gathered with these strings of shifting light.

For a while, tiny rays wandered over the dark interior, playing upon the floor, upon clothes and skin, creating the space I looked through, holding the world beyond, which had been gathered from the furthest hidden places of the earth and lodged there across the centuries. The world beyond, on each visitation, stood briefly there.

The faces on the walls flickered, on the verge of disappearing. Evening began to fall within the dark shell of stone. Light had come alive on the dust of the floor, from time to time, in an abandoned place, out of nothingness. But there was nothing to

be seen: a grey, empty window; a floor of cold, musty earth; a tomb incubating, from time to time, new light.

I had heard voices though, in the cold damp wind – not admonishing, not recounting, simply a presence there, outside myself – calling me out, conjuring pathways leading into the emptiness beyond. Showing the routes by which light gathers, by which empty space becomes illuminated, by which empty space gathers light.

Before me an empty floor of dust, ten square feet or so, raised high above the ocean, filled with the prayer of centuries, shot through and activated with returning and then abandoned light. I walked out into the evening through hundreds of visits pressed together within that small room.

Light flickering over the faces from the past, speaking to one another in an unknown discourse. Light burnishing the shell of the heart and then cast off, out into the emptiness, out over the headlands beyond.

The light cast out: but something left behind, upon each visit, charging the walls of that small prison made of light.

Holding this cold, empty light in outstretched hands and tossing it away upon the grey, windswept evening.

This Is the Place Where All Light Eventually Comes

Demons mock, say we carry
No light here, that the space
We tread is static, that as we walk
These roads along the sea, the steps
Of stone, the island, the rock
Will wear away. They are correct;
At least in part. I have observed
For many years; I see changes.
Precipices are sharper,
More friable; between them,

The wide way rising to the glory
Of the high platforms is worn
By passing feet. Details disappear;
Attendants warn along the way;
The route has become tidy.
And, at the small holy site,
Near the summit, where pilgrims
Have climbed for many centuries,
We sometimes feel we see no further
Than when we first arrived.

The messages we send, hurled
to ride a distance upon the open
air, return to haunt, gather ahead,
Dog our way. Ghosts convene,
Disperse on open pathways.
I have begun to understand
What has happened.
All of the light we have taken
From this place stands now
Within us, manifest
In numberless ways. The rock
Will not support us; it will fail.
We will be forced to intertwine
Our feet, our spines within
The deeper earth. In a way,
This has already happened.
That is why it has become
More difficult to move against
The wind; we have become
Rooted, moored, ensconced.

We have been forced to adapt
To changes, to learn to walk anew

Along the edges of rough stone:
Loose within confined darkness,
Storing data which is unseen:
Unwatched, unknown, against
Oncoming unimpeded wind,
Balancing against the ridges,
Refinding breath held in burrow,
Breast, in unreachable crevasse,
In each exhalation of hidden light
Released from within the rock.
Each day and night, we scavenge
For light along the edges of the shore
To learn how it is cast, how it charges
The rocks, the pinnacles, the surging waves;
Winding in a line through every exposure
Of the heart, and at each extreme place.

CHAPTER TWELVE

Brief Expositions of Eternity

I sit at my window on the Skelligs over thirty years since first arriving here. It is raining, and there is a south-easterly blowing, force 5, so there is a choppy sea beyond, bearing in on the hut from the horizon, bearing in from the Bull Rock, from Beara. Beads of rain glisten on the window, and a dozen puffins laze at random angles on the lighthouse road wall. Most of them stare ahead; two perch with their backs to the others, looking back over the road for safety – they keep all angles covered this way.

There is no difference ahead at all, compared with what might have been seen in the 1980s. Beyond, the sea is grey and agitated. When the wind is south-easterly, there is no regularity of movement, in comparison with the high and regular waves of swell that arrive on westerlies from the Atlantic. It is squally down at the landing, but a lone boat comes in, bringing a television crew for an hour.

This is the first week in July, and across the island chicks can be heard: feeding, growing, calling to one another in burrows, on cell floors, on ledges, and on the sea. And this afternoon, high within the monastery walls, I heard a particular sound I would not have recognized in 1987. A razorbill chick was calling:

that very high-pitched call, haunting the sky over the cells, and the valley, and the peak. Though coming from the tiniest of creatures, I could hear the call over the entire island. Long ago I found the cry so piercing it was almost unsettling, particularly late at night, like the sound of a baby far away. Now I find this crisp, piercing sound an expression of a form of joy.

Every time I have returned to Skelligs I have entered upon a different world, one with an atmosphere that is quite different from the one I know ashore. Gannets usher the boat towards the strange green rock at the horizon where the calls of tiny razorbills pierce the heart. Time stops briefly on each encounter here, where every turn of the road exposes yet another view of the endlessness stretching beyond this last point of land, and where empty sky and sea stretch ahead, beyond my outstretched hands.

And I have come to know these brief expositions of eternity, though poorly expressed in my words, to be grounded most precisely in certain things observed over a long time: in the incredible network of sea trails etched within the wilderness that the migrating birds from Skellig Michael follow – to South America, into the mid-Atlantic, and across the equator, returning in a definition of flight utterly individual for each species to burrow, ledge, floor. I have seen this surgery of the air performed by the tiny petrels, squeezing into the tiniest gaps within the stones of the cells, home once more from the endless roaming. And I have come to know another form of surgery, another exposition: that of light moving across the floors and slopes and ridges of this place; watching the daggers of light form on the floors of the cells high above on September afternoons every year since arriving here, watching them move within the architecture designed for their capture and release, made to allow light to intensify and sharpen in dark rooms high above the sea.

So I have learned over time how extremity and endlessness continue to cover and shape the heart, speaking in languages we do not fully know, at this exposed place.

30 July 2018

Gusts knock the barrels down the road; a lone puffin scutters under the veranda. Pipits soar by in rising arcs, scattered by the wind, and great banks of white horses stretch to the horizon. A fortress of water stands around the grey rock this morning. Once again, as on so many occasions, a soft pool of grey light rests on this table. The light outside – all that wild activity striking against the rock and passing beyond it – draws me against the window. My life briefly opens to mirror this charged presence once again.

> This has happened over many years:
> The heart will be continually remade;
> Yet what happens within the advance
> Of the swell, on the grey, swift sea
> Has changed, and is different now.
> After many arrivals, we have come
> To see through the ebb and flow
> And the fluctuations of the tide.
> Now the floor of the sea stands
> Revealed. We know we stand
> On a brink; we know great trouble.
>
> We know what has, to this point,
> Sustained: benevolent currents
> Of water and of air, and the great
> Plenitude; but these have all been altered.
> Depths are stirred, tossed by hands
> Raised in uncertain agitation;
> The sea-bottom stands enflamed.
> These are the facts that impel us now,
> embedded in our new knowledge.

But the light remains dull here in the hut.
Knobs, dials lie inert, lifeless: No charge,
No gas, no power on. What is moving beyond,
And below, has absorbed all colour and light.
What is arriving now, far beyond
Us, and along the further shores,
Striking the headlands beyond,
Is neither you nor I, but an amalgam
of what has been shorn from us,
Shorn from your skin and mine,
Leaving our fingers woven together
Over time and their adventure;
Our bodies shorn
Upon advancing waves of all the passing
Souls, falling now upon the surf beyond.

This is what will be heard, finally,
There: this strange hissing, this sound
Of the sea coming alive, of the sea alive.

The birds have woven a fluid medium, stretched just beyond me here, in sky and air and rock, for three and a half decades. Over time, the sea and the island have become intertwined. The rock stretches towards the mainland in pulsating, shifting lines. These lines cross one another and dissolve, leaving behind only the featureless and dim light from the sun stretching upon an empty surface. The face, the open mouth of the sea is dull and yellow, set against a far shore, pressing against this jagged, inscrutable rock, pressing against the distant headlands. Deserted today.

But suddenly, this afternoon, the rock opens to light once more. Its avenues and surfaces, its skin of glistening rock, shines brightly again – alive in yellow light. Medallions of golden lichen glow softly along the way: talismans hung along these corridors, revealing the paths of the rock ahead. The way through the heart

is the way opening before me as I march through the cut in the rock down the lighthouse road. It is the descending silence, held in each gap between the rocks, each space between the raised waves, that has opened the rock so. All moving unheard sound – of briefly held air, briefly restrained running water – gathers to strike upon the shore beyond: one thunderclap of arriving light upon another, gathering over the mainland.

I go slowly down the North Steps into the bath of white light in the late evening and the line of the water, the swell, rises steadily over my head as I descend, and it covers me with its arms. The light breaks through the raised waves. I travel up and down the lighthouse road, to the landing and back. The raw light, the fresh wind, the raised spray of the sea surrounds me in a blanket, a covering of mist. The blanket lifts, and the heart is prised open; the light strikes directly through open, endless, empty air, as if I were there no longer; it strikes upon the mainland hills beyond.

29 May 2020
I cannot go to Skellig Michael today, though the puffins are returning, though their bright coloured beaks appear suddenly and begin to circle the rock empty of life all the winter long. The world of the mainland is in lockdown. All ordinary means of travel are closed. Though I have not heard it verified, the puffins are beginning to whirr in rings through the valleys and peaks of the Skelligs in the evenings and at dawn. Soon they will be preparing burrows for the arrival of new life. The messages arrive, over distances upon the clear empty air this hot afternoon, two hundred miles to the north.

I have gone up and down these stairways now for thirty-three years. The island has become a conjuring heart, wrenched out of the solid rock, standing far out from me, standing upon the far horizons of my daily living, yet intertwining itself with my own heart and wrenching it open, casting light, signal, currency far

away, out over unknown wilderness beyond. A process that continues beyond my conscious understanding.

To tell this story, I can only think of the stories from the Skelligs that I know.

It is near the end of the season last year, in August, possibly one of my last journeys to Skellig Michael. There is acrimony, restlessness, in our tight quarters – as in the tight quarters locked down across the earth today. I continue my early morning trips down the lighthouse road and, incongruously, after all the other birds have fledged, a small puffin chick scurries away to hide under a rock on the road ahead.

Against better practical sense, I pick him up, keep him close in my pocket, take him into my hut and examine the little creature. He has weeks yet to go before he will be able to fly. For days this little creature sleeps on my floor in a box. Sprats sent over from Dingle are fed to him regularly. As has so often been the case with fledglings, I know they can perish quickly, sometimes immediately, upon becoming relatively stabilized in a new location. And yet, this little creature – Cruiser, I come to call him – comes to sit on my lap after feeding, locking huge dark eyes on my face, oblivious for these moments to any other event. The bond he creates, necessitated initially by his utter need, somehow comes to incorporate, when the time comes, the inevitable acceptance of my carrying him once more, at night, down the lighthouse road, with a storm coming up, at perhaps the best opportunity for departure – acceptance of being carried seaward, of arrival at the wild landing a quarter-mile away, of the fresh and still passable water coming up there, and his releasing into the otherworld. I do not know what will be the ultimate outcome of releasing this smallest of creatures on a dark pier below. His state is utterly perilous, minute by minute. The eye of the little creature, fixed upon my face, remains permanent there.

28 September 2019, the Eve of the Feast of St Michael, the last day on the Skelligs

Torrential continual rain. Climbing up to the monastery for one last time in the near dark, I saw a damp and bedraggled tiny form, standing out from masonry, huddled just within the shadow of an overhanging step, about halfway up the mountain. I passed this little creature by and spent my last hour of this year – and, of course, as always, possibly of my life – making a last check of the monastery, moving about within the domes overhead. They are empty, already abandoned to the winter. Coming down an hour later I sought the little petrel and found him unmoved, as I had left him – hardly moving in my hand, utterly exposed, soaked through, obviously very near death.

I stuck him in my pocket for the descent and brought him out into the light of the hut. He was put in a dry box, and I did not expect to see him living when I went to check on him some minutes later. In a half-hour, though, the soaked surfaces of his wings and body had begun to dry. He appeared a little more bullet-like, more a natural shape, something of a bird; yet he remained immovable, mesmerized. A little later his wing began to quiver. His body temperature rose; he began to dry out in his core; he began eventually to fluff out his wings.

My colleague unbelievably found another in a similar condition, similarly bedraggled and imperilled. I was wary of adding this one to the box, as it suddenly seemed possible that the first inmate might recover. In an hour, they were as twins. All night the box sat in a corner in the dim light of the hut on Skellig Michael, in an alien lockdown of sorts, hopeful for an unlikely survival, even one more dry night.

The next day we had to leave in a hurry. Storms – set to last, possibly for weeks – were imminent off the west coast of Ireland. The sea at the landing was uncertain and rising; the skipper was unsettled, angry.

We had anticipated one more night on the island. When I picked up the box, the two petrels immediately became animated, and the box was filled with fluttering wings. They were set free quickly under the veranda, as we had no time for any other course of action. They were left near the entrances to the burrows the puffins had used under the huts, now abandoned for several weeks. The last I saw of them, as I was running down the road to the boat, they were fluttering there, hidden under boards, looking for shelter for the day under the hut in order to launch out into the Atlantic at nightfall.

Though fresh, it was a warm, sunny afternoon. They were setting out upon their uncertain, unravelling track, for whatever unknown and uncertain period, their release from this island part of a great migration. Like ourselves, cleared for one more day. For an hour, for forty years.

The birds were chattering under the boards in the sunlight. The island taking their song in, storing it for their possible return against the darkness beyond and below.

They were making one more ascent, one more plunge into the vast circles of flight dividing the emptiness ahead, beyond the fringes of normal human traffic: a pair, a handful of ragged creatures, setting out on the pathways on which we also tentatively embark.

The little creatures rise, pushing against us still; their trails of departure flicker ahead, above the rock unfolding along the sea from Skellig Michael. On the cell floors, after we leave, the light will continue to quiver, dance for a few more days, and then return to rise in spring. Each departure is a lift from the safety of ordinary and established light into the great currents that cross just beyond our fingertips here. However hazardous, imperilled, forgotten, these vistas continue to suddenly come into view.

I think of the mesmerizing effect of my arrival at a far shore, so many years ago, observing the lines of flight unfolding in the sky ahead, drawing me out to the horizon. And those outlines

of flight gleaned and remembered from early manuscripts coming alive before me there.

~

Now, from the perspective of this lockdown, which I share with so many across the globe, this bright summer's day I am called back to my hut in my mind's eye, and I remember that last afternoon with Cruiser. I see him very clearly, sitting once more on my lap, his eye latched upon my face, two weeks after first lifting him from the road, on the afternoon before I take him down to the landing. Quite possibly my efforts to promote his departure have been erratic, but a window in the weather appears, and it is time for him to be given a chance to fly. He is late, one of the last puffins on the island, if not the last. His chances are perhaps slim. At the moment, he is, he remains, perfectly formed; his wings steadily fan the air on the floor of the hut.

At one point, the lens of his eye brushes up against my skin. For a moment, I sense its soft delicate curve against my arm in passing. I study the little head: the two glossy eyes ready to engage in the engine of travel, to adapt quickly to stimuli in dangerous situations. He is pushed forward by his need and instinct. We share the hut, breathing together as he sits up on my leg in the reciprocal silence of anticipation: a trust by default, of one need on the other. The wiring for travelling out under starlight is already glimmering in the falling darkness within his eyes and he stares confidently ahead at me.

Up in the domes far overhead, there are other small canopies of light, of starlight, that have been carved by the mind's and heart's eye to guide flickering light on the courses of stone inside the monastery. The progressions of light upon stone have been regenerated and internalized there over centuries. Here there is a silence revealing music from passing but briefly held light. The schemes, the dogma, the belief by which these lights have been

observed and guided falter, change, adapt. Still these lights glow each evening, mixing with the soft unheard cries of arriving, departing messengers operating on orbits that reach far out upon emptiness.

The little night birds, the petrels and shearwaters, call greetings as their partners return, night upon night, throughout the summer. The air in the cells fills with this current charged with light and song. Yet it is utterly still; it is the stillness of time standing still, a stillness sensed in this quiet hut tonight, as I sit with Cruiser. This stillness forces appropriation of all dangers, its chances, its mysteries. At every step here, the land falls away. At every opening, at every entrance here, at each new perspective on the endlessness seething beyond, conventional time opens. The silence charges.

First light is struck here: this is the first place the elements strike reaching for the mainland. Each breath, each passing spirit, glows, is charged, in this first awareness of wind and sea, above cathedral of stone or brick, beyond all dogma, beyond the ravages of time, beyond the hatred and the greed that can be rampant only a few miles away. Here, there are constructs, courses of stone that briefly hold passing starlight, briefly hold the silent music of passing stars, that will enter and activate the deepest heart in an instant, that will activate the deepest places of the heart, wherever they are hidden.

ACKNOWLEDGEMENTS

First of all, it would have been impossible to write this book without the support of my family. They have been the real presence behind my trips to the Skelligs from the very beginning. I cannot thank Maigread, Daniel, and Lillian enough for their support and their love. Maigread travelled with me to that 'far place' on my first journey, and – in so many different ways – has travelled with me each time since.

I must also thank all the people I have worked with on the island since 1987, particularly the guides there: for putting up with me, and for laughing with me countless times, often in adverse conditions.

Because of lockdown, I have never met my editor, Catherine Gough, face to face, and yet I have been amazed by her understanding with regard to what I have attempted to write in this book. Her help and good nature have been essential, and are deeply appreciated. I must also give sincere thanks to Emma Dunne, my copy editor, for smoothly rounding the rough edges, and making the book's completion so very much easier. Graham Thew, who designed the beautiful cover of the book, and Karen Vaughan, who provided the marvellous interior illustrations, deserve special mention and appreciation. Thank you, all.

Three great writers come to mind as direct inspiration: William Dalrymple, Patrick Leigh Fermor, and Thomas Merton. In very different ways, they have reminded me of the value of, and the ways, of sending love from far distances.

Finally, I have to acknowledge the *Agnes Olibhear*, and her skipper, Owen Walsh. The *Agnes* has faithfully taken me to the Skelligs for 34 years, in all weathers. Many times, I have sat up through the night with Owen - me on the Skelligs, Owen on Valentia - watching the sea, to see when there would be safe passage.

I also acknowledge the care and love and support of the many who have walked the paths of the Skelligs with me, and are now with me in a different way: my father, and those who have died on the island; many dear friends.

Final entry: Tuesday, 15 July 1999 (in the year Trish died)

It's late in the evening down at the huts. I heard a fluttering down the road a little while ago, and there was a young puffin, ready to fly – just a Mohawk ridge of down left along his forehead. I lifted him up onto the wall and away he went, straight out over the ocean. First flight.